THE WORLD OF M.C. ESCHER

The World of M.C.Escher

Harry N. Abrams, Inc., Publishers, New York

Edited by J. L. Locher

Standard Book Number: 8109-0107-2
Library of Congress Catalogue Card Number: 70-161039
Copyright 1971 in the Netherlands by Meulenhoff International, Amsterdam
All rights reserved. No part of the contents of this book may be reproduced without the written permission of the publishers
Harry N. Abrams, Incorporated, New York
Printed and bound in the Netherlands

Contents

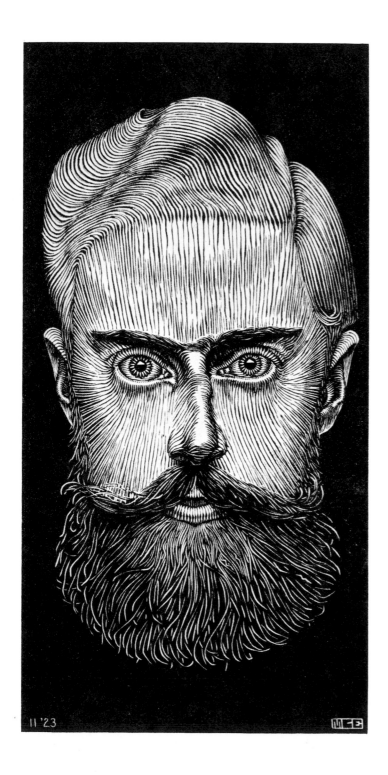

The Work of M. C. Escher

J. L. Locher

Maurits Cornelis Escher was born on June 17, 1898, in Leeuwarden, the capital of the province of Friesland in the northern part of the Netherlands. He spent most of his youth in the city of Arnhem, where he attended secondary school. It was evident even then that he liked to draw, and the drawing teacher at his school, F. W. van der Haagen, encouraged him and instructed young Escher in making some prints, most of them linoleum cuts.

After secondary school, on his father's advice, Escher went to Haarlem to study architecture at the now defunct School for Architectural and Decorative Arts. One of the faculty members there was the Dutch artist Samuel Jessurun de Mesquita, who discerned Escher's talent for the graphic arts and advised him to drop architecture. Escher, who had already found that architecture was not to his taste, took this advice gladly and pursued his education in the graphic mediums under Jessurun de Mesquita from 1919 to 1922.

After finishing his studies, Escher traveled frequently, mainly in Italy. In the spring of 1922, he went directly to Italy, and in the autumn of the same year he made a trip to Spain. From there he returned to Italy, which had begun to fascinate him so greatly that he moved to Rome, where he lived from 1923 to 1935. While living in Rome, Escher made long journeys through the Italian countryside every spring. During these trips, on which he often covered long distances by foot, he explored southern Italy, not popular for travel at that time and far from accessible. His destinations during the earlier years are difficult to trace, but we know that in 1926 he was in the vicinity of Viterbo ; in 1927, in the northern part of the Abruzzi ; in 1928, on the island of Corsica ; in 1929, in the southern part of the Abruzzi ; in 1930, in the little-known towns of Calabria ; in 1931, on the coast of Amalfi ; in 1932, first in Cargano and later in the vicinity of Mt. Etna and northeastern Sicily ; in 1933, again in Corsica ; in 1934, again on the coast of Amalfi ; and in 1935, again in Sicily. On these journeys, he made drawings of whatever interested him, working out the best of them for prints during the winter.

The rise of fascism in the thirties made life in Rome less and less bearable for him, and he therefore moved in July, 1935, to Château d'Oex in Switzerland. From May to the end of June in 1936 he made what was to be the last of his long study trips, this time by ocean freighter along the coast of Italy to Spain. On this trip he made detailed copies of the Moorish mosaics in the Alhambra and in the mosque, La Mezquita, at Córdoba. In 1937 he moved to Ukkel, near Brussels, and from there he returned in 1941 to the Netherlands to settle in Baarn. In 1970 he moved to Laren.

Since 1937 Escher has been less mobile. He travels only as a form of vacation, to visit his children who live abroad, or on rare occasions in response to an invitation to lecture on his own work. In 1960, for instance, he visited England, Canada, and the United States to give lectures. But his trips no longer have importance for his work. His prints now originate—from the first

studies to the final result—in his studio. Corresponding to the change in his way of living, there has also been a change in his work since 1937. The direct impulse to make a print now almost always comes not from observations of the world around him but from inventions of his own imagination—what we may call his visual thinking. This change is so distinctly observable that we can divide his work into two groups : the work done before 1937 and the work done after 1937.

The first group, done before 1937, is dominated by the representation of visible reality—the Italian landscape and the architecture of the Italian cities and towns. In innumerable prints landscape and architecture are represented exactly and realistically. This realism demonstrates a vivid and, at the same time, highly individualistic way of looking at things, expressed in the special attention to peculiar and irregular rocks, plants, cloud formations, and architectonic details. We also see this individuality given special expression in Escher's concentration on the structure of space. There is a frequently recurring preference for an angle of view by which different, often strongly contrasting, spatial experiences are emphasized simultaneously. Again and again we look into a landscape upward and downward as well as into the distance. Examples of this are found in the prints *Bonifacio, Corsica* (Cat. 30), *Coast of Amalfi* (Cat. 47), and especially *Castrovalva* (Cat. 39). In the last of these, we look upward into a formation of clouds, downward into a town in the valley, and into the distance of the mountains stretching before us. Escher preferred the landscape of southern Italy because it so often offered him this range of spatial structures.

In his architectural subjects, too, we repeatedly encounter combinations of different spatial experiences. A typical example is the print *Vaulted Staircase* (Cat. 48), in which a blend of height and depth coincides with a view to the left and a view to the right. The same combination occurs even more strongly in the print *St. Peter's, Rome* (Cat. 69).

Although he took the Italian landscape and the architecture of the Italian cities as his main subjects, in these years Escher also worked from time to time on the portrayal of other observations. It is typical of Escher that these prints, too, reveal the attraction of singular or bizarre elements as well as a marked interest in the conjunction of disparate spatial perceptions. His interest in the unusual is exemplified by a remarkable rendering of the phosphorescent wake of dolphins swimming ahead of the bow of a ship at night (Cat. 13), by a print of fireworks (Cat. 58), by another of mummified bodies in a church in southern Italy (Cat. 49), and also by a copy of a bizarre detail from Hieronymus Bosch's painting *The Garden of Delights* (Cat. 79). The conjunction of different spatial experiences is seen, for instance, in several prints showing mirror effects, the most striking of which are the *Still Life with Mirror* (Cat. 60) and *Hand with Reflecting Sphere* (Cat. 67). A mirror effect is preeminently a

phenomenon in which widely different spatial circumstances can occur together at a single place. In *Still Life with Mirror*, the space of the street is combined via the mirror with the space of the room, and in *Hand with Reflecting Sphere* the spatial effect of the surface of the sphere coincides with the space around the maker of the print, who sees himself reflected in that surface.

During the years before 1937, Escher was not solely concerned with the representation of the observed world but also gave shape in a number of prints to inventions of his own imagination. Typical examples are *Castle in the Air* (Cat. 25), *Tower of Babel* (Cat. 26), and *Dream* (Cat. 76). In the first two we see again a combination of height, distance, and depth. In spatial structure, *Castle in the Air* bears a relationship to *Castrovalva* (Cat. 39) ; *Tower of Babel* to *St. Peter's, Rome* (Cat. 69). *Dream* is an example of another way of linking different facets of reality, one which Escher used several times during this period. Although the subject as a whole is entirely imaginary, this print is built up of elements that each derive from real observations. Separate observations are combined into a whole (Cat. 72-75). For Escher two different forms of reality also coincide in the interpretation of this print. Its meaning is ambiguous : is the bishop dreaming of a praying mantis or is the entire picture the dream of its creator ? *Castle in the Air*, *Tower of Babel*, and *Dream* all show an extravagant world. Their bizarre content has, in addition, a distinctly humorous cast. Humor is expressed in the castle's literal suspension in the air and in the somewhat derisive combination of the two widely divergent forms of prayer in *Dream*—the prayer of the statue of the dead bishop and the prayerful attitude of the mantis.

A strange and highly individual fantasy is shown in the print *Eight Heads* (Cat. 7) and the closely related pair of drawings with repetitions of an animal motif (Cat. 22, 23). These are examples of a way of working that up to 1937 took only a subordinate and isolated place in Escher's work. The remarkable thing, however, is that in these works, too, a combination of different elements of reality is brought about, this time by means of an unusual double use of the contours. In both the print and the drawings, the contours do not serve, as they normally would, to outline a figure against its surroundings but instead delineate figures in two directions, both to the right and to the left. Various figures share the same contours ; by these contours they are related to each other ; and they are so constructed that they can be repeated, in this linkage, to infinity.

A reference to the possibility of continuation into infinity, as occurs here so distinctly, is, in fact, also present in many of Escher's representations of landscapes and architecture in which different spatial experiences coincide. In these prints, when our gaze is thrust into different directions and far into space, often the suggestion is also created that what we see

represented is only one facet of a much greater space comprising different angles of view and continuing into infinity.

Besides a preoccupation with reality and his own fantasies, Escher's work from before 1937 shows a passionate concern with the graphic métier as such. In this work he can be seen experimenting repeatedly with the expressive possibilities of graphic techniques—with shading, sharp contrasts between black and white as well as subtle tonal nuances, the use of more than one block for a single print, and the addition of many other technical elements. His choice of sketches for development into prints was determined primarily by their relevance for the technical problem on which he was working at the time. One of the important aspects of the print *Dream* (Cat. 76) is Escher's experimentation with the technical problem of achieving a gradual transition from light to dark in a woodcut or wood engraving. Here, gray is not an unstructured mixture of black and white but a series of black and white lines. A light area consists of thin black lines alternating with wider white ones. By a gradual widening of the black lines and narrowing of the white ones, the area becomes darker. In *Dream* the rendition of the vaulting offered an especially good opportunity to experiment with this transition from light to dark. The sequence of black and white lines can sometimes be handled in such a way that they contribute toward the effect of perspective ; Escher's experiments with this problem are particularly evident in *Tower of Babel* (Cat. 26). In 1934 he made a series of prints depicting nocturnal Rome, using a different woodcut technique in each one to create effects of light and dark. In the print *Colonnade of St. Peter's in Rome* (Cat. 61), for instance, he used only diagonal lines ; in *Nocturnal Rome : The Capitoline Hill, Square of "Dioscuro Pollux"* (Cat. 62), only horizontals ; and in *Basilica di Massenzio* (Cat. 63), he experimented with a particular shading technique.

Up to 1929 Escher worked almost exclusively with woodcut technique. After that period he devoted considerable time to lithography, and since 1931 the refined form of the woodcut—the wood engraving—has also taken an important place in his work. Except for incidental experiments, he has never used the etching technique, which he disliked because the effects are obtained by dark lines placed against a white background. He has always preferred to work in and with the surface, which is possible in the woodcut, wood engraving, and lithograph. For Escher, drawing was then—as it still is—mainly an approach to his prints. He usually drew to record interesting motifs when he came across them. However, he has experimented with this technique, too. The most important of these experiments are the so-called scratch drawings, made by coating parchment evenly with printer's ink and then drawing on this surface by scoring it with a pointed tool. He began to use this technique in 1929 (Cat. 32) ; the results were important not only as independent experiments but also because they led him

directly to lithography. He found that he could work in the same way on a lithographic stone covered with ink, and his first lithograph, *Goriano Sicoli, Abruzzi* (Cat. 34), originated as an attempt to apply the scratch technique graphically.

In looking back on his work before 1937, Escher himself is inclined to emphasize experimentation with graphic mediums and to consider most of the works of this period no more than exercises ; but we also can recognize in this work a keen observation of the world around him as well as the expression of his own fantasies. In addition, there exists in all this early work a preference for the simultaneous perception and combination of several, often contrasting, facets of reality, which is manifested most often in the spatial structures and occasionally in the contours. We have seen that the linkage of different aspects of reality is usually taken from observations of the visible world but is also sometimes constructed from imagination. We see it here in combinations of angles of view, there in a coinciding of spatial perspective achieved by mirror effects, and again in the combination of separate observations and the double use of the contours.

The linkage is present most distinctly in the mirror effects and the double use of contours. However, both these forms occur the least frequently in the work dating from before 1937. This makes it even more remarkable that in Escher's earliest work, done in the period when he was still attending the School for Architectural and Decorative Arts, we encounter examples of both a mirror effect and the double use of contours : the drawing *St. Bavo's, Haarlem* (Cat. 1) and the print *Eight Heads* (Cat. 7). In the drawing we look obliquely into the church of St. Bavo. We see part of the ceiling and a hanging candelabrum. In the mirror image on the shiny ball at the base of the candelabrum, we can see part of the rest of the church and, much smaller, the draftsman himself with his easel. The space in which the draftsman is standing and the space at which he is looking are linked by this mirror effect. In *Eight Heads*, as we have already seen, various heads (four male and four female) are linked because their outlines coincide.

St. Bavo's, Haarlem gives a representation of an observed reality ; *Eight Heads* gives a personal construction. Both belong to Escher's first works but already contain not only the nucleus of his own image-structure but also the principal ways in which it can be expressed. However, such a distinct manifestation of Escher's image-structure as is seen in these two initial works is exceptional for the work done before 1937. It usually emerges in a less obvious way, in combinations of angles of view or in the suggestion of a unity which is actually his own construction based on several individual observations.

In 1935 Escher left Italy and, after short stays in Switzerland and Belgium, settled in the Netherlands in 1941. In Switzerland, and to an even greater extent in Belgium and the Netherlands, nature and architecture began to lose the attraction they had had for him in

11

Italy, and he became increasingly absorbed in his own inventions and less and less interested in the portrayal of the visible world. Generally speaking, what had once been only latent and concealed in the early constructions now became openly manifest. The fundamental possibilities stated as early as the *St. Bavo's, Haarlem* and *Eight Heads* were consciously incorporated and developed in this period. This can be seen at a glance in the two prints marking Escher's new phase in 1937 : *Still Life and Street* (Cat. 97) shows a linking of different aspects of space ; and *Metamorphosis I* (Cat. 99), a linking of different figures by the double use of their contours. *Still Life and Street* is closely related to Escher's earlier applications of the mirror effect, particularly the *Still Life with Mirror* (Cat. 60) of 1934. In both these prints, the space belonging to a room and the space belonging to a street are drawn together.

Despite this structural relationship, however, there is a fundamental difference. In the 1934 print, this linkage is expressed as it would be observed in the real world, whereas in the 1937 print, it has been constructed during the making of the print. Two different observations are combined, one a street recorded in a sketch and the other a view of a worktable with books. We have already seen that a combination of observations made separately at different times and places also occurs in prints such as *Dream* (Cat. 76) ; even though the combination is not immediately apparent, we know that it is there. In *Still Life and Street*, however, the independent views are directly evident. Although unity is suggested in this print, too, it is done in such a way that we remain conscious of its literal impossibility, conscious that the suggested unity is due solely to the artist's ingenuity. The observation of the street and the observation of the worktable are cleverly combined in a single perspective, but they remain two separate observations because each is represented on a different scale. There is a unity of space but a difference in scale. This difference in scale is ambiguous : is the worktable with its books abnormally large or is the street absurdly small ? The relativity of the concept of scale could hardly be stated with a lighter touch.

The parallel cases formed in Escher's earliest work by the St. Bavo drawing and *Eight Heads* are repeated in 1937, in the two prints *Still Life and Street* and *Metamorphosis I*. The latter shows once again how a contour can not only set off a figure from its surroundings but also have a similar indicative effect in two directions. This print also shows—and this element is not found in *Eight Heads*—how gradual changes in contours can serve to bring about a transformation or metamorphosis. A figure can be modified or can become an entirely different figure.

Escher's copies of the Moorish mosaics in the Alhambra and in La Mezquita (Cat. 83-88), made in the summer of 1936, contributed to his renewed interest in the possibility of a double use of contours. These mosaics are composed of regular repetitions of basic geometric figures

that could in principle continue to infinity. They fascinated Escher because he recognized in them problems with which he had been preoccupied several times in 1922 and 1926 but for which no application had occurred to him at that time. The mosaics led him to take up the problem again and to carry it further. His half-brother, B. G. Escher, who held a professorship in geology at the University of Leiden, pointed out to him that crystallography involved the same problem. Using his copies of the Moorish mosaics and the results of some reading in the literature on crystallography, Escher began to construct contiguous, repeated forms of his own. The pure geometry derived from his two sources was not sufficient ; he was attempting to reach an essentially different result, for ultimately he was interested not in an interlocking series of abstract patterns but in the linkage of recognizable figures. He tried to bring abstract patterns to life by substituting them with animals, plants, or people. He had an inherent need to give these abstract patterns form by means of clearly recognizable signs or symbols of the living or inanimate objects surrounding us. Working from the abstract geometric figures taken from the Moorish mosaics and crystal formations, Escher developed innumerable realistic figures that, when linked in contiguous symmetrical series, could be repeated to infinity. Step by step, he filled his notebooks with these motifs until he had an inexhaustible supply of source material for his prints.

In the prints in which Escher used these motifs, the process leading to the animation of abstract structures is carried still further. The bringing to life of an abstract structure of contiguous repetitions produces individualization of this structure, which, carried to its logical conclusion, means that it will ultimately become finite. The motifs constituting the regular division of the surface, which in themselves could be continued to infinity, were now individualized to such a degree that their structure acquired a beginning and an end. What we see in these prints is no longer a fragment but a whole, a completed picture.

Metamorphosis I (Cat. 98, 99) is an excellent example of this development from motif to complete entity. The point of departure for this print was a motif consisting of contiguous repetitions of a small Chinese man. The drawing shows clearly that the underlying structure of this motif is formed of a regular division of the surface into equilateral triangles. Like these triangles, the little men in the drawing are only fragments of a structure that could continue to infinity ; but in the print this structure is used to create a picture containing its own resolution. Toward the right, the little man becomes increasingly detailed, until he finally releases himself from the series ; as an independent individual, he takes a position against a background. In the middle of the print, he transforms himself into connecting hexagons, which, in their turn, undergo a gradual transformation into the houses of the Italian town occupying the left side of the print.

The possibilities inherent in this animation or individualization of basic motifs were worked out in innumerable prints, each time in a different way. One of the striking things about these prints is how frequently the genesis of the individualized figures is accomplished not only by a gradual differentiation of a given geometric structure but also by the use of a vague gray tone that makes a gradual transition into a sharp black-and-white contrast. For Escher, this vague gray is another basic element that can be brought to life. We see this very clearly in the print called *Development I* (Cat. 100), dated 1937.

A complex structural variant of *Development I* is offered by *Verbum* (Cat. 116), done in 1942. Unlike *Development I*, *Verbum* does not represent the process of individualization from the margins toward the center but the reverse, from the center outward. In this print, we see an indefinite central gray area differentiate itself into a motif of contiguous black and white triangles, which in turn gradually change into birds, fish, and reptiles, symbolizing air, water, and earth. Each of these animal species manifests itself in both black and white versions, thereby indicating day and night. These contrasting figures originate not only from the same gray tone and the same abstract motif but also from each other. In a clockwise direction, the birds change into fish; the fish, into reptiles; and the reptiles, back into birds. At the outer margins, where the animals are individualized, this movement simultaneously becomes a complex exchange of foreground and background. The white day behind the black birds gives rise to white birds, while the black birds become the black night behind the white birds. The white birds merge with the white day behind the black fish, which, in their turn, derive from the black night, and so on.

The movement by which the birds, fish, and reptiles are transformed into each other in *Verbum* forms a closed cycle, a feature recurring in many of Escher's prints. The closed cycle fascinates him because with it something of infinity can be captured within the finite. We see closed cycles in such prints as *Reptiles* (Cat. 120), *Magic Mirror* (Cat. 134), *Swans* (Cat. 211), and *Cycle* (Cat. 104). An especially good example is *Day and Night* (Cat. 102), in which an interlocking series of diamond-shaped figures gradually becomes a contiguous series of black and white birds. These birds are each other's mirror images, and they fly in opposite directions. As they approach the sides of the print, they release themselves from their neighbors; the white birds gradually become the diurnal landscape behind the black birds, and the black birds, the nocturnal landscape behind the white birds. It seems now as though an individualization has been completed on both sides; but then we see that the diurnal and nocturnal landscapes, too, form each other's mirror image. Furthermore, the landscapes are composed of fields, and, in the lower central portion of the print, the fields take on the shape of a contiguous series of diamonds. These diamonds connect the diurnal and nocturnal landscapes, but at the same

time they are the figures from which the birds developed, and so they generate two closed cycles, a left and a right, which mesh like two cogwheels. It is typical that here, too, the animation of an abstract motif is accompanied by a differentiation of gray into sharp contrasts of black and white.

An individual combination of finite and infinite is illustrated by the prints *Circle Limit I* (Cat. 233), *Circle Limit III* (Cat. 239), and *Circle Limit IV* (Cat. 247). A motif to regularly fill the surface is used radially in these prints, with the concentric rings of the motif becoming smaller and smaller in an exactly executed process of reduction. Although this reduction can in principle continue to infinity, it is at the same time limited by the circle to which it gives rise. Escher first attempted to suggest the infinitely small by progressively reducing the motif by half toward the center, as in *Smaller and Smaller I* (Cat. 219). But this print left Escher unsatisfied, because the result was an artificial limitation at the outer margins and therefore only a fragment, rather than a self-enclosing composition. In this respect the reverse approach used in the *Circle Limit* prints—the reduction toward the margins—is much more successful ; a suggestion of the infinitely small is visible in a composition forming a self-contained whole (see also pages 39-40).

Escher also combined finite and infinite in a more complicated version of *Metamorphosis I*. Done in 1939, this new version, *Metamorphosis II* (Cat. 111), was more than four times longer and much more complex ; in it, he converted the individualized and completed process of the 1937 *Metamorphosis I* (Cat. 99) into a suggestion of a closed cycle. In place of the man and the town at the two extremes, Escher now made the beginning and the end of the print coincide. If the ends of the print were joined to form a cylinder, the patterns at the beginning and the end would merge.

In its continuous motion, this print also demonstrates many of the possibilities of linkage and permutation. We see not only transformations dependent on form but also transformations determined by the content of the subject. When hexagons change into honeycombs, this is the result of an association of the form ; but when Escher makes bees fly out of the honeycomb, this is a logical possibility suggested by the content. Another shift determined by such an association is the transformation of the tower into a rook in the chess game. Escher has always taken immense pleasure in playing with associations. He remembers that as a child he set himself riddles such as : how can a logical connection be drawn between the letter *l* and my dog's tail ? One answer would be, for instance : by starting with the *l* of *lucht* (air) and then going via bird—nest—branch—garden—dog to tail. Many of his prints, exemplified by *Metamorphosis II*, constitute a visual demonstration of this kind of game.

We have seen that *St. Bavo's, Haarlem* was done in the same period as *Eight Heads* and that in

1937 Escher produced not only *Metamorphosis I* but also *Still Life and Street*. A parallel interest in surface-filling motifs and spatial structures can also be seen in the drawings Escher made in 1936 at La Mezquita in Córdoba, where he not only copied the regular repetitions of the mosaics (Cat. 88) but was also fascinated by the perspective effects created by the long rows of columns. In the drawing *La Mezquita, Córdoba* (Cat. 89), we see the coinciding of a distant view to the left and a distant view to the right. This drawing corresponds to a series of prints reflecting related observations, such as *Vaulted Staircase* (Cat. 48) and *St. Peter's, Rome* (Cat. 69). Because the drawing remains in every way a realistic representation of the observable world, it does not anticipate the coming work as clearly as the copies of the mosaics, but it is not surprising that it originated in parallel with these copies.

Although in 1937 Escher produced both an original construction based on surface-filling motifs (*Metamorphosis I*) and an original compositional construction with spaces (*Still Life and Street*), his work during the next few years shows a distinct preference for the former direction. In a certain sense, this is logical. Original pictorial constructions were directly present in Escher's work before 1937, especially in the occasional drawings and prints with contiguous series, so it is understandable that these early works took on a special importance when he began to concentrate on pictorial constructions after 1937. This trend was further solidified by his contact with the Moorish mosaics and crystallography, which suddenly made him conscious of the many unsuspected possibilities in this area. During the first few years after 1937, the use of repetitive motifs, rather than spatial structures, offered Escher greater opportunity to create an individual pictorial construction and thus to express himself in a highly individual way. When Escher speaks of his own work today, he still names this field of surface-filling constructions as his richest source of inspiration. However, by this analysis, Escher gives a very one-sided vision of his work. This statement applies only to the years shortly after 1937; after that period, and particularly after 1944, he began to concentrate once again on his own spatial compositions.

The experimentation with spatial constructions after 1944 led Escher to more and more surprising results; good examples are given by *Other World* (Cat. 142), *Relativity* (Cat. 188), and *Belvedere* (Cat. 230). In these prints we see recognizable figures and spaces in impossible situations, where they possess an absurd strangeness. *Other World* shows within a single space the same bird figure and architecture seen from above, below, and the side. *Relativity* contains many remarkable elements, such as the two figures in the upper part of the print who are walking on the same stairs in the same direction but one ascending and the other descending. Startling phenomena are also found in *Belvedere*—a ladder begins inside and ends outside the building but can still be climbed normally, and a man and a woman look out

16

through two openings in the same wall, one directly above the other, although the man is looking obliquely away from us into the distance and the woman obliquely toward us. The singularities in these prints are the result of an ingenious linkage of different spatial realities. These connections are not established arbitrarily; in each case there is a particular underlying principle, worked out logically to the last detail. Consequently, what seems absurd in relation to our normal experience is presented in these prints as a logical possibility of a deliberate visual system. The singularities in *Other World* and *Relativity* result from the fact that in these prints each plane has been given not the usual single function but three: each flat surface is at the same time wall, floor, and ceiling. The absurd building in *Belvedere* is constructed according to the principle—possible only on paper—of a cube whose edges have been exchanged. The figure on the bench has such a cube in his hands, thus illustrating the structure of the print. The transposition of the edges is expressed in the building by the columns of the second story. Because here our attention is purposely distracted in a very subtle way to the mountainous landscape in the background, we must make a deliberate effort to observe this exchange.

As in the prints based on surface-filling motifs, in the spatial constructions an abstract principle is always brought to life by means of recognizable motifs. This animation or "narrativization" was achieved step by step in numerous studies. Good examples of this process are provided by the studies for *Relativity* (Cat. 186, 187) and for the *House of Stairs* (Cat. 168-71). We can follow the introduction of the narrative element into an abstract structure especially clearly in the studies leading up to the *Waterfall* print (Cat. 250-58). The point of departure in this case was a perspective drawing of a triangle published by L. S. and R. Penrose ("Impossible Objects, A Special Type of Visual Illusion," *The British Journal of Psychology*, February, 1958). No error can be discovered in any of the subsidiary elements of this triangle (Cat. 250), but the whole is impossible because the manner in which these parts have been related to each other admits modifications. In Escher's drawings we can see how he gradually transformed this figure into an extraordinary building with an impossible waterfall that feeds itself and can only cease to exist if the water is lost by evaporation. Typically, the surroundings of this waterfall are composed of reminiscences of Italian landscapes, and even the wondrous fantasy of a garden is based on a drawing Escher made many years earlier.

The grafting of a narrative onto an abstract structure is itself never visible in the completed prints of spatial constructions. The generative processes, such as we have seen in *Verbum* or *Day and Night*, for example, do not occur in the final prints. When in rare cases the underlying framework of the print is recognizably conveyed in the completed picture, it is always done in a static manner. In *Belvedere* the figure on the bench reveals the structure of the print by the cube

17

in his hand, but we do not actually see the picture evolve from this structure. In the same static manner, the structure of *Convex and Concave* (Cat. 198) is indicated on the flag at the upper right. On this flag we see a group of three cubes, which we can read in two ways. At one moment we see three standing cubes, at another moment three cubes lying on their sides; the two gray planes in the middle of the group can form either the upper surface of two of the standing cubes or the lower surface of two of the cubes on their sides. The rest of the print consists of a narrative manipulation of this structure; for example, the surface on which a man sits at the lower left is the same surface from which an oil lamp is suspended at the lower right.

We have already mentioned that in the representation of spaces before 1937, there is a suggestion that what we see is only a fragment of a much greater space extending to infinity. Various prints showing spatial constructions from the period after 1937 also contain a very explicit suggestion of endlessness, for example, *Cubic Space Division* (Cat. 181) and *Depth* (Cat. 206). Structurally, these prints are directly related to drawings like *La Mezquita*, while at the same time showing a shift from observation of reality to invented construction.

A print such as *House of Stairs I* (Cat. 172) contains a suggestion of infinity in that the subject can be repeated endlessly in both downward and upward directions. Because the upper and lower margins fit together perfectly, this repetition can even be accomplished literally by repeated printings of the lithographic stone (Cat. 173).

The pictorial constructions with spaces contain not only suggestions of the infinite but also repeated changes from one reality to the other, with the structure of a closed cycle. In *Waterfall* (Cat. 258), for instance, the water flows endlessly in its circular course. In *Ascending and Descending* (Cat. 243), one group of monks climbs eternally and the other descends endlessly. In an unusually complicated construction, *Print Gallery* (Cat. 216) shows a boy watching himself viewing a print, with the boy who is looking and the boy who is being looked at coinciding.

Invented compositions have dominated Escher's work since 1937, and recorded observations of the real world have become much less important. The few occasions on which he has returned to the realm of observation have mainly concerned mirror effects; the best examples are *Three Worlds* (Cat. 207) and *Three Spheres II* (Cat. 135). In *Three Worlds* the water of the pond functions as a surface, as depth, and as reflector of the world above it. *Three Spheres II* is an elaboration of *Hand with Reflecting Sphere* (Cat. 67) of 1935; in a still clearer way, Escher has shown once again how various spaces coincide in this mirror effect and how, in the process of representing this coincidence, the maker is inevitably present at the center. Escher's prints are always concerned with a search for a logical connection between the many

forms in which reality is manifested. This connection can be observed or constructed. In *Three Spheres II*, he shows how even when it is observed, the connection is, in the final analysis, his own construction. Observer and creator are not separate but indivisibly connected.

After 1937, experimentation with graphic techniques also became much less important for Escher and recurred with true passion only between 1946 and 1951, when he attempted to master the technique of the mezzotint. But this experiment was limited to eight prints (Cat. 136, 139-41, 147, 149, 155, 166)—enough, it may be said in passing, to show that he had acquired complete mastery of this difficult technique. But he felt that these experiments cost him more time than he wanted to spare, time he needed for working out the unending succession of pictorial constructions that welled up in his mind. Generally speaking, after 1937 technique became no more than a means for giving form to his conceptions ; from that date on he employed the technique most suitable for presenting the idea with which he was occupied and not the other way around, as had often been the case. But his affection for manual skill has never entirely disappeared ; though it has become subordinate to the content, the actual making of a print continues to give him great pleasure, and he still tries to do as much of his own printing as possible. Especially in the past few years, now that he rarely creates new work, he spends most of his working day printing. He complains about the number of orders to be filled, but at the same time he enjoys the wide distribution of his work. After all, he became a graphic artist because he wished to be able to offer multiple examples of each idea. He makes very large editions of his prints, usually more than a hundred and occasionally more than a thousand. He exploits to the utmost the possibilities for multiplication offered by graphic techniques. The unique holds little interest for Escher ; repetition fascinates him.

If we consider Escher's work as a whole, we can distinguish both before and after 1937 a preference for combinations of various facets of reality. In the work done before 1937, we find a distinct accent on spatial structures ; only in occasional instances does Escher play with surface-filling motifs, giving the contours a linking function. After 1937 the accent shifts first to the surface-filling motifs, but particularly after 1944 he also experiments intensively with spatial relationships. Before 1937 we see a secondary emphasis on recording reality; but after that date invented constructions become most important. We could say that what was only latent in the first phase became completely manifest in the second phase ; this progression occurring rather rapidly and radically. Besides this change and a growing technical control, Escher's work has actually undergone no important development. He consistently creates ingenious variations on the original thematic material which remains the nucleus of his entire oeuvre.

In many respects Escher's work is extremely compact, and his prints repeatedly refer to each

other. We can divide them into various groups, but each time we begin to do so it becomes apparent that other combinations are equally possible, that innumerable other relationships are also present. For instance, *Magic Mirror* (Cat. 134), *Horseman* (Cat. 138), and *Swans* (Cat. 211), which are all composed of surface-filling motifs, show a spiral closed cycle that we also find in spatial constructions such as *Print Gallery* (Cat. 216), *Spirals* (Cat. 191), *Moebius Strip I* (Cat. 248), and *Knots* (Cat. 264). There is an unmistakable relationship between *Convex and Concave* (Cat. 198), a play on space, and *Day and Night* (Cat. 102), a composition of repeated motifs. Both prints have a stable subject laterally but in the middle show a perpetual conflict between the different ways in which the pictorial elements can be read. In *Day and Night* this conflict is between foreground and background ; in *Convex and Concave*, as the title itself indicates, between these two opposites. Close analysis also shows a distinct agreement between *Three Worlds* (Cat. 207) and *Other World* (Cat. 142), two prints which at first sight seem to have little to do with each other. In both, three spaces are linked because a single plane has not one but three spatial functions. In *Other World* wall, floor, and ceiling coincide ; in *Three Worlds*, depth, height, and surface. There is also a similarity between *Order and Chaos* (Cat. 157) and *Circle Limit I* (Cat. 233). Both show a fascination with and appreciation of a mathematical figure. *Order and Chaos* employs an existing mathematical figure, a dodecahedron, in the form of a star ; *Circle Limit I* contains Escher's own construction of a mathematical figure—a radially diminishing motif of contiguous fish based on an accurately executed division of the dimensions by two.

An interest in mathematical and especially geometric basic figures is one of the constants in Escher's work (see pages 49-52) ; this element, too, was latent before 1937 and only emerged fully after 1937. The prism-like basic forms which are latent in *Goriano Sicoli, Abruzzi* (Cat. 34), done in 1929, and *Morano, Calabria* (Cat. 43), of 1930, but which are nevertheless indicated by the way in which the small cities are placed in the landscape, have become manifest in such later prints as *Stars* (Cat. 152), *Order and Chaos* (Cat. 157), and *Tetrahedral Planetoid* (Cat. 194). The same progression from implied to explicit is seen in the early print *San Gimignano* (Cat. 10) and the drawing *Palm Tree* (Cat. 14) on the one hand, and a later print like *Spirals* (Cat. 191) on the other.

Still another lasting characteristic of Escher's work is a bizarre sense of fantasy combined with a highly individual sense of humor, as can be seen from almost any of the prints. Here there is no development from latent to manifest—this element is just as distinct in *St. Francis* (Cat. 9), done in 1922, in which not only the saint but also some of the animals have been given a halo, as it is in *Curl-up* of 1951 (Cat. 167), in which this little animal with its rolling locomotion is presented as a scientific discovery. Escher's humor is often characterized by a sarcastic

20

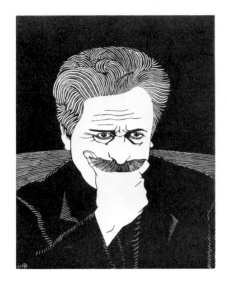

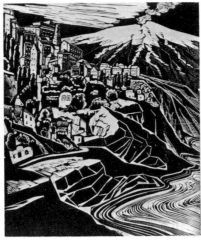

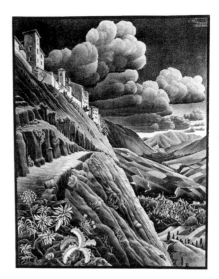

1 2 3

reference to comparative values. The haloes around the animals are a comment on the halo around St. Francis. Escher considers it a joke that a biblical interpretation is usually given to the little book of "Job" in *Reptiles* (Cat. 120) when actually it is only a packet of a Belgian brand of cigarette papers. Even a fascinating construction like *Ascending and Descending* (Cat. 243) is not without its touch of sarcasm, although to appreciate why it is monks who ascend and descend into infinity one must know that the Dutch term for useless labor is "monk's work."

Up to this point, we have examined Escher's work from the inside. But we can also approach it from the outside and relate it to other developments in the field of art. Escher's work is to a high degree unique ; nevertheless, it cannot be completely isolated from other artistic developments. Escher's first prints are related to the work of his teacher, Jessurun de Mesquita. We repeatedly see in them a stolid and angular style resembling Mesquita's (Fig. 1). Escher's preference for the woodcut technique and his passion for technical experimentation are also directly related to what he learned from his mentor, who was known for his endless experiments, especially with woodcuts. This early output not only bears a relation to Mesquita's work but actually forms part of what was at that time a vital Dutch graphic tradition, characterized by a combination of late Art Nouveau, a mild Expressionism, and Realism, with an emphasis on craft and technique. Other artists who worked in this tradition were Jan Mankes, Chris Lebeau, Jan Wittenberg, and J. G. Veldheer, to name only a few. Since Veldheer, like Escher, often worked in Italy during the twenties and thirties, it is interesting to compare his Italian landscapes, for instance his *Mt. Etna* woodcut (Fig. 2), with Escher's Italian landscapes, such as the *Sicily* (Cat. 55), *Morano, Calabria* (Cat. 43), and *Castrovalva* (Fig. 3 ; Cat. 39) prints. There is certainly an agreement in style and atmosphere. But we see how much tighter and more systematic Escher's prints are and, in particular, how much more clearly accentuated the perspectives and spatial planes. This difference in the treatment of space is clearly illustrated by *Castrovalva*, which concerns roughly the same kind of situation as Veldheer's landscape in *Mt. Etna*. A comparison of the two makes us conscious of the fact that emphasizing different

21

4

5

spatial aspects such as height, depth, and distance is characteristic of Escher's work.
Strictly individual, too, is Escher's interest in reflections, which is not present in the work of
such artists as Mankes, Veldheer, and others. It is remarkable, however, that in the tradition in
which Escher began, we do here and there encounter surface-filling motifs. A poster designed
by Chris Lebeau around 1910 carries a border motif of linked fish (Fig. 4), and in a book on
ornamentation frequently used in this tradition, *De grondslag voor het ontwerpen van vlakke
versiering* (Fundamentals for the Design of Surface Ornamentation) by N. J. van de Vecht
(Rotterdam, 1930), we even find diagrams for unending ornamental motifs (Fig. 5). Thus, the
area-covering designs that came to play such a large part in Escher's work were related not
only to the Moorish mosaics but also to elements in his own national tradition. But, as we have
seen, he began to use these motifs in a way that was entirely his own—not subordinately, solely
as ornaments, but as his main subjects or as basic vehicles for expressing special ideas.
Although in many of its aspects Escher's first work fits into an existing tradition, it also had from
the very beginning individual basic themes which bore little relation to this tradition. As we have
seen, these themes, expressed as the linking and combining of different, often opposing,
aspects of reality, were Escher's own creations. When they became fully manifest after 1937,
his work became almost entirely independent of the tradition from which it had sprung.
Although the work after 1937 often appears so unique that there seems to be nothing with
which it can be compared, this is only partially true. In the art of different places and times we
repeatedly encounter works that show in a certain sense parallel thematic material. For
instance, there is a related interest in reflections in a Mannerist portrait by Parmigianino (Fig.
6) and a related impossible spatial construction in a print by Hogarth (Fig. 7). We have already
pointed out how Escher himself encountered a preoccupation with surface-filling motifs in the
Moorish mosaics, and we know that he greatly admired some of Piranesi's prints because their
tangle of dizzy spaces accorded with his own feeling for space.
Up to the twentieth century, however, those works of European art which bear any relation to
Escher really occur only in peripheral areas and do not belong to the main movements of their

22

Fig. 4. Chris Lebeau. Poster (detail).
c. 1910. Woodcut

Fig. 5. Diagrams for unending
ornamental motifs, from N. J. van de
Vecht, *De grondslag voor het
ontwerpen van vlakke versiering*,
Rotterdam, 1930

Fig. 6. Parmigianino. *Self-Portrait*. 1524.
Oil on panel. Kunsthistorisches
Museum, Vienna

Fig. 7. William Hogarth. Frontispiece
to *Dr. Brook Taylor's Method of
Perspective*. 1754. Engraving. British
Museum, London

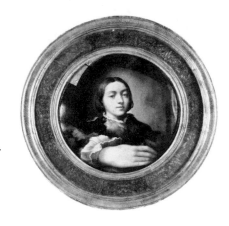

6

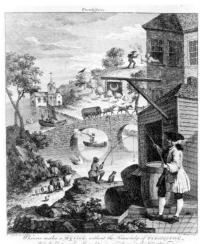

7

times. What is remarkable, however, is that in the twentieth century we see works belonging to a few of the main currents of European art that have developed independently but have a distinct structural relationship to the basic thematic material of Escher's prints. They show that Escher's work, although apparently isolated, is nevertheless in certain aspects closely related to the major developments of art in the twentieth century.

The series of trees done by Piet Mondrian in 1912 (Fig. 8) are often cited as a clarifying example of the radical change that took place in art at the beginning of the present century. In this series we see how a recognizable tree can gradually change into an abstract structure, how the large shape of the tree is converted into a series of small shapes, and how the contrast between foreground and background is simultaneously abolished. For Mondrian, at some time around 1912, the unquestioned unity of the visual world, as present in a traditional perspectivistic construction, was suddenly no longer self-evident. In the customary representation using perspective, there is always a clear distinction between foreground and background, between what is of principal importance and what is incidental. For Mondrian, this distinction between elements of unequal importance became unbearable, for in his opinion visible reality was composed of essentially equivalent elements. To abolish the inequalities inherent in a perspective representation, he changed the tree, ground, and air into small, equally important components which, without a contrast between foreground and background, are directly linked with each other.

Another modification of traditional perspective is found in Paul Citroen's photo-collage *Metropolis* of 1923 (Fig. 10), one of the best known early examples of this technique which was to play such an important part in modern art. In this photo-collage a city is represented from many viewpoints simultaneously. Different photographs of the same city are combined. The space belonging to each one has a traditional perspective ; but the juxtaposition of the separate photographs illustrates the limitations of that perspective. In this photo-collage, too, there is no unalterable unity with a sharp distinction of foreground and background but rather an accumulation of equally important elements.

23

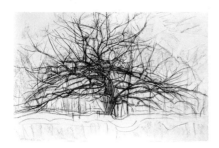 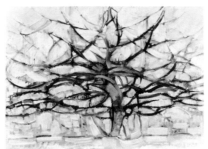

8

Although Escher's prints may seem at first to bear little relation to these works by Mondrian and Citroen, a closer analysis shows that all three approaches have a similar structure. In Escher's prints, too, visible reality has lost its intrinsic unity. *Day and Night* (Fig. 9 ; Cat. 102) contains a process that is related to the process in Mondrian's trees. In the lateral parts of the print, there is an apparently normal relationship between foreground and background and thus between main and subsidiary elements, but the middle part of the print shows that these concepts are to a high degree relative and that the elements involved in them can even exchange roles. As in Mondrian's process of abstraction of a tree, here the contrasting dominant and subordinate components are converted into equally important small elements that are directly related.
A print like *Other World* (Fig. 11 ; Cat. 142) is related to Citroen's collage because it contains not a single viewpoint but rather a combination of different angles of view on the same situation. In Escher's print, as in Citroen's collage, each individual viewpoint is shown in a traditional, perspectivistic manner, but the intrinsic unity of the representation is shaken because the different views are directly connected.
In the art of the twentieth century, visible reality has lost its apparent unity and has become a multiplicity of visual phenomena, which are all equally unique. The central problem of modern art is how to organize coherently the many different visual elements without reducing the uniqueness of each. Escher's basic thematic material is essentially connected with this problem. For him, too, visual reality is not singular but plural. We have seen in his prints a repeated search for new relationships between the many and often contrasting forms in which the observed world is manifested. As a result he alternately concentrates on the limits, the outlines—which leads to the filling of surfaces—and on the spatial structure and relationship of things. The simultaneous occurrence of these two lines of development is also found in the main currents of modern art. We have seen how Mondrian changed the values of the outline of a tree, which led to an abstract sequential covering of area ; and how Citroen manipulated many views of a city, which led to a combination of spaces. In Cubism and the *De Stijl* movement, the central concern is a relativization of contours ; and in Dadaism and

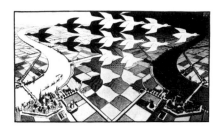

9

Surrealism, a relativization of space. What was begun by these movements is still a source of experimentation for contemporary artists.

Despite their similarity in certain aspects, there is an important difference between Escher's work and most modern art. They are related in their basic structure, but Escher's use of this structure is unique. The multiplication of visual reality is interpreted in Dadaism and Surrealism as chaotic and absurd, but in Escher it is rational; it contains not chaos but order. In Citroen's photo-collage, a combination of spatial observations is created in an intuitive, chaotic manner, but in Escher's *Other World* various spatial realities are linked in a strictly rational way—the picture forms a logical and self-enclosing whole. It is typical of Escher's work that the shifts in spatial relationships take place within a total composition using traditional perspective. All the separate viewpoints are dependent on the same vanishing point. In Citroen there is only a chaotic linking of separate and conflicting images, and therefore the total is not self-enclosed but open.

This difference can also be seen between Mondrian's trees and Escher's *Day and Night*. Mondrian's abstraction of the outlines of the tree is based on feeling, in contrast to the simplification of the contours of the birds in *Day and Night*, which is again the consequence of a logical principle. The abstraction developed by Mondrian in three successive works is completed by Escher in a single print. And in Escher's work there is not only a progression from a recognizable world to an abstract motif, for instance from polders to diamonds, but in particular the reverse development from an abstract motif to a recognizable world, for instance from diamonds to birds. There is a two-way movement between an abstract principle and a narrative world—all within a self-enclosing representation. Here, too, the composition as a whole is constructed using traditional perspective, and the relativization of this perspective occurs only within it.

As a further development of the work of such artists as Mondrian, recent art is repeatedly concerned with abstract visual constructions which are organized according to a fixed principle and which no longer have any emotional content in their structure. In these works visible

25

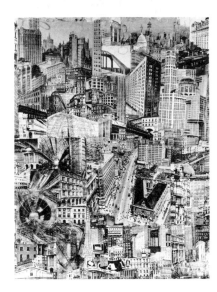

Fig. 10. Paul Citroen. *Metropolis*. 1923.
Photo-collage

reality is seen not as chaos but as order. In this respect they are related to Escher's work. But only very rarely, if at all, does anyone work as logically as does Escher in his prints. Furthermore, this recent art is concerned exclusively with abstract structures as such; for Escher, however, it is of essential importance that an abstract principle be made narrative through recognizable motifs.

In the traditional art world, Escher's work has always been regarded with a certain reserve, and he has never been highly esteemed. Respect has been paid the mastery of graphic techniques and the great originality shown in his prints, but otherwise his work is considered to be too intellectual and to lack a lyrical quality. In certain recent art currents, there is a deliberate effort to be, like Escher, intellectual and not very lyrical, and, as with Escher, the primary concern is the consistent and logical development of a given principle or concept. But in this quarter, too, there is little interest in Escher's work, in this case because of a dislike of his traditional narrative motifs and of his preservation of traditional perspective for space in the composition as a whole.

Although these two reasons explain why Escher has never been highly regarded in the art world, they are, however, directly responsible for his fame outside it. In his prints conventional and therefore easily recognizable motifs are used to give form to a modern pluralistic picture of the world. This new concept of reality is not present in traditional representations of landscapes, still lifes, or portraits. And although it occurs in movements such as Cubism, *De Stijl*, Dadaism, Surrealism, and the recent continuations of these currents, their visual language is still readable only for a small number of specialists. In Escher's prints, on the contrary, there is a traditional, realistic visual language that almost anyone can read.

It is typical of this difference in esteem inside and outside the art world that in a recent number of the journal *Delta* (Winter, 1969-70) devoted to art in the Netherlands during the past twenty-five years, not one of Escher's prints is reproduced or discussed, in spite of the fact that it has been in just this period that Escher's work has attracted so much attention both in the Netherlands and abroad. His works are now being widely studied and collected and are being

26

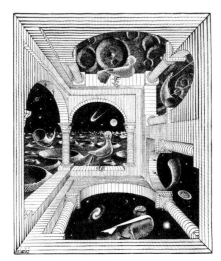

Fig. 11. M. C. Escher. *Other World*.
1947. Wood engraving (Cat. 142)

used on contemporary posters and records, and especially as illustrations in many popular books and specialized scientific publications.

It is striking that although in general there is a distinct cleavage between art and science at the present time, Escher's work has gained international fame among scientists. Articles published in *The Studio*, *Time*, and *Life* had given him an international name as early as 1951, but it was an exhibition of his work in September, 1954, in the Stedelijk Museum in Amsterdam, organized on the occasion of an international congress of mathematicians, that marked the beginning of this phase of popularity in the scientific community. This exhibition was an enormous success and brought Escher into contact with many scientists and theoreticians. In the years that followed, he was invited to other conventions to lecture on his work. Scientists are fascinated by Escher's work because they recognize in it not only a concept of the world with which they are familiar but also a similar attitude toward that world. For them as for him, the plurality of the world signifies neither absurdity nor chaos but a challenge to look for new logical relationships between phenomena. The strangeness or absurdity that seems at first sight to be present in Escher's prints can, in the final analysis, be solved and explained. This is a main source of fascination in Escher's prints. In them reality is wondrous and at the same time comprehensible.

Abstract

1 In Escher's work there is an interaction between a given structure and a recognizable world. Before 1937 the recognizable world served as the starting point from which a structure was to be reached. But after 1937 the structure became the starting point and was made visible by means of recognizable motifs. In *Castrovalva* (Cat. 39), for instance, visible reality is seen in a way that gives rise to a structural combination of height, depth, and distance. In *Other World* (Cat. 142) the principle that a surface can be given three spatial functions is elucidated by means of a recognizable bird in a recognizable architecture.

27

2 Escher's structuralism is expressed primarily in a linkage of contours and a linkage of spaces. Both concern interrelationships in a pluralistic vision of the world.

3 A pluralistic concept of the world also belongs to the main currents in modern art, but with the following differences. In Escher the plurality of the world does not mean chaos but order, and he is never concerned solely with plural structures as such but rather with an interaction between structures and recognizable motifs.

4 A pluralistic concept of the world, seen as orderly and as a challenge to find new logical relationships between phenomena, combined with inseparability of structure and narration, has led to Escher's solid reputation among scientists as well as a very large public which is generally uninterested in what is considered today to be typically modern art.

Escher: Science and Fiction

C. H. A. Broos

In 1943 M. C. Escher drew his *Reptiles* (Cat. 120) on a lithographic stone. The print shows a notebook lying on a table, opened to a drawing consisting of a repeating pattern of small interlocking reptilian animals. A regular division of the plane is worked out here in three shades of gray, with the reptile as the basic element. The notebook is one of six still in existence, which together contain a series of drawings consisting of similar divisions of the plane, arranged by Escher according to a special system of his own. As can be seen from the date under each drawing, starting in 1926 the series grew steadily as new ideas were added. Although a geometric principle underlies each drawing, its final form is always realized through figures taken from animate nature. The notebooks have provided the basic material for many of Escher's prints, such as *Day and Night* (Cat. 102), *Sky and Water I* (Cat. 106), *Encounter* (Cat. 127), *Horseman* (Cat. 138), *Swans* (Cat. 211), and *Circle Limit IV* (Cat. 247).

The *Reptiles* print itself illustrates one of Escher's predilections—the bringing to life of an abstract structure. By arranging a few small personal effects around the notebook—a gin glass, an ashtray, and a packet of cigarette papers—Escher suggests the presence of the artist; or rather, his temporary absence, during which the drawing in the notebook, his creation, begins to have a life of its own.

One of the reptiles detaches itself from the geometric structure holding it to the paper. The miniature alligator creeps upward on a zoology textbook and a draftsman's triangle and, "at the high point of its existence" (to quote Escher himself), sitting on a dodecahedron, one of the five Platonic solids, it sends out a snort of smoke. The little animal is now brilliantly alive, and its perfection contrasts sharply with that of the solid geometrical body it has mounted. But, as in many of Escher's prints, the circle is closed. Via ordinary and short-lived objects—a package of cigarettes, a matchbox—the little animal returns to its flat, static, paper existence.

In 1943 this print was known only to a small group of print collectors in the Netherlands. Now, more than twenty-five years later, the situation has changed. For instance, two reproductions of this print appeared at almost the same time in two very different contexts. The basic drawing of *Reptiles* was reproduced as an illustration in an Italian chemistry textbook for secondary schools. The print also appeared on the record-album cover of an American Pop group (Fig. 12). Evidently, the print contains significant material for both the chemist and the Pop-music producer. The scientist is interested in the regular division of the plane, appropriate for his chapter on crystallography; the record producer, in the idea of the "eternal cycle of life" that he sees in the print.

These examples are only two of many, but they show how Escher's work has acquired, in addition to the original function of an independent work of graphic art, new functions supplied by the mediums of reproduction, which can be as varied as in the two cases just mentioned.

Fig. 12. Record-album covers of Pop music

In the early fifties prints made by Escher were used to illustrate a Dutch secondary-school mathematics textbook and a treatise on crystallography. The first and most widespread application of Escher's graphics was within the natural sciences, and it is worth discussing a few examples.

Escher has often written about his interest in science, especially mathematics and crystallography, although he is the first to admit the limits of his own knowledge of these fields. He once said in a letter: "My affinity with the exact approach to natural phenomena is probably related to the milieu in which I grew up as a boy: my father and three of my brothers were all trained in the exact sciences or engineering, and I have always had an enormous respect for these things. And now again my three sons try to think scientifically, in other words honestly, rather than unverifiably, hazily, sentiently, in the manner of the artist."

That certain prints can serve as illustrative material in mathematics is obvious. We need think only of the polyhedrons in *Stars* (Cat. 152) or the topological figures in *Moebius Strip I* (Cat. 248) and *Knots* (Cat. 264). In the teaching of mathematics, the function of the prints is to show the student the pleasurable and unexpected aspects of mathematics and the fascination that even rather simple geometric figures can produce when they have been transformed by an artist.

For other prints the mathematical basis is less noticeable at first glance, because the narrative element predominates. In these cases it is the preliminary studies and working drawings that reveal the mathematical structure from which the picture was developed. Such structures can be seen not only in the working drawings for the lithograph *Print Gallery* (Cat. 213-15) and for the woodcut *Circle Limit IV* (Cat. 244-46) but also in an even more preliminary phase in the notebooks that Escher drew on so often for the basic material of many of his prints. The variety of surprises Escher's prints contain for professional mathematicians is conveyed by H. S. M. Coxeter's article in this volume (see pages 49-52).

Not only mathematicians and crystallographers but also research workers in other scientific fields frequently make use of Escher's prints as illustrative material. The combination of logical

development on the one hand and comprehensibility—provided by the use of realistic motifs—on the other, make certain prints preeminently suitable as direct hypothetical models in a given science or as visual, didactic elucidations of an abstract theory.

The Norwegian geologist I. T. Rosenqvist, who used *Sky and Water I* (Cat. 106) to illustrate a scientific treatise, wrote Escher, "I find that your *Lucht en water I* could illustrate this [theory] in a qualitative way much better than I could do in writing!" In other words, the print is able to visualize an abstract theory or structure; it shows in an easily understood way what language can convey only with great difficulty.

Still more interesting than the use of a print to illustrate one scientific theory is the way some of the prints have been used repeatedly for widely differing scientific disciplines. A good example of this is given by the same woodcut *Sky and Water I*, which dates from 1938. This print has been used in physics, geology, chemistry, and in psychology for the study of visual perception. In the picture a number of elements unite into a single visual representation, but separately each forms a point of departure for the elucidation of a theory in one of these disciplines.

The basis of this print is a regular division of the plane consisting of birds and fish. We see a horizontal series of these elements—fitting into each other like the pieces of a jigsaw puzzle—in the middle, transitional portion of the print. In this central layer, the pictorial elements are equal: birds and fish are alternately foreground or background, depending on whether the eye concentrates on light or dark elements. The birds take on increasing three-dimensionality in the upward direction, and the fish, in the downward direction. But as the fish progress upward and the birds downward they gradually lose their shapes to become a uniform background of sky and water, respectively.

We can think of a number of paired concepts applying to this picture: light-dark, top-bottom, flat-rounded, figure-background, interlocking pictorial elements-independent pictorial elements, geometric structure-realistic form; and, with respect to the subject of the print, birds-fish, sky-water, immobility-movement. Any scientist who uses a print to illustrate a theory selects one or more elements from the print which are analogous to components of the theory, and in this way the print becomes a model for the theory.

The Dutch physicist Jan de Boer, whose research concerns the structure of matter, discovered in *Sky and Water I* startling parallels with his own visualization of a problem. He selected from the print the middle boundary layer, with its different but equal pictorial elements. This image clarified and gave visual form to his question: "In the structure of a crystal, what is of greater physical importance, the atoms forming the building stones of the structure or the spaces between the atoms?"

The South African chemist L. Glasser also used the boundary layer in this print to illustrate a

theory in crystallography. He wanted to describe the growth of a particular kind of crystal on a substratum of another kind. For his purposes the two kinds of crystals were symbolized by the birds-fish antithesis, and the division of top and bottom contributed to the clarity of the explanation. If we take the boundary layer literally as a representation of the top layer of a given type of crystal (the fish), then the fish in this layer symbolize the particles which, in a favorable configuration, could serve as nuclei for the growth of crystals of another type (the birds). Rosenqvist, the Norwegian geologist mentioned earlier, took the same contrast of birds and fish as a model for two different kinds of matter, clay and water. The boundary layer of the print then becomes an analogy for the border between the clay particles and the water molecules. In this way the woodcut illustrates Rosenqvist's theory that clay minerals influence the behavior of adjacent water molecules, reducing their motility, and *vice versa*. In the print the birds fly more freely the further removed they are from the boundary layer upward and downward, just as, according to Rosenqvist's theory, water molecules move more freely with increasing distance from the clay particles.

One of the important aspects of Escher's work, his intensive and systematic investigation of the principles of symmetry and the regular division of a plane, has long since earned him considerable fame among research scientists, undoubtedly because he was already wrestling with this material before mathematicians and crystallographers had supplied a broad theoretical foundation and because of his virtuosity in the use of naturalistic basic motifs, usually derived from flora and fauna.

In his book *Symmetry* (Princeton, 1952) the mathematician Herman Weyl vividly described how, by using the principle of symmetry, man "through the ages has tried to comprehend and create order, beauty, and perfection." In mathematics, in art, and in the description of matter, the concept of symmetry has often been a productive starting point. For Escher, symmetry, as it involves the regular division of the plane, has often been the main source of inspiration. It is therefore hardly surprising that the Russian edition of Weyl's book carries—although in a somewhat mutilated form—one of Escher's drawings on its cover (Fig. 13).

A drawing by Escher has even been adopted as an illustration in quantum mechanics, because of his use of the principle of symmetry. The physicist and Nobel Prize winner Chen Ning Yang formulated a new hypothesis involving symmetry. In this connection he remarked, "It is scarcely possible to overemphasize the importance of the symmetry principle in quantum mechanics" (*Elementary Particles*, Princeton, 1961, p. 53). The hypothesis was put forward to explain the deviation, occurring in certain elementary particles, from the generally valid left-right symmetry of physical laws. To illustrate his theory and to elucidate it for a large audience of laymen, Chen Ning Yang used the drawing *Horseman* (Fig. 13 ; Cat. 137) whose

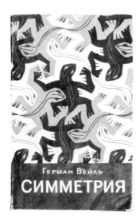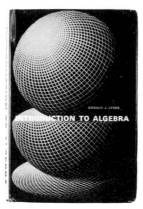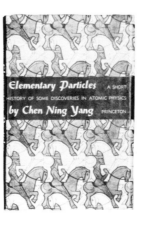

Fig. 13. Book jackets

interesting mathematical and crystallographic aspects have been discussed in books by
H. S. M. Coxeter and C. H. MacGillavry. In this drawing, consisting of a regular division of a
plane into light and dark horsemen riding in alternate series to the left and to the right, the
original and the mirror image are not identical. They would have been had all the horsemen
been the same color—for instance, if they all had been drawn with black outlines on white
paper—since they all have the same shape. But because half of them have a different tint than
the other half, the mirror image is no longer identical and must be modified. Escher indicates
that the dark horsemen are the mirror images of the light ones by portraying a circular band with
the pattern of horsemen woven into it (Cat. 138). Thus, the dark knights on the light
background change color on the reverse side of the band, and the mirror image is identical
with the original figure again. This feature makes the drawing suitable to illustrate the fact that
the result of an experiment with elementary particles can be duplicated only when the
experiment is carried out, as it were, in the mirror-image form: in order to obtain symmetry it is
necessary to "combine the operation of switching matter and anti-matter with a mirror
reflection" (Chen Ning Yang, *op. cit.*, p. 60).

Of course, Chen Ning Yang could have illustrated his theory with a geometrical pattern of light
and dark areas possessing the same characteristics as Escher's drawing. It unquestionably must
have been the specific, familiar form of Escher's work that led him to apply it in a popular
explanation of his theory.

However, scientists do not use Escher's work only when there is a direct structural agreement
between picture and theory. In other cases the effect of the print itself on the viewer can be
used to clarify similar relationships between object and observer. In research on visual
perception, the relationship between figure and background has been studied intensively. The
close interaction between seeing and thinking can be investigated and demonstrated on the
basis of the interpretation of ambiguous images in which optical illusions play an important
part—the print *Sky and Water I* is itself an example of this. When we concentrate on the dark
birds as objects, we see them against a uniform white background occupying slightly more than

33

half of the print; or, similarly, we can view the light fish against the black background. Thus, both readings give more than we know is measurable in the print, and we become conscious of the subjective element in our observation. J. F. Schouten, Director of the Institute for Perceptional Research at Eindhoven, who used this example, extended the reasoning to the natural sciences in order to illustrate the subjectivity inherent in observation, measurement, and interpretation in these fields.

In *Sky and Water I* there is a balance between black birds and white fish in the central boundary layer; but when the viewer looks steadily at that area for a while, this equilibrium produces a kind of flickering effect. In research on perception, it has been found that the observer can become confused in other situations as well and will lose his normal capacity for orientation when the figure and the background are in visual equilibrium with each other (in terms of color, shape, brightness). A practical application of this finding was described by the oculist J. W. Wagenaar in an essay on the vital importance of correctly observing the distinction between figure and background in motor traffic. At dusk it is difficult for the driver's eye, still accustomed to daylight, to distinguish clearly between figure and background (in traffic, between oncoming car and road and landscape). Escher's print serves well to illustrate this effect, which can occur similarly, in small dimensions, on paper.

Studies on visual perception have become familiar in the field of aesthetics and the history of art, for instance in the work of Rudolf Arnheim and E. H. Gombrich. Escher's work has proved to be particularly useful in these studies, especially with respect to the problems of the ambivalence of the image and the representation of space on a flat surface. His prints often represent concise formulations or contain logical developments of themes with which European art has long been preoccupied, albeit in an indirect way (see the article in this volume by J. L. Locher, pages 7-28).

Sometimes it is the suggestive effect of the picture itself, rather than any direct structural agreement, that serves to illustrate an idea. It was in this sense that Melvin Calvin used the lithograph *Verbum* (Cat. 116) as the final illustration for a descriptive review of new ideas about the chemical evolutionary series, atoms-molecules-polymers-living matter. In his own words: "The gradual merging of the figures, one to another, and the transformations which eventually became apparent, seem to me to represent the essence not only of life but of the whole universe" (*Chemical Evolution* [Condon Lectures], Eugene, Oregon, 1961).

Other scientists have used Escher's graphic works to illustrate the similar gift of creativity shared by the scientist (but in particular the mathematician) and the artist. The mathematician D. J. Lewis, who drew a comparison between the elegance of mathematical solutions and Escher's approach, commented: "Like Mr. Escher's prints, the most beautiful results [in

Fig. 14. Magazine covers

algebra] often entail a systematic approach combined with some ingenious ad hoc argument''
(*Introduction to Algebra*, New York, 1965, p. viii ; Fig. 13).

The foregoing examples concern the use of Escher's prints by scientists and scholars and, in
the case of mathematicians, a scientific interpretation of his work after the fact. But the
reverse has also occurred—the scientific world has given Escher valuable ideas that he has
worked out in his prints. His lifelong interest in symmetry and the regular division of a plane
surface began in the early twenties when his brother initiated him into the secrets of
crystallography.

Many years later, J. F. Schouten pointed out to Escher the peculiar optical shift that can occur
in the representation of a cube on a flat surface. The result was the lithograph *Convex and
Concave* (Cat. 198). On the flag in the upper right-hand corner of the print, we find the basic
figure from which the print was developed. In this figure each group of three diamonds gives
the illusion of being a cube, and the eye—in the absence of other indications—cannot
distinguish between concavity and convexity.

A similar example of a simple illusionistic figure that inspired a print was provided by the
article by L. S. and R. Penrose (page 17) on visual illusions and impossible objects. As we have
seen, this paper led to *Ascending and Descending* (Cat. 243) and *Waterfall* (Cat. 258).

During an exchange of letters with the mathematician H. S. M. Coxeter, Escher made the
woodcuts *Circle Limit I* (Cat. 233), *Circle Limit III* (Cat. 239), and *Circle Limit IV* (Cat. 247).
He discussed the exchange of the functions of figure and background with J. W. Wagenaar
and this resulted in the polychrome woodcut *Sun and Moon* (Cat. 150). The experimental
physicist H. de Waard drew his attention to the problems dealt with by topology, which led to
Knots (Cat. 264).

The scientists, a relatively large group, were the first, after the print collectors, to become
interested in Escher's work ; the sixties saw science fiction join the ranks, and, finally, Escher's
work was annexed by mystic and psychedelic circles (Fig. 14). Our first example, *Reptiles*,
showed the two differing content layers that a chemist and Pop-music producers adopted

35

from the print and cast according to their own purposes. For scientists, the logical pictorial structure of Escher's prints (whether or not it is applied to an absurd point of departure), as well as the way in which he creates a connection between the visual phenomena, are the attractive aspects of his work. The other groups are less interested in the ingenious than in the mysterious and incomprehensible in Escher's prints. They are fascinated particularly by Escher's representation of imaginary spatial constructions, which can exist on paper but not in our everyday world, as, for example, in *Relativity* (Cat. 188), *Other World* (Cat. 142), or *House of Stairs I* (Cat. 172).

Escher's world is extraordinary but explicable; yet those who are susceptible to more irrational arguments prefer to speculate about its enigmatic qualities. An early example of this kind of interest was supplied by the French journal *Planète*, a mixture of science and mysticism, when it "discovered" Escher for France in 1963. Prints such as *Day and Night*, which elsewhere helped to brighten mathematics, were here the source of a certain bewilderment. Escher's prints were sometimes discussed as products of "another logic," or of an "algebraic logic," until finally the main emphasis was put on the "alienation effect."

This attitude was the forerunner of a rage that led to an extraordinary popularity of Escher's prints in the world of hippies and Pop music. In the United States innumerable posters in Day-Glo colors—with titles such as *Atlantis (Double Planetoid)* and *Bad Trip (Dream)*—were manufactured after his work, which was also in demand for the decoration of record albums or T-shirts.

A hint of the reason for this popularity can be seen in these sentences by Thomas Albright at the beginning of an otherwise straightforward review of Escher's work ("Visuals—Escher," *Rolling Stone*, 1970): "Like the ideas of Buckminster Fuller and the novels and short stories of Hermann Hesse, the graphic art of M. C. Escher has been around for a long time. . . . The main reason for the sudden run on Escher is the close parallel of his vision to the themes of contemporary "psychedelic art" . . . [and] the fact that nothing is really as it seems and that everything is governed by higher laws of logic and mathematical laws that draw the universe and all its opposing elements together in a mysterious, unknowing harmony."

One who searches after mystery will indeed be able to find it in the prints of M. C. Escher. For Escher himself, even the wildest fantasy remains subject to the rules of the game. No one knowing Escher's preference for Lewis Carroll will be surprised that he underlined the following passage by the mathematical physicist J. L. Synge: "In submitting to your consideration the idea that the human mind is at its best when playing, I am myself playing, and that makes me feel that what I am saying may have in it an element of truth."*

Hermathena, 19 (1958), p. 40, as quoted in H. S. M. Coxeter, *Introduction to Geometry*, New York and London, 1961, p. 77.

Approaches to Infinity

M. C. Escher

Man is incapable of imagining that time could ever stop. For us, even if the earth should cease turning on its axis and revolving around the sun, even if there were no longer days and nights, summers and winters, time would continue to flow on eternally.

It is no easier for us to imagine that somewhere, past the farthest stars in the nocturnal heavens, there is an end to space, a borderline beyond which "nothing" exists. The concept "empty" does have some meaning for us, because we can at least visualize a space that is empty, but "nothing," in the sense of "spaceless," is beyond our capacity to imagine. This is why, since the time when man came to lie, sit, and stand on this earth of ours, to creep and walk on it, to sail, ride, and fly over it (and now fly away from it), we have clung to illusions—to a hereafter, a purgatory, a heaven, and a hell, a rebirth or a nirvana, all existing eternally in time and endlessly in space.

Has a composer, an artist for whom time is the basis on which he elaborates, ever felt the wish to approach eternity by means of sounds? I do not know, but if he has, I imagine that he found the means at his disposal inadequate to satisfy that wish. How could a composer succeed in evoking the suggestion of something that does not come to an end? Music is not there before it begins or after it ends. It is present only while our ears receive the sound vibrations of which it consists. A stream of pleasant sounds that continues uninterrupted through an entire day does not produce a suggestion of eternity but rather fatigue and irritation. Not even the most obsessive radio listener would ever receive any notion of eternity by leaving his set on from early morning to late in the night, even if he selected only lofty classical programs.

No, this problem of eternity is even more difficult to solve with dynamics than with statics, where the aim is to penetrate, by means of static, visually observable images on the surface of a simple piece of drawing paper, to the deepest endlessness.

It seems doubtful that there are many contemporary draftsmen, graphic artists, painters, and sculptors in whom such a wish arises. In our time they are driven more by impulses that they cannot and do not wish to define, by an urge which cannot be described intellectually in words but can only be felt unconsciously or subconsciously.

Nevertheless, it can apparently happen that someone, without much exact learning and with little of the information collected by earlier generations in his head, that such an individual, passing his days like other artists in the creation of more or less fantastic pictures, can one day feel ripen in himself a conscious wish to use his imaginary images to approach infinity as purely and as closely as possible.

Deep, deep infinity ! Quietness. To dream away from the tensions of daily living ; to sail over a calm sea at the prow of a ship, toward a horizon that always recedes ; to stare at the

passing waves and listen to their monotonous soft murmur; to dream away into unconsciousness . . .

Anyone who plunges into infinity, in both time and space, further and further without stopping, needs fixed points, mileposts, for otherwise his movement is indistinguishable from standing still. There must be stars past which he shoots, beacons from which he can measure the distance he has traversed.

He must divide his universe into distances of a given length, into compartments recurring in an endless series. Each time he passes a borderline between one compartment and the next, his clock ticks. Anyone who wishes to create a universe on a two-dimensional surface (he deludes himself, because our three-dimensional world does not permit a reality of two nor of our dimensions) notices that time passes while he is working on his creation. But when he has finished and looks at what he has done, he sees something that is static and timeless; in his picture no clock ticks and there is only a flat, unmoving surface.

No one can draw a line that is not a boundary line; every line splits a singularity into a plurality. Every closed contour, no matter what its shape, whether a perfect circle or an irregular random form, evokes in addition the notions of "inside" and "outside" and the suggestion of "near" and "far away," of "object" and "background."

The dynamic, regular ticking of the clock each time we pass a boundary line on our journey through space is no longer heard, but we can replace it, in our static medium, by the periodic repetition of similarly shaped figures on our paper surface, closed forms which border on each other, determine each other's shape, and fill the surface in every direction as far as we wish.

What kind of figures? Irregular, shapeless spots incapable of evoking associative ideas in us? Or abstract, geometrical, linear figures, rectangles or hexagons at most suggesting a chess board or honeycomb? No, we are not blind, deaf, and dumb; we consciously regard the forms surrounding us and, in their great variety, speaking to us in a distinct and exciting language. Consequently, the forms with which we compose the divisions of our surface must be recognizable as signs, as distinct symbols of the living or dead matter around us. If we create a universe, let it not be abstract or vague but rather let it concretely represent recognizable things. Let us construct a two-dimensional universe out of an infinitely large number of identical but distinctly recognizable components. It could be a universe of stones, stars, plants, animals, or people.

What has been achieved with the orderly division of the surface in *Study of Regular Division of the Plane with Reptiles* (Cat. 119)? Not yet true infinity but nevertheless a fragment of it, a piece of the universe of the reptiles. If the surface on which they fit together were infinitely

large, an infinitely large number of them could have been represented. But this is not a matter of an intellectual game ; we are aware that we live in a material, three-dimensional reality, and we are unable in any way to fabricate a flat surface extending infinitely on all sides. What we *can* do is to bend the piece of paper on which this reptilian world is represented fragmentarily and make a paper cylinder of it so that the animal figures on that cylindrical surface continue without interruption to interlock while the tube revolves around its longitudinal axis. In this way, endlessness is achieved in one direction but not yet in all directions, because we are no more able to make an infinitely long cylinder than an infinitely extending flat surface.

The *Sphere with Fish* (Cat. 112) gives a more satisfactory solution : a wooden ball whose surface is completely filled by twelve congruent fish figures. If one turns the ball in one's hands, one sees fish after fish appear to infinity.

But is this spherical result really completely satisfying? Certainly not for a graphic artist, who is more bound to the *flat* surface than is a draftsman, painter, or sculptor. And even apart from this, twelve identical fish are not the same as infinitely many.

However, there are also other ways to represent an infinite number without bending the flat surface. *Smaller and Smaller I* (Cat. 219) is a first attempt in this direction. The figures with which this wood engraving is constructed reduce their surface area by half constantly and radially from the edges to the center, where the limit of the infinitely many and infinitely small is reached in a single point. But this configuration, too, remains a fragment, because it can be expanded as far as one wishes by adding increasingly larger figures.

The only way to escape this fragmentary character and to set an infinity in its entirety within a logical boundary line is to use the reverse of the approach in *Smaller and Smaller I*. The first, still awkward application of this method is shown by *Circle Limit I* (Cat. 233). The largest animal figures are now located in the center, and the limit of the infinitely many and infinitely small is reached at the circular edge. The skeleton of this configuration, apart from the three straight lines passing through the center, consists solely of arcs with increasingly shorter radii the closer they approach the limiting edge. In addition, they all intersect it at right angles. The woodcut *Circle Limit I*, being first, shows many deficiencies. Both the shape of the fish, still hardly developed from linear abstractions to rudimentary animals, and their arrangement and attitude with respect to each other, leave much to be desired. Accentuated by their backbones, which pass into each other longitudinally, series of fish can be recognized in alternating pairs—white ones with heads facing each other and black ones whose tails touch. Thus, there is no continuity, no one-way direction, no unity of color in each row.

In the colored woodcut *Circle Limit III* (Cat. 239 ; Colorplate VII) most of these defects have

been eliminated. There are now only series moving in one direction : all the fish of the same series have the same color and swim after each other, head to tail, along a circular course from edge to edge. The more closely they approach the center, the larger they become. Four colors were required in order that each total series contrast with its surroundings.

No single component of all the series, which from infinitely far away rise like rockets perpendicularly from the limit and are at last lost in it, ever reaches the boundary line. Outside it, however, is the "absolute nothing." But the spherical world cannot exist without this emptiness around it, not only because "inside" presumes "outside" but also because in the "nothing" lie the strict, geometrically determined, immaterial middle points of the arcs of which the skeleton is constructed.

There is something in such laws that takes the breath away. They are not discoveries or inventions of the human mind, but exist independently of us. In a moment of clarity, one can at most discover that they are there and take them into account. Long before there were people on the earth, crystals were already growing in the earth's crust. On one day or another, a human being first came across such a sparkling morsel of regularity lying on the ground or hit one with his stone tool and it broke off and fell at his feet, and he picked it up and regarded it in his open hand, and he was amazed.

Structural Sensation

G. W. Locher

One day in 1953, I sat listening to a small group of Dutch specialists in Oriental and monumental archaeological art, who were also interested in art in general, discuss the aesthetic qualities of ancient and modern art.

Our host had just shown us his private collection of Oriental art and European—mainly Dutch—art of the late nineteenth and early twentieth centuries. After comparisons had been made between the two parts of the collection, the talk turned to the aesthetic level of the older art and later developments in the present century. None of those present had much to say in favor of the aesthetic quality of modern art. Although I knew very little about contemporary art in our country, I recalled reading appreciative comments on Dutch graphic art by writers whose judgment was not to be disregarded. I mentioned this, and our host handed me a small book by Jos de Gruyter, *Grafiek* (Graphic Art), which had appeared in 1952 as one of a series of publications on contemporary Dutch art. He told me to see for myself whether this graphic art had such an exceptional quality. I began to leaf through the forty-six pages of illustrations and was just about to put down the book with a sense of disappointment when my eye was caught by a picture that gave me a strange sensation, which I felt mainly as an agreeable physical excitement without any conscious thought. This picture was *Three Spheres I* (Cat. 133), a wood engraving by M. C. Escher dating from 1945. Two other prints by Escher were reproduced in the book, the wood engraving *Other World* (Cat. 142) and the lithograph *Encounter* (Cat. 127). They impressed me, too, but differently. Having discovered Escher's work in this way, I pointed to the *Three Spheres* and said, "But this is quite extraordinary, isn't it?" Then I showed them the other two prints, which I thought were, at least, fascinating. The reaction was: "Oh, yes. That's Escher. He is certainly important!" But their conclusion was that his work was too cerebral to be real art.

I have heard the same comment many times since that discussion, while showing the collection of Escher's work that I began to form very soon after discovering his prints (which fortunately were not so very expensive at that time). I also learned from this remark that what was, in its time, an understandable reaction to a dry academicism in art had later developed into the stereotyped idea that an artist should not use his intellect in his work. This view has also produced much nonsensical adulatory sentimentality about Oriental and so-called primitive art, although even this kind of admiration is certainly to be preferred to the coarse incomprehension of non-European art and culture that had prevailed so long in the Western world.

My first introduction to Escher's work took place shortly before a change occurred in my official position. After having spent many years as curator and director of ethnological museums, I accepted a university appointment that brought with it a certain shift in the

direction of my study of non-European societies and cultures. The time was approaching when I would no longer be using official funds to collect what I and other museum staff members considered to be important and beautiful. In this period my private acquisition of some of Escher's prints was the beginning of a substitute for the collecting I had done with so much pleasure in the museum. But I very soon discovered another aspect of this collecting. I found that many ideas I encountered in my work as an anthropologist and sociologist in the university were also represented in Escher's prints.

In 1963, the American poet and literary critic Howard Nemerov wrote a penetrating article on Escher's work in the professional journal *Artist's Proof* ("The Miraculous Transformations of Maurits Cornelis Escher." *Artist's Proof*, Vol. 3, no. 2 [1963-64], p. 32). In it he said: "Whether things are or are not as they seem is an enduring preoccupation of art." This persisting fundamental problem is not restricted to art; it holds at least as equally for science. I regard this as one of the main reasons why Escher's work, which is concerned both with phenomena and with what underlies them, appeals to so many scientists whose work concerns fundamental aspects of modern science, whether the natural sciences, social sciences, or linguistics. They recognize a certain similarity between the work of the artist and their own work (see pages 29-36).

In this respect Escher occupies a very special place in modern times. In his well-known lecture on art and science in contemporary Western society, the scientist and novelist C. P. Snow pointed out that "it is bizarre how very little of twentieth-century science has been assimilated into twentieth-century art." When an attempt at assimilation is made, he added, it usually involves an erroneous interpretation. But this gap between the two fields does not hold for Escher. It is striking to see how many scientists, including some of international reputation, have used prints by Escher to elucidate or even summarize their scientific explanations.

The art establishment and many other artists were very willing to join scientists in complaining about their mutual estrangement and about their inability to understand each other's language and forms of expression. But they were not in the least interested in looking for artists who succeeded in assimilating modern science to a certain extent in their work and who tried in an orderly, logical way to give expression to their experience of the plural existence of modern life. They even resented such attempts as a challenge to the doctrine that the artist should not make use of his intellect in his work. Contemporary Western art is still dominated to a great extent by symbols of chaotic reaction to the present world, but Escher's approach and forms of expression are quite different. He remains genuinely open to

the idea of the empirical world as an illusion, but he deeply dislikes the disorganized interpretation and presentation of that world.

Escher was not at all afraid that his art might be regarded as too cerebral; quite the contrary. Although fellow artists and the official art world were very critical of the appreciation he received not only from scientists but even from the field of education, Escher enjoyed the inclusion of some of his prints in mathematical and natural science textbooks for secondary schools. He regarded it as an honor that Caroline H. MacGillavry, professor of chemical crystallography in Amsterdam, wrote *Symmetry Aspects of M. C. Escher's Periodic Drawings* (Utrecht, 1965), a book published for the International Union of Crystallography.

In the catalogue for the 1954 exhibition of his work organized by the International Congress of Mathematicians in the Stedelijk Museum, Professor N. G. de Bruijn stated: "It will give members of the Congress a great deal of pleasure to recognize their own ideas, interpreted by quite different means than those they are accustomed to using." Escher also greatly enjoyed de Bruijn's remark: "Probably mathematicians will not only be interested in the geometrical motifs; the same playfulness which constantly appears in mathematics in general, and which to a great many mathematicians is the peculiar charm of their subject, will be a more important element."

When, in 1968, Escher reached the age of seventy and was given a retrospective exhibition by the Gemeentemuseum in The Hague, he said in an interview published in the weekly *Vrij Nederland* (May 20, 1968): "People always think mathematicians are stuffy old gentlemen. They are really gay, childlike, very playful; they have big heads bursting with knowledge but they are boyish in behavior." Through his regular contacts with the world of science, Escher became aware of the play element in modern science—the playful working out of possibilities inherent in scientific fundamentals and viewpoints. To his great pleasure, in his later years he often received ideas from well-known scientists for the construction of prints in which he succeeded in combining strictly scientifically designed representations with optical illusions (see page 35).

This element of illusion was not a new development in Escher's work. His earlier prints often show his capacity to balance an admiration for perfect forms and stern structures on the one hand with the idea that everything is but an illusion on the other. Once when I was taking leave of him with a few more prints for my collection, he said, "You are now departing with a package of illusions of an illusion."

That the print gives only an illusion of reality was conveyed by Escher in more ways than just in the explanation he has written of his work. He has often attempted to express this idea in the print itself. The greater his respect for the reality of a consummate form, the deeper his

awareness of the illusion in his representation of it. This is clearly expressed in his wood engraving *Three Spheres I* (Cat. 133), where in the uppermost sphere he attempted to achieve a strong suggestion of the spatial nature of the perfect form he admired so deeply. At the same time, he knew quite well that it was not a real sphere but a flat disk of Japanese paper carrying some printer's ink. It is this conflict that he attempted to convey to others in the rest of the print, as he has explicitly stated several times.

In Escher's prints the spherical form continues infinitely, as do processions in crypts and endless metamorphoses. The representations of this infinity, however, are basically illusions. In his discussion *Approaches to Infinity*, Escher points out that neither infinite time nor infinite space is present in these representations (see page 38).

Escher is thoroughly convinced that in our empirical existence we are actually made fools of, just as the artist is deluding himself when he thinks he can truly represent reality. In his existence man certainly is concerned with a reality based on a logical foundation. But at the same time, this reality is of a singular character—not only in the sense that it is extraordinary but also in its quality of mystification and self-illusion.

In his very existence, Escher feels himself played for a fool, and he, in turn, often includes this mockery as an element in his prints, sometimes playfully, sometimes sarcastically, sometimes bizarrely, sometimes quite crazily, and even sometimes in all these ways simultaneously (see pages 20-21). The meters-long print *Metamorphosis II* (Cat. 111) is full of playfulness and crazy humor. Escher was once rather shocked when someone who could ill afford the expense bought this print just after a painful loss because she found consolation in this representation of continuous transformations. As J. L. Locher has mentioned, the little book with the word "Job" on it in *Reptiles* was long a source of enjoyment for Escher because it was so often given a deep interpretation. In a later edition of his prints accompanied by his own comments, he remarked in connection with this print: "N.B. the booklet Job has nothing to do with the Bible but contains Belgian cigarette papers."

That things are often not what they seem to be is an element of the expression of reality in several of Escher's prints. He also believes that things and beings could occur that do not exist now but, on the basis of what we think and know, are conceivable and therefore potentially realizable. Because the artist has a creative power at his disposal, he can act as creator of conceivable but nonexistent beings and situations. Escher has done this more than once. A sublime example is the famous creation of the *Curl-up* (Cat. 167), which he brought to life—with a splendid, crazy explanatory text—via lithography to fill an aching gap in nature. He then let it, still revolving, play a role in the related *House of Stairs I* (Cat. 172), a lithograph rigidly constructed on the basis of mathematically worked out drawings (Cat. 168-71).

In my opinion it is pure fallacy to characterize Escher's work as coldly intellectual. Escher is not simply a constructor of geometric figures and a technical draftsman, although a few of his works do lean heavily in this direction. He once rightly remarked, in his introduction to *Catalogus M. C. Escher* (Stedelijk Museum, Amsterdam, 1954), that self-expression was what he was trying to realize as an artist. As a creator, with his rational knowledge and his emotional nature, he is himself the center of his universe. This is what he has so successfully expressed in the lithograph *Three Spheres II* (Cat. 135). This central place in his universe is assigned, in his approach to reality, to the demiurge, the creative spirit of his world. And from this place he brings forth the Curl-up as something possible in our reality that has not yet been realized. Like his *Other World* (Cat. 141), it is constructed on the basis of possibilities and perspectives belonging to our world but set in an unfamiliar combination and realization. The creativity of the artist is not sovereign, however, but inextricably bound to the possibilities that are fundamentally present. Escher is deeply convinced that empirical reality is one given possibility of realization, and that from the same fundamental basis an equally different one might have arisen.

Encounter (Cat. 127) and *Predestination* (Cat. 165) represent, according to Escher, two different realizations developing from the same fundamental basis. In both cases we see figures emerging from the primeval gray to take on manifest white and black shapes. In *Encounter*, initially vague but gradually more clearly developing white and black human shapes separate themselves from the gray, two-dimensional back wall to enter the third dimension and then meet each other in the foreground as sharply outlined figures. The meeting ends safely with a handshake—this time, at least. But in *Predestination* there is a different atmosphere to the meeting of figures, again initially vague and emerging into the third dimension from a gray background and assuming increasingly distinct shapes : the white bird narrowly escapes the meeting the first time, but the second time, the monstrous black fish crushes it ferociously between its jaws. As an impassive predestinator, Escher allows fate to take its course, taking care only that some trait or other should dominate during the genesis of the figures. In what happens after that, he functions only as the reproducer and not as the author of the event. In an elucidation of *Predestination* (J. C. Ebbinge Wubben, "M. C. Escher : Noodlot." *Openbaar Kunstbezit*, Vol. 1, no. 6, [1957]), he unburdened himself of even more of the responsibility : "Thus it was suddenly clear to me that I had to do with a rapacious cruel fish and a timorous terrified bird which, still as it were in its embryonic state, already feels the teeth of its enemy in its neck. What other course was left to me than to attempt to let the tragedy reach its conclusion in a distinct way ? . . . It is a sad case, but what can I do about it ?" Escher adds laconically : "Let it be a consolation to us that in reality fish are usually eaten by birds."

For Escher, too, in the final analysis, it does make some difference whether a meeting ends in receiving a hand or in being crushed. This became clear to me during a conversation about these prints. He had first reacted by remarking that, in essence, there was no difference between the two representations. But what he was concerned with in both prints was an identical initial situation containing different possibilities of further realization. Escher allowed these possibilities to reach consummation in a narrative event. His primary interest, however, was not in the event itself but in the basic plan, with its potential alternatives of development.

In many respects, therefore, Escher may be called a typical structuralist, especially if structure is taken in the sense used by the famous social anthropologist Claude Lévi-Strauss. Structure would then mean primarily a design or model with the potential for realizations present in it. Many of Escher's prints represent realizations unmistakably based on such a structure. As a result, we often feel in looking at them a structural sensation that is both emotional and intellectual.

Escher himself, in describing the making of his prints, speaks of a sensation he often experiences. It is obviously a sensation of dynamic structure, although he does not employ the word structure. In working out a basic plan or form, he has the feeling that he himself is no longer directing its development but that he is being possessed by it and that the movements of his hand are being led by it. In his explanatory comment on *Predestination* quoted above, he also says that a sense of fatality came over him when he saw the characters revealed by the features of the two animal motifs, the bird and the fish. He continues : "However remarkable it may be that such simple figures have a character, it seems even stranger to assume that they themselves create their character." He then formulates this idea more generally : "I undergo this sensation each time I am occupied with the designing of a regular division of the plane. I then feel as though it is not I who determines the design but rather that the simple little plane compartments on which I fuss and labor have a will of their own, as though it is they that control the movements of my hand."

Escher's comments here show a remarkable correspondence to a well-known statement made by Lévi-Strauss in his structural analysis of the myth. In the same way as Escher's figures develop and move themselves via the artist according to a plan implicit in the structure, myths, according to Lévi-Strauss ("Le cru et le cuit." *Mythologiques*, Vol. 1 [1964], p. 20), take form in a way determined by certain structures in the thinking of peoples with no involvement of their conscious minds (*"Les mythes se pensent dans les hommes et à leur insu"*).

More than once Escher has not been aware in advance of where he would arrive in the

working out of a basic plan. But he is usually highly conscious of the basic structure itself (see his studies for prints), even to the extent of sometimes including it separately in his prints. This is the case in *Convex and Concave*, in which the inversional structure is shown on the right in the motif of the flag (see page 18). In *Belvedere* the structure of the print is drawn on a sheet of paper in the foreground, and the figure on the bench holds the model thoughtfully in his hand (see page 17).

The structural sensation in Escher's work often lies in the anticipation of the development from the basic structure. Conversely, the empirical realization in the print can evoke fundamental structures. In Escher's work these structures are often dialectic in nature, which is to say that the interaction between unity and disparity and between the contrasting elements themselves fulfills a central function in his work. The term dialectical structuralism can appropriately be applied to Escher's work.

Contrasts are unmistakably important in his work. They may be opposites such as black and white, day and night, or even flat and three-dimensional. Even more important are contrasts such as latency against manifestation, infinity with dizzy perspectives against sharply defined and concrete nearness, representation of spatial relativity against the traditional treatment of space, and other world against familiar world.

In Escher's work a structural sensation finds expression and is consciously or unconsciously experienced by many in looking at it. Their reaction need not necessarily correspond to the intention of the artist himself. For instance, *Three Spheres I* (Cat. 133) can be experienced not only as the sensation of a collapse of the suggested space of a sphere into the flat reality of plane existence but also as the sensation of the emergence from the two-dimensional into the three-dimensional.

Escher frankly accepts this interpretation as a possibility. He has had much more trouble with the enthusiasm for his work among younger people whose attitudes are generally associated more with chaos than with cosmos. Escher's work unquestionably includes the view of empirical reality as illusory in character in many respects, but at the same time there is the idea that it is ultimately based on a logical reality. This is also why "the contrast between chaos and cosmos" as fundamental category is totally absent in his work. He tried to express this theme in *Order and Chaos* (Cat. 157), but the result was a comic failure. What he did was to represent chaos by neatly arranging a series of broken objects around the symbol of order and perfection located in the center of the print.

Escher was doomed to fail in this attempt, because he has a deep aversion to disorder and to any kind of slovenly, unfinished representation. So it is not surprising that he often is amazed at the enthusiasm for his prints among groups of young people lacking this aversion

entirely. But their excitement is nevertheless understandable. They find a strong element of playfulness, and they are fascinated by the representation of the existing world and a conceivable world as reality in the same print. They are probably most struck, however, by his representation of the plurality of the present visual world in an atmosphere of strangeness and absurdity. They either do not notice or else ignore the fact that this world, which is so peculiar for Escher, too, ultimately has a logically comprehensible basis for him.

Whatever the reasons are, it is certain that Escher's prints fascinate many people and provide many kinds of pleasure, including enjoyment in a purely aesthetic sense, when he succeeds in a very specific combination of form, content, and material. What strikes one at an Escher exhibition is how little the people there show the usual solemnity and silent incomprehension. Some of them laugh aloud in enjoyment of certain aspects of his prints, usually in complete accord with the intention of the artist. Discussions develop among them. Young people explain things to older people. Scientists who encounter their own fundamental scientific problems in Escher's prints are told how Escher relates to contemporary art. However unintentionally, his work seems to be susceptible to many different interpretations. In looking at his prints, the visitors to his exhibitions have widely varying perceptions and feelings. For many of them, the most important of these is the conscious or unconscious experience of the structural sensation.

The Mathematical Implications
of Escher's Prints

H. S. M. Coxeter

The late Professor G. H. Hardy once described "real mathematics" as having "a very high degree of *unexpectedness*, combined with *inevitability* and *economy*." These words describe equally well the work of M. C. Escher. As Escher said himself, "By keenly confronting the enigmas that surround us, and by analyzing the observations that I had made, I ended up in the domain of mathematics. Although I am absolutely innocent of training or knowledge in the exact sciences, I often seem to have more in common with mathematicians than with my fellow artists" (*The Graphic Work of M. C. Escher*, New York, 1967, p. 9). The following examples illustrate the compatibility of Escher's work with the world of mathematics.

A fascinating introduction to elementary topology is provided by the two wood engravings *Moebius Strip I* (Cat. 248) and *Moebius Strip II* (Cat. 260). The first moebius strip has been cut down its entire length to illustrate the fact that it remains connected. The one-sidedness of the second strip is demonstrated by nine ants crawling along it ; they are so lifelike that one can almost *feel* their little claws.

Like Leonardo da Vinci and Albrecht Dürer, Escher has a strong appreciation of the five Platonic solids : the regular tetrahedron, octahedron, cube, icosahedron, and dodecahedron. "They symbolize," he says, "man's longing for harmony and order, but at the same time their perfection awes us with a sense of our own helplessness. Regular polyhedra are not inventions of the human mind, for they existed long before mankind appeared on the scene."

Tetrahedral Planetoid (Cat. 194) is essentially a tetrahedron, and *Double Planetoid* (Cat. 156) is the compound of two reciprocal tetrahedra which Kepler named *stella octangula*. *Flatworms* (Cat. 236) features the tetrahedron and the octahedron, showing the interesting way in which the entire space can be filled with a honeycomb of replicas of these two solids. *Stars* (Cat. 152) exhibits a combination of three concentric octahedra as a skeletal model in which the edges appear as rods. (Leonardo made many such models at the beginning of the sixteenth century, when he was illustrating Luca Pacioli's *De divina proportione*.) In *Cube with Magic Ribbons* (Cat. 221), a skeletal cube is reinforced by diagonals in four of the six square faces. (Notice the contrast between the reality of the rods and the fantastic impossibility of the two endless ribbons, on which the buttonlike protuberances can appear either convex or concave.) *Cubic Space Division* (Cat. 181) is the cubic honeycomb or cubic lattice ; its perspective gives a wonderful sense of infinite space.

Order and Chaos (Cat. 157) and *Gravity* (Cat. 178) are based on Kepler's small stellated dodecahedron, a "star polyhedron" which has the same face planes as the dodecahedron and the same vertices as the icosahedron.

Two-dimensional patterns, such as those commonly appearing on wallpaper or on tiled floors, were used by the ancient Egyptians and, more systematically, by the Moors in their

49

decoration of the Alhambra. In 1891, the Russian crystallographer E. S. Fedorov proved that every such pattern is systematically repeated according to one of just seventeen groups of isometries. (By *isometries* I mean displacements, possibly combined with reflections. The simplest *displacement* is the *identity*, which leaves every point unchanged. The result of applying several transformations successively is called their *product*. If the product of two transformations is an identity, each is called the *inverse* of the other. A set of transformations is said to form a *group* if it contains the inverse of each and the product of any two, including the product of one with itself or with its inverse.)

Any such group may be regarded as the symmetry group of a tessellation of congruent (or "isometric") tiles, in which one tile could be transformed into any other by an isometry that leaves the whole pattern unchanged. The smallest tile possible in such a design is called a *fundamental region* for the group. In 1963 Heinrich Heesch and Otto Kienzle published a book called *Flächenschluss* (Springer, Berlin) describing mathematically the possible ways in which the shape of a fundamental region (for each of the seventeen groups) can be varied. They went on to consider practical applications of this idea—for instance, the most economical way to cut out soles for shoes from a large sheet of leather. They were unaware that Escher had already been working for many years along the same lines, ingeniously using as a fundamental region a fish or a lizard or a bird or a horseman. In Escher's own words, "The border line between two adjacent shapes having a double function, the act of tracing such a line is a complicated business. On either side of it, simultaneously, a recognizability takes shape. But the human eye and mind cannot be busy with two things at the same moment, and so there must be a quick and continual jumping from one side to the other. . . . This difficulty is perhaps the very moving-spring of my perseverance" (quoted in C. H. MacGillavry, *Symmetry Aspects of M. C. Escher's Periodic Drawings*, Utrecht, 1965, p. viii).

In 1951 and subsequent years, A. V. Shubnikov, N. V. Belov, and others extended the theory of crystallographic groups by combining the systematic repetition of shapes with a systematic repetition of colors. This theory of polychromatic symmetry adds to Fedorov's seventeen groups 46 two-color, 6 three-color, 6 four-color, and 3 six-color extensions. The Russians were almost certainly unaware of the fact that Escher, using his artistic intuition without any mathematics, had anticipated many of their results. For instance, the fascination of his famous pattern of horsemen (Cat. 137) is enhanced by the fact that they are white or gray depending on whether they are proceeding to the left or the right. This extraordinary anticipation of a difficult mathematical theory has been well described by Professor Caroline H. MacGillavry in her above-mentioned book.

In 1956 Escher extended his scope from infinite groups of isometries to infinite groups of

similarities. Smaller and Smaller I (Cat. 219) involves not only a quarter-turn about the center and a dilatation in the ratio 2 :1 but, more subtly, a dilative rotation or *spiral similarity* which is the product of a dilatation in the ratio $\sqrt{2}$:1 and a rotation through forty-five degrees. In 1957 he began work on the still more sophisticated extension to infinite groups of Moebius transformations or *homographies* (which are products of inversions in two or four circles) and *antihomographies* (which are products of inversions in three circles). In *Whirlpools* (Cat. 224) any two fish of the same color are related by a loxodromic homography (if we ignore the insufficient distortion of the outermost fish). Two loxodromes (a *loxodrome* is the inverse of an equiangular spiral), running down the backbones of the fish, have been drawn with remarkable accuracy. Moreover, any two fish of different colors (i.e., one dark and one pale) are related by a hyperbolic antihomography (the product of inversions in three circles such that two are nonintersecting while the third is orthogonal to both). In *Circle Limit I* (Cat. 233), the fundamental region for the group is an isosceles triangle with angles of sixty degrees, forty-five degrees, and forty-five degrees, formed by the arcs of three circles. This triangle is transformed into its neighbors by inversions (or reflections) in its two equal sides (which are backbones of fishes) and a Moebius involution (or half turn) about the midpoint of the third side (which is the crossing point of two white fins and two black fins). Escher admits that this is only a first attepmt, leaving much to be desired because there is no transformation of a white fish into a black fish. Far more successful is *Circle Limit III* (Cat. 239), a very interesting four-color extension of a group generated by Moebius involutions. When the whole round pattern is regarded as Poincaré's circular model of the hyperbolic (non-Euclidean) plane, the fish become congruent, and the Moebius involutions become half-turns about the points where the fins of four fish come together. These points are the vertices of the regular hyperbolic tessellation $\{3,8\}$ (equilateral *triangles, eight* at each vertex), and evidently the half-turn about such a point (e.g., the center of the whole picture) preserves the color scheme. On the other hand, by ignoring the colors, we obtain a symmetry group in which a single fish serves as a fundamental region. This group contains quarter-turns about these same points and rotations of period three about the vertices of the dual tessellation $\{8,3\}$ (*octagons, three* at each vertex). These centers of trigonal rotation appear alternately as points where three fins come together and as points where the mouths of three fish meet the tails of three others. In my opinion this woodcut would have been still more beautiful without the white arcs, which artificially divide each fish into two unequal parts.

Perhaps it is the absence of such "backbones" that makes *Circle Limit IV* (Cat. 247) so particularly appealing. In this, the fundamental region consists of half a white angel plus half

51

a black devil, or of an isosceles triangle having two angles of thirty degrees (at the feet of the angels and devils) and one right angle (at their wingtips). This triangle is transformed into its neighbors by a reflection in the long side (hypotenuse) and a quarter-turn about the opposite vertex (where the right angle occurs).

Last, but not least, there are the whimsical works such as *Belvedere* (Cat. 230), *Ascending and Descending* (Cat. 243), and *Waterfall* (Cat. 258), which are not mathematical in detail but only in spirit. They remind one of the words of J. L. Synge, "Beside the actual universe I can set in imagination other universes in which the laws are different" (*Kandelman's Krim,* London, 1957, p. 21). Of course these other universes are fantastic, but are they any more fantastic than the non-Euclidean spaces or the square root of minus one?

Appendices

Selected Bibliography

Writings of M. C. Escher

Grafiek en tekeningen M. C. Escher. Introduction by P. Terpstra. Zwolle, 1959.
The Graphic Work of M. C. Escher. London and New York, 1961. Enlarged ed., New York, 1967.
"Hoe ik er toe kwam, als graficus, ontwerpen voor wandversiering te maken." *De delver*, Vol. 14, no. 6 (1941), p. 81.
"Introduction." *Catalogus M. C. Escher*. No. 118, Stedelijk Museum, Amsterdam, 1954.
"Nederlandse grafici vertellen van hun werk II." *Phoenix*, Vol. 2, no. 4 (1947), p. 90.
"Oneindigheidsbenaderingen." *De wereld van het zwart en wit*, edited by J. Hulsker, Amsterdam (1959), p. 41.
Regelmatige vlakverdeling. Utrecht, 1958. (Limited ed., Stichting De Roos.)
"Samuel Jessurun de Mesquita." *Catalogus tentoonstelling S. J. de Mesquita en Mendes da Costa*, Stedelijk Museum, Amsterdam, 1946.
"Timbre-poste pour l'avion." *Les Timbres-poste des Pays-Bas de 1929 à 1939*, The Hague (1939), p. 59.

Books Illustrated by M. C. Escher

Drijfhout, A. E. *XXIV Emblemata dat zijn zinne-beelden*. Bussum, 1932.
Stolk, A. P. van. *Flor de pascua*. Baarn, 1921.
Walch, J. *De vreeselijke avonturen van Scholastica*. Bussum, 1933.

Scientific Books and Articles in Which Escher's Prints and Drawings Have Appeared

Abram, I. *Leerboek der stereometrie*. Groningen, 1960.
Adler, I. *Inside the Nucleus*. New York, 1963.
Angrist, S. W. "Perpetual Motion Machines." *Scientific American*, Vol. 218, no. 1 (1968), p. 115.
Barre, A., and Flocon, A. *La Perspective curviligne*. Paris, 1968.
Boer, J. H. de. *Reactivity of Solids*. Amsterdam, 1960.
Bos, W. J., and Lepoeter, P. E. *Wegwijzer in de meetkunde 1*. Amsterdam, 1954.
Brinkman, A. A. A. M. "De symmetrie in het werk van M. C. Escher." *Chemie & Techniek Revue*, Vol. 21, no. 8 (1966).
Calvin, M. *Chemical Evolution* (Condon Lectures). Eugene, Ore., 1961.
Cameron, A. G. W. (ed.). *Interstellar Communication*. New York, 1963.
Carraher, R. G., and Thurston, J. B. *Optical Illusions and the Visual Arts*. New York and London, 1966.
Coda, A. (ed.). *La materia e le sue trasformazioni*. Milan, 1967.
Coxeter, H. S. M. *Introduction to Geometry*. New York and London, 1961.
Craig, E. J. "Phenomenal Geometry." *British Journal for the Philosophy of Science*, Vol. 20 (1969), p. 121.
Dodder, C., and Dodder, B. *Decision Making*. Boston, 1968.
Dolciani, M. P. (ed.). *Modern School Mathematics—Algebra and Trigonometry 2*. Boston, 1968.
Ernst, B. *Werkboek der algebra 4*. Amsterdam.
_____. *Pythagoras, Wiskundetijdschrift voor jongeren*. Vols. 2, 3, 5-7, 9.
Flocon, A. "Art et savoir." *Démocratie nouvelle*. Paris (1967).
Froman, R. *Science, Art and Visual Illusions*. New York, 1970.
Fuchs, W. R. *Exacte Geheimnisse, Knaurs Buch der modernen Mathematik*. Munich and Zurich, 1966.
_____. *Mathematics for the Modern Mind*. New York, 1967.
Gardner, M. "Concerning the Diversions in a New Book on Geometry." *Scientific American*, Vol. 204, no. 4 (1961), p. 164.
_____. "The Eerie Mathematical Art of Maurits C. Escher." *Scientific American*, Vol. 214, no. 4 (1966), p. 110.
_____. *New Mathematical Diversions from Scientific American*. New York, 1966.
_____. "Of Optical Illusions." *Scientific American*, Vol. 222, No. 5 (1970).
_____. "The World of the Möbius Strip." *Scientific American*, Vol. 219, No. 6 (1968).
Glasser, L. "Teaching Symmetry." *Journal of Chemical Education*, Vol. 44, no. 9 (1967), p. 502.

Gombrich, E. H. *Art and Illusion*. London and New York, 1960.

———. "How to Read a Painting." *The Saturday Evening Post*, Vol. 234, no. 30 (1961), p. 20.

———. *Meditations on a Hobby Horse*. London, 1963.

Gregory, R. L. *The Intelligent Eye*. New York, 1970.

Hawkins, D. *The Language of Nature*. San Francisco and London, 1964.

Holt, M. *Mathematics in Art*. London and New York, 1971.

Jacobs, H. R. *Mathematics—a Human Endeavor*. San Francisco, 1970.

Jurgensen, R. C. (ed.). *Modern School Mathematics—Geometry*. Boston, 1969.

Kettelkamp, L. *Puzzle Patterns*. New York, 1963.

Knorre, E., and Konovalov, B. "Question Marks in Physics." *Nauka I Zhizn*, Moscow, no. 11 (1964).

Krech, D. (ed.). *Elements of Psychology*. New York, 1969.

Lewis, D. J. *Introduction to Algebra*. New York, 1965.

Lipson, H. "Diffraction." *Memoirs & Proceedings of the Manchester Literary and Philosophical Society*, Vol. 104, no. 1 (1962).

Loeb, A. L. "The Architecture of Crystals." *Module, Proportion, Symmetry, Rhythm*, edited by G. Kepes, New York (1966), p. 38.

Maas, J. B. *Slide Group for General Psychology*. New York, 1968.

MacGillavry, C. H. *Symmetry Aspects of M. C. Escher's Periodic Drawings*. Utrecht, 1965.

May, K. O. "Mathematics and Art." *The Mathematics Teacher*, Vol. 60, no. 6 (1967), p. 568.

McGeary, B. *My World of Art*. Boston, 1964.

Mueller, C. G. (ed.). *Light and Vision*. Life Science Library, New York, 1966.

Nicol, H. "Everyman's Artist." *Brewer's Guild Journal*, Vol. 46, no. 548 (1960), p. 333.

Parry, R. W. (ed.). *Chemistry : Experimental Foundations*. Englewood Cliffs, N. J., 1970.

Penrose, L. S., and Penrose, R. "Impossible Objects, A Special Type of Visual Illusion." *The British Journal of Psychology*, Vol, 49, no. 1 (February, 1958), p. 31.

Read, A. J. *Physics : A Descriptive Analysis*. Reading, Mass., 1970.

Robertson, W. D. "Needed : Architects of Matter." *Materials—Research and Standards*, Vol. 3, no. 10 (1963), p. 832.

Rosenqvist, I. T. "The Influence of Physico-chemical Factors upon the Mechanical Properties of Clays." *Publications of the Norwegian Geotechnical Institute*, Oslo, no. 54 (1963).

Ruch, F. L. *Psychology and Life*. Glenview, Ill., 1967.

Ruth, W. van. *Stereometrie*. Utrecht, 1965.

Schouten, J. F. "Waan, waarneming en werkelijkheid." *Akademiedagen*, Amsterdam, Vol. 15 (1963).

The Scientist. Life Science Library, New York, 1964.

Sobel, M. A., and Maletsky, E. M. *Developing Mathematical Ideas*. Boston, 1967.

Terpstra, P. *Introduction to the Space Groups*. Groningen, 1955.

———. *Some Notes on the Mathematical Background of Repetitive Patterns*. London, 1961.

———, and Codd, L. W. *Crystallometry*. London, 1961.

Thijn, Van. *Leerboek der goniometrie*. Groningen, n.d.

Tóth, L. Frejes. *Regular Figures*. New York, 1964.

Troelstra, R. (ed.). *Transformatiemeetkunde*. Groningen, 1962.

Wagenaar, J. W. "The Importance of the Relationship 'Figure and Ground' in Fast Traffic." *Ophtalmologica*, Vol. 124, no. 5 (1952), p. 309.

Weyl, H. *Symmetry*. Princeton, 1952 (Russian ed., *Simmetrija*. Moscow, 1968).

The Worm Runner's Digest. University of Michigan, Ann Arbor, Vol. 5, no. 2 (1963).

Yang, C. N. *Elementary Particles*. Princeton, 1961.

———. "Symmetry Principles in Physics." *The Physics Teacher*, Vol. 5, no. 7 (1967), p. 311.

Zusne, L. *Visual Perception of Form*. New York and London, 1970.

Commentaries on the Art of M. C. Escher

Albright, T. "Visuals—Escher." *Rolling Stone*, no. 52 (1970).

Chapelot, P. "Une Découverte : le visionnaire Escher." *Planète*, no. 8 (1963), p. 60.

Ebbinge Wubben, J. C. "M. C. Escher : Noodlot." *Openbaar Kunstbezit*, Vol. 1, no. 6 (1957).

"M. C. Escher lithographies." *Caractère Noël* (1963).

"Escher's Eerie Games." *Horizon*. Vol. 8, no. 4 (1966), p. 110.

Flocon, A. "A la Frontière de l'art graphique et des mathématiques : Maurits Cornelis Escher." *Jardin des arts*, no. 131 (1965) p. 9.

"The Gamesman." *Time*, Vol. 65, no. 17 (1954), p. 68.

's-Gravesande, G. H. "De graphicus M. C. Escher." *Halcyon* (1939).

———. "M. C. Escher en zijn experimenten." *De vrije bladen*, Vol. 17, no. 4 (1940).

———. "Nieuw werk van M. C. Escher." *Elseviers geïllustreerd maandschrift*, Vol. 48, no. 11 (1938), p. 312.

———. "M. C. Escher en de zwarte kunst." *Maandblad voor beeldende kunsten*, Vol. 20, no. 1 (1948), p. 18.

Hofmeijer, D. H. "The Wondrous World of M. C. Escher." *Circuit*, no. 26 (1969).

Hoogewerff, G. J. "M. C. Escher, grafisch kunstenaar." *Elseviers geïllustreerd maandschrift*, Vol. 40, no. 10 (1931), p. 225.

———. "Nederlandsche gebouwen te Rome." *Heemschut*, no. 11 (1933).

Koomen, P. "M. C. Escher, houtsnijder en teekenaar." *Maandblad voor beeldende kunsten*, no. 7 (1930), p. 211.

Locher, J. L. *Catalogus overzichtstentoonstelling M. C. Escher* (with contributions by C. H. A. Broos, G. W. Locher, M. C. Escher, H. S. M. Coxeter, Bruno Ernst), Gemeentemuseum, The Hague, 1968.

Loveland, R. J. *Graphic Imagery of M. C. Escher*. Master's thesis, University of Wyoming, 1967.

Maas, J. "The Stately Mansions of the Imagination." *Horizon*, Vol. 5, no. 7 (1963), p. 10.

Nemerov, H. "The Miraculous Transformations of Maurits Cornelis Escher." *Artist's Proof*, Vol. 3, no. 2 (1963-64), p. 32.

Platt, C. "Expressing the Abstract." *New Worlds*, Vol. 51, no. 173 (1967), p. 44.

"Prying Dutchman." *Time*, Vol. 57, no. 14 (1951), p. 50.

Roozen, L. J. C. *Het Leidsche stadhuis*. Leiden, 1950, p. 35.

Severin, M. F. "The Dimensional Experiments of M. C. Escher." *The Studio*, Vol. 141, no. 695 (1951), p. 50.

Sheldon-Williams, P. M. T. "Graphic Work of M. C. Escher." *Apollo*, Vol. 76, no. 82 (1962).

"Speaking of Pictures." *Life*, Vol. 5, no. 18 (1961), p. 18.

"Tricks Played on Hand and Eye." *The UNESCO Courier*, Vol. 19, no. 5 (1964), p. 14.

Veth, C. "Huib Gerritsen en M. C. Escher bij Mart. Liernur." *Maandblad voor beeldende kunsten*, Vol. 12 (1946), p. 115.

Wennberg, G. "Tillvaron som synvilla." *Ord och bild*, no. 1 (1962), p. 52.

Exhibitions and Lectures

Major Exhibitions of the Work of M. C. Escher

1923 Siena : Circolo artistico Sienese
1924 The Hague : "De Zonnebloem" Art Gallery
1926 Rome : Palazetto Venezia
 Amsterdam : Scheltema and Holkema Bookshop
 (with Mesquita, Veldheer, Weiland, and Wittenberg)
1927 Amsterdam : Amsterdam Ateliers for Interior Art
 (with Reyer Stolk)
1928 Leiden : Lakenhal (with S. van Stek-van der Does de
 Willebois)
1929 Rotterdam : Huize van Hasselt (with Jaap Gidding)
 Utrecht : Bij den Dom Art Gallery
 Leeuwarden : Princessehof
 Arnhem : Th. Brouwer Artshop
1930 Laren : Rogmans & Vos Art Galleries
 Baarn : Baarns Lyceum
1931 The Hague : M. Liernur Art Gallery
1933 The Hague : Joh. D. Scherft Art Gallery
1934 Arnhem : Artibus Sacrum
 Rome : Istituto Olandese (with Otto B. de Kat)
1935 Amsterdam : Santee Landweer Art Gallery
 The Hague : Joh. D. Scherft Art Gallery (with Alma,
 W. van den Berg, and Van Heusden)
1937 Château-d'Oex : Riant Chalet (with J. Paschoud)
1938 Rotterdam : Academy
1939 Amsterdam : Aalderink Art Gallery (with Debora
 Duyvis)
1941 Baarn : Baarns Lyceum
1946 Stockholm : N.K.'s Studio (with Van Gelder and
 Brinks)
 Pretoria : University (J. J. Klant Collection)
1947 The Hague : Joh. D. Scherft Art Gallery
1948 Johannesburg : Constantia Gallery (J. J. Klant
 Collection)
 Arnhem : Mariënburg Art Gallery (with Edm. de
 Cneudt)
1949 Blaricum : Van Lier Art Gallery
 Rotterdam : Museum Boymans (with Van Heusden
 and Van Kruiningen)
 Leiden : Prentenkabinet, University (with
 Van Heusden and Van Kruiningen)
 Tilburg : Donders Art Gallery (with Brinks,
 Duyvis, and Van Gelder)
1950 Dordrecht : Pictura (with Van Kruiningen)
 Amsterdam : Moderne Boekhandel (Modern
 Bookshop)
 Amsterdam : Galerie le Canard
1951 Baarn : Baarns Lyceum
 Haarlem : Leffelaar Art Gallery

1952 Rotterdam : Museum Boymans, *4 Graphic Artists*
 (with Prange, Van Heusden, and Van Kruiningen)
 Venice : Biennale
1953 Arnhem : Gemeentemuseum, *4 Graphic Artists*
 Amersfoort : 't Oude Wevershuys
1954 Hilversum : Goois Museum
 The Hague : Gemeentemuseum, *4 Graphic Artists*
 Amsterdam : Stedelijk Museum
 Washington, D.C. : Whyte Gallery
1955 The Hague : Dijkhoffz Bookshop
1956 Ghent : Museum A. vander Haeghen (with
 A. Jaquemin)
1957 Amsterdam : Stedelijk Museum, *4 Graphic Artists*
 (with Disberg instead of Prange)
 Groningen : Kunsthistorisch Instituut
1958 Arnhem : Gemeentemuseum, *4 Graphic Artists*
 Laren : Singer Museum
1959 Eindhoven : Stedelijk Van Abbemuseum,
 4 Graphic Artists (with J. Laqueur)
 Hengelo : Hengelo Artshop (with J. Laqueur)
1960 Leeuwarden : Van Hulzen Art Gallery
 (with J. Laqueur)
 Utrecht : Kunstliefde Society (with J. Laqueur)
1964 Hilversum : Goois Museum (with Pierre d'Hont)
 Lincoln, Mass. : DeCordova and Dana Museum
 Cambridge, Mass. : Massachusetts Institute of
 Technology, Hayden Gallery
1965 New York : IBM Gallery, *Drolleries and Demons*
1968 Washington, D.C. : Mickelson Gallery
 The Hague : Gemeentemuseum
 Laren : Singer Museum
1969 Bonn : Landesmuseum
 Bern : Kunsthalle
1971 The Hague : Gemeentemuseum

Major Lectures Given by M. C. Escher

1951 Haarlem : Sociëteit Teisterbant (Teisterbant Society)
1953 Utrecht : Physisch Laboratorium, Ver. Natura
(National Science Laboratory, Natura Society)
1957 Groningen : Kunsthistorisch Instituut (Art History
Institute)
1960 Cambridge, England : International Congress of
Crystallography
Cambridge, Mass. : Massachusetts Institute of
Technology
Toronto : Ontario College of Art, Art Gallery
Montreal : McGill University, School of Architecture
1961 Soesterberg : Instituut voor Zintuigphysiologie
(Institute for Sensory Physiology)
1962 Leiden : Leids Academisch Kunstcentrum
(Leiden Academic Art Center)
Delft : Studentensociëteit Phoenix (Phoenix
Students' Club)
1963 Groningen : Natuurkundig Genootschap
(Society for the Natural Sciences)
Amsterdam : H.T.S. "Amsterdam" (Technical
High School "Amsterdam")
Amsterdam : Mathematisch Centrum
(Mathematical Center)
Amstelveen : at home of Professor Van Wijngaarden

1964 Amsterdam : Academie voor Bouwkunde
(Academy of Architecture)
Oss : Natuurwetenschappelijk Genootschap
(Natural Science Association)
1965 Paris : Institut Néerlandais
Eindhoven : International Institute of Technological
Studies
1966 Rotterdam : Wiskundig dispuut "Thom. J. Stieltjes"
(Thom. J. Stieltjes Mathematical Students' Club)
1967 Utrecht : Vereniging van Doctorandi Wis-, Natuur-
en Sterrenkunde (Association of Doctors of
Mathematics, Physics, and Astronomy)
Amsterdam : Lustrum Nat. Fil. Faculteitsvereniging
V.U. (Faculty Association of Natural Philosophy,
Free University)
1968 The Hague : Gemeentemuseum
1969 Delft : Technische Hogeschool (Technical University)

The Plates

In the following illustration section, the black-and-white reproductions present a chronological survey of Escher's work. Although the interplay between black and white is dominant in his work, Escher also worked with color. To illustrate this, eight of the works are shown not only in black and white, but also in color ; the colorplates are presented as an extra supplement which appears before the chronological catalogue. The second set of numbers on these color reproductions correspond to those in the black-and-white section ; titles and descriptions can be found in the fold-out Catalogue at the front of the book.

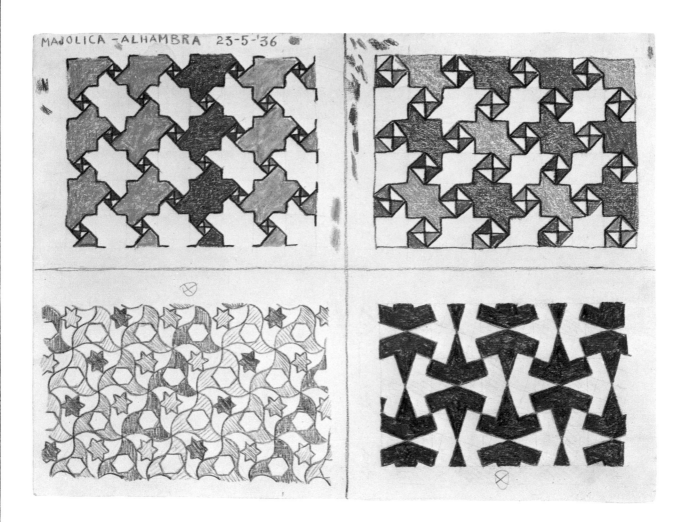

Colorplate I [Cat. 83]

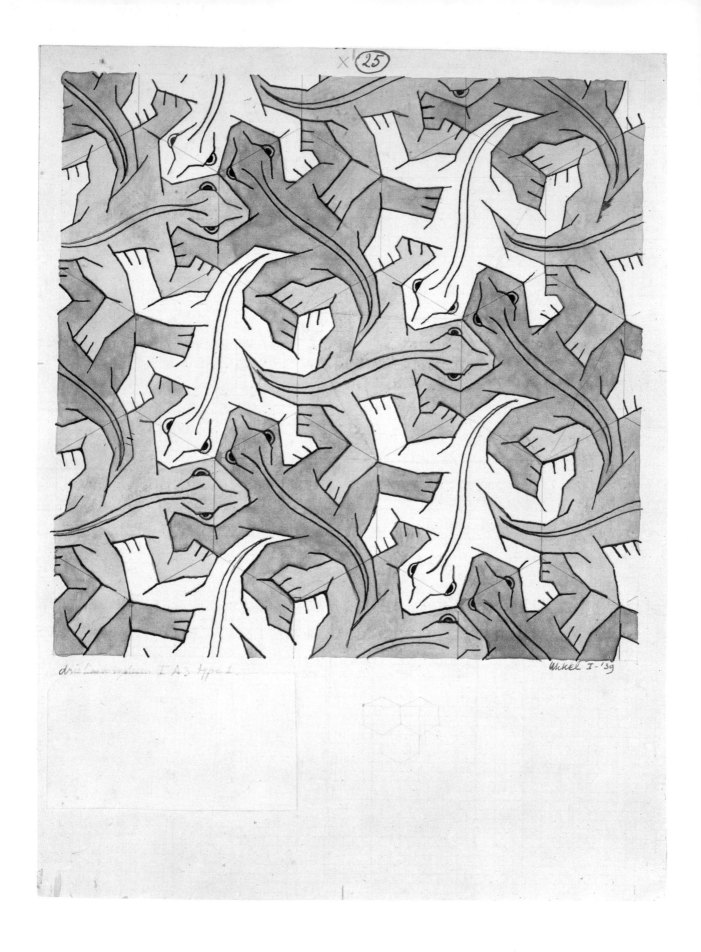

Colorplate II [Cat. 119]

Colorplate III [Cat. 175]

Colorplate IV [Cat. 200]

Colorplate V [Cat. 206]

Colorplate VI [Cat. 219]

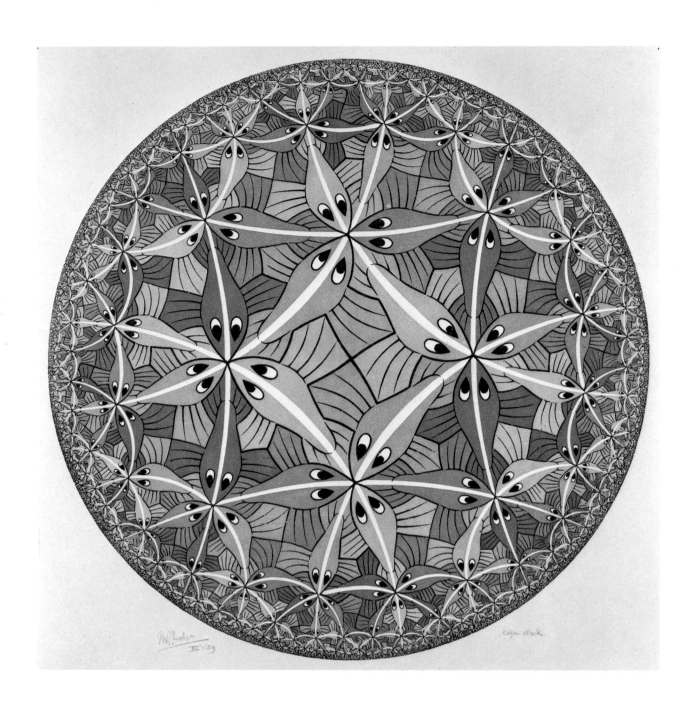

Colorplate VII [Cat. 239]

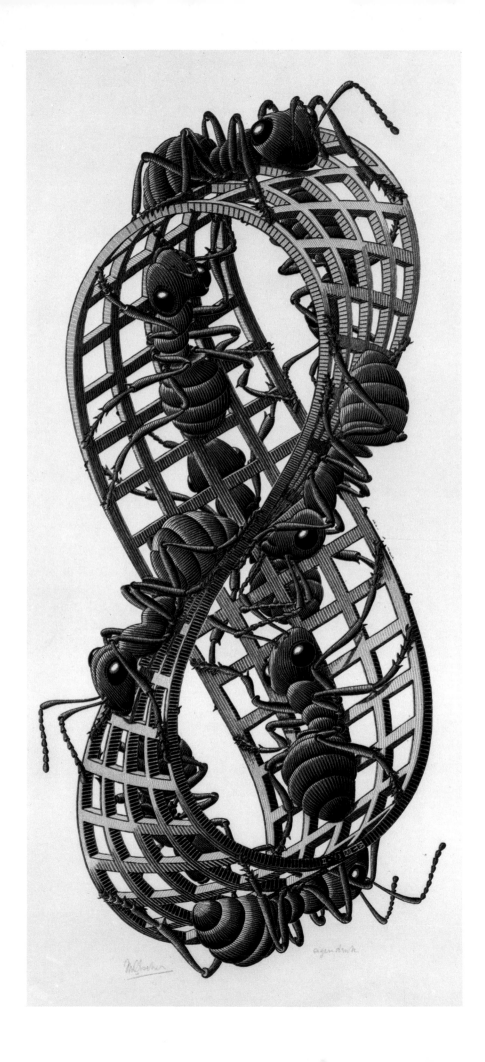

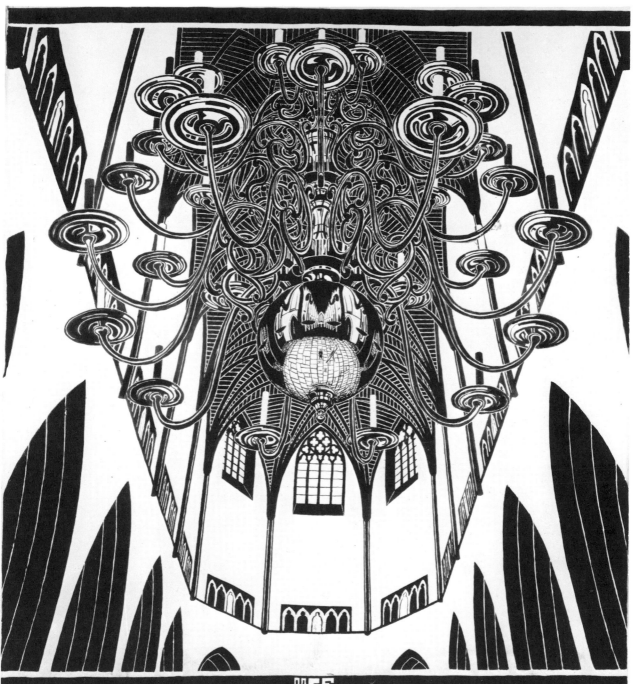

2

3

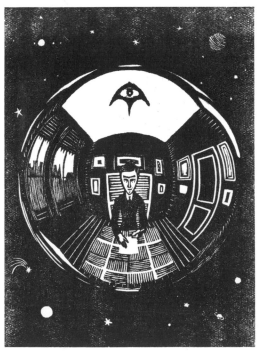

4

5

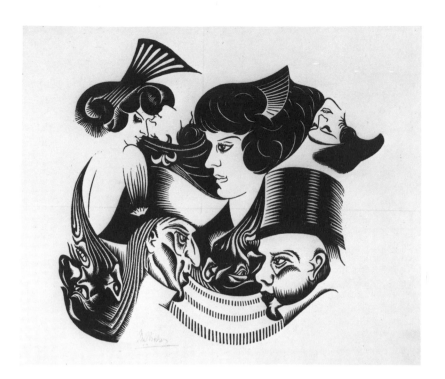

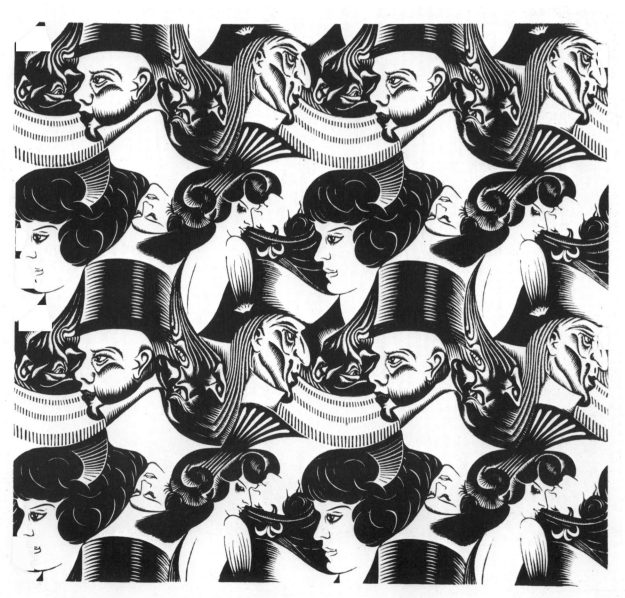

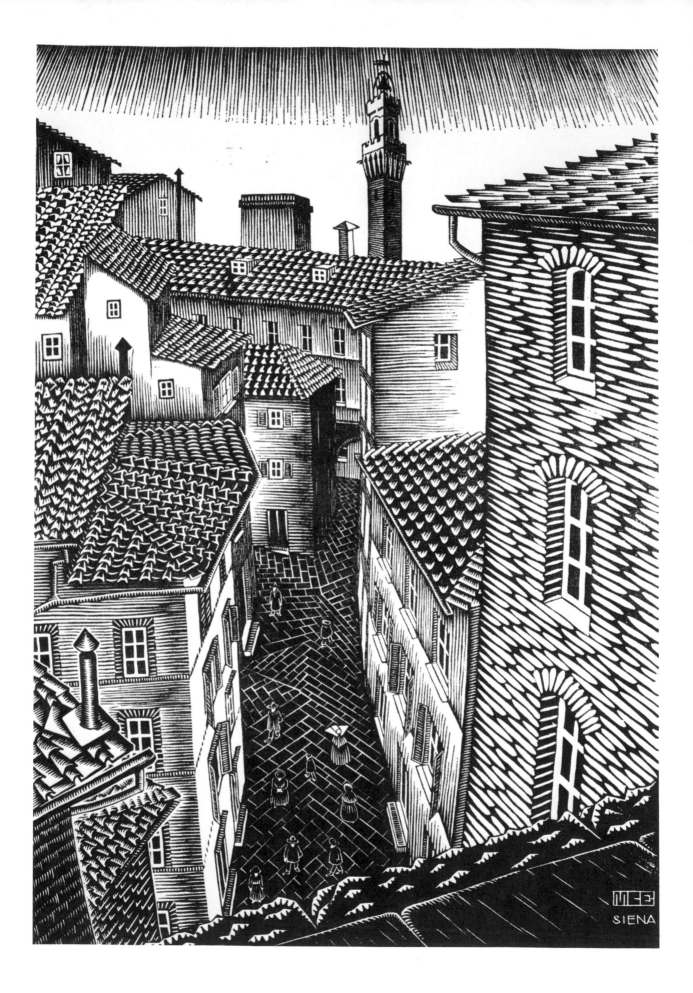

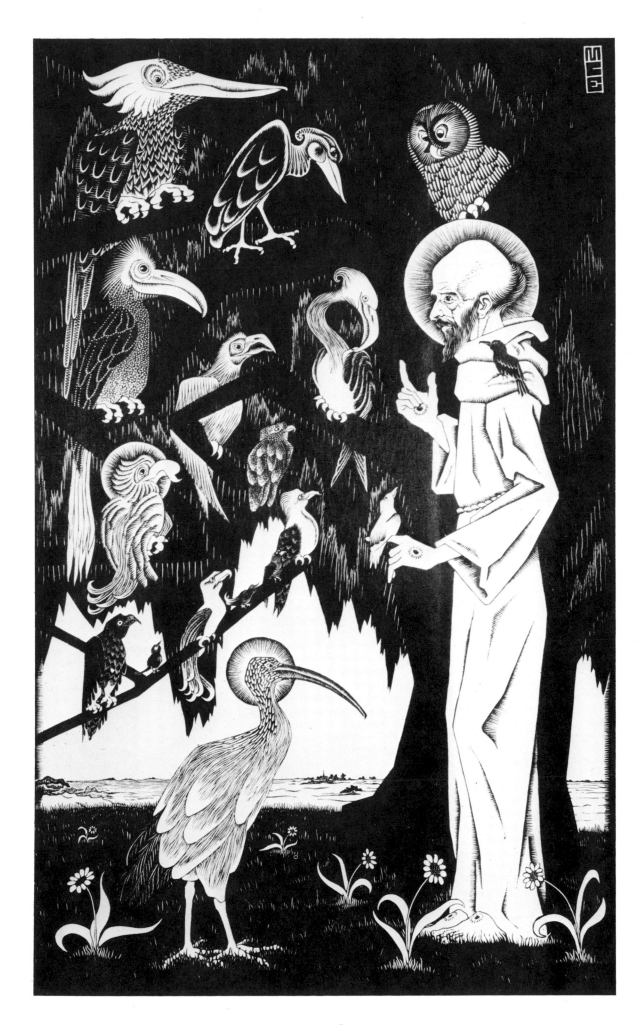

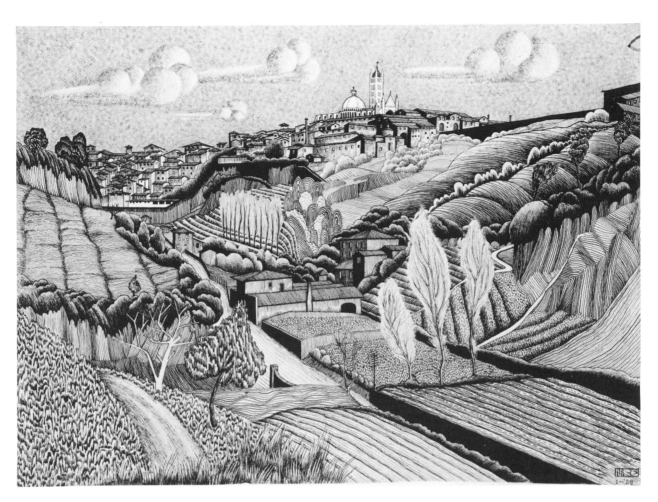

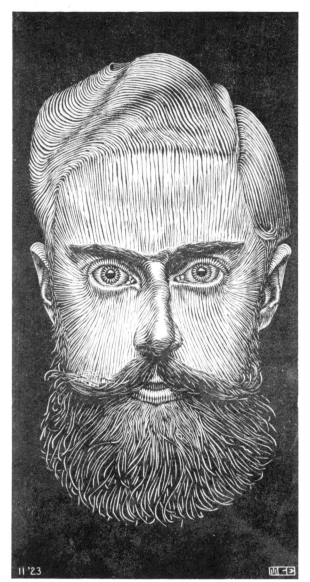

15

16

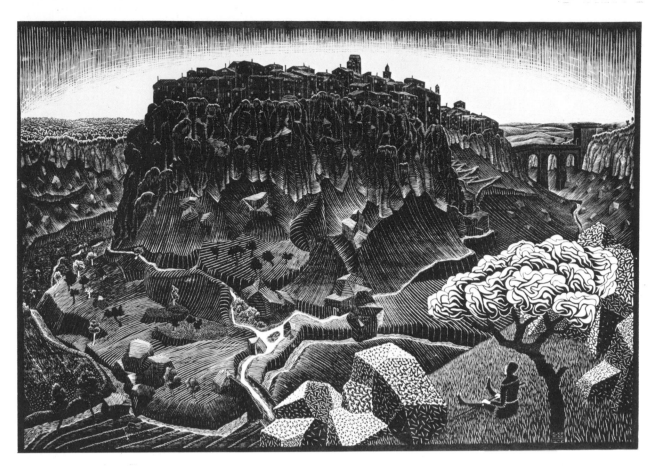

17

18

19

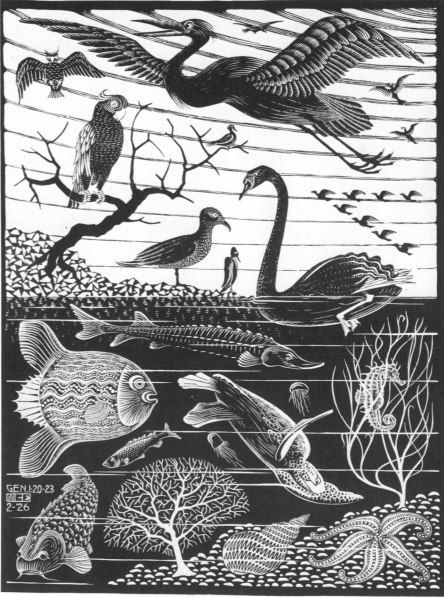

20

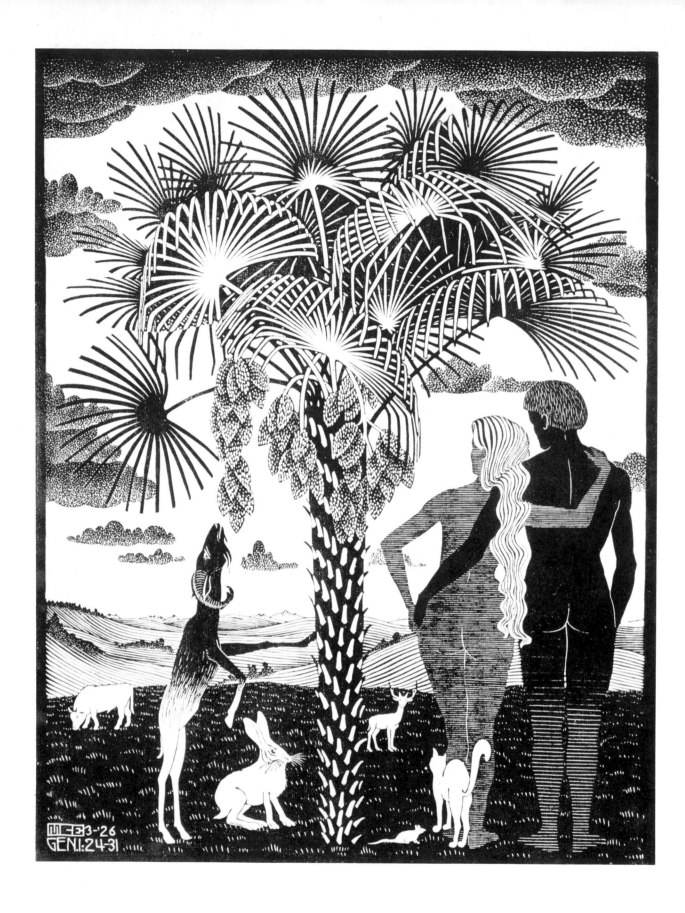

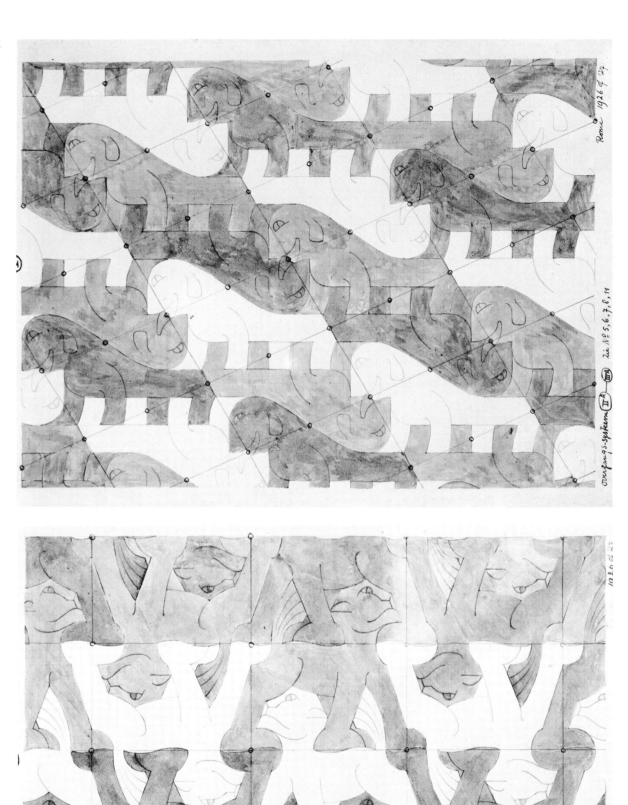

22

23

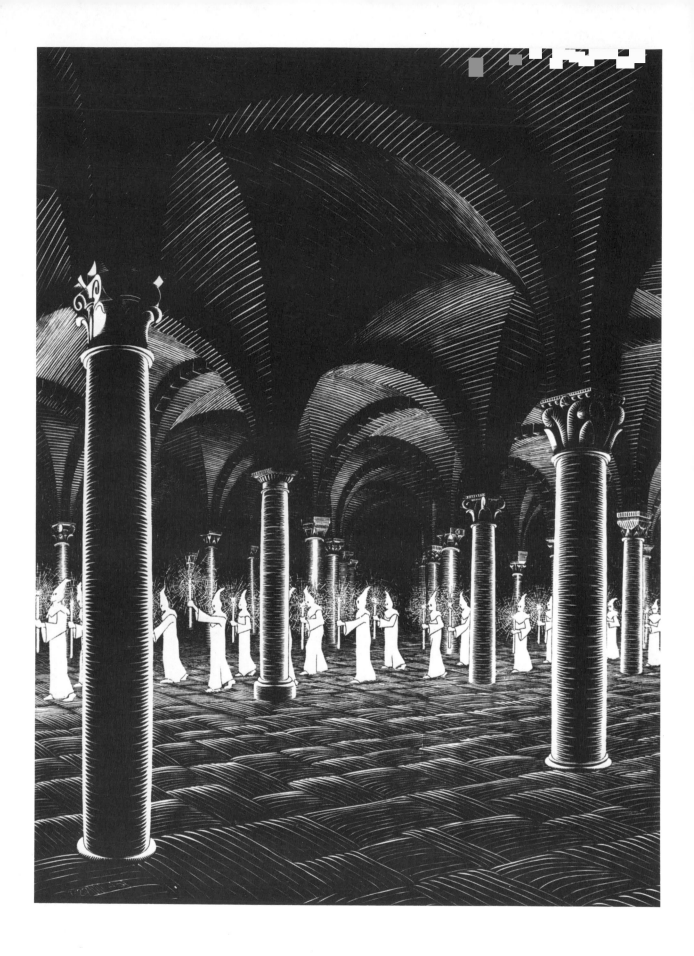

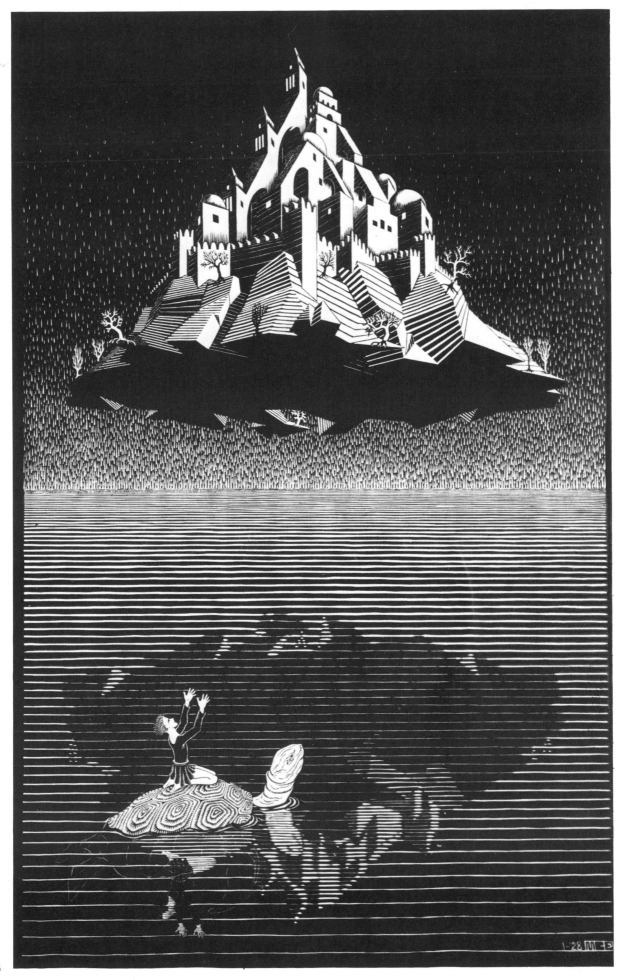

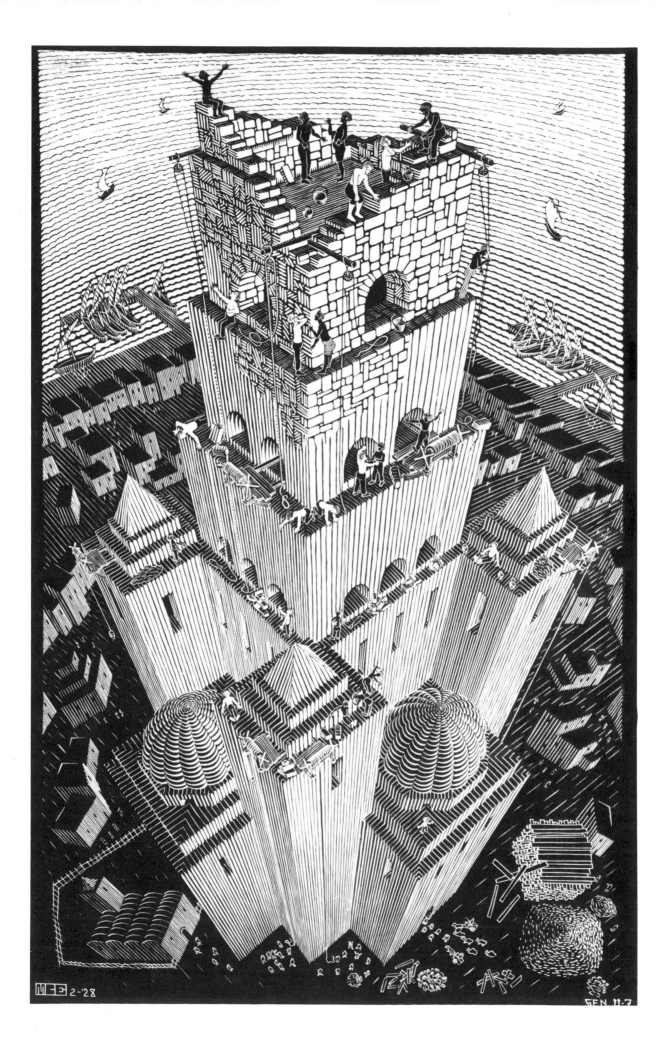

28

29

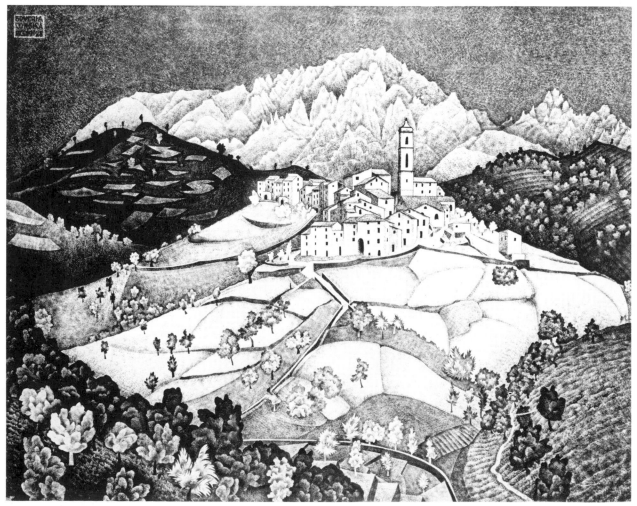

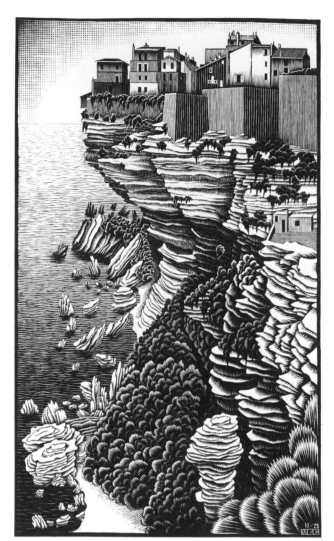

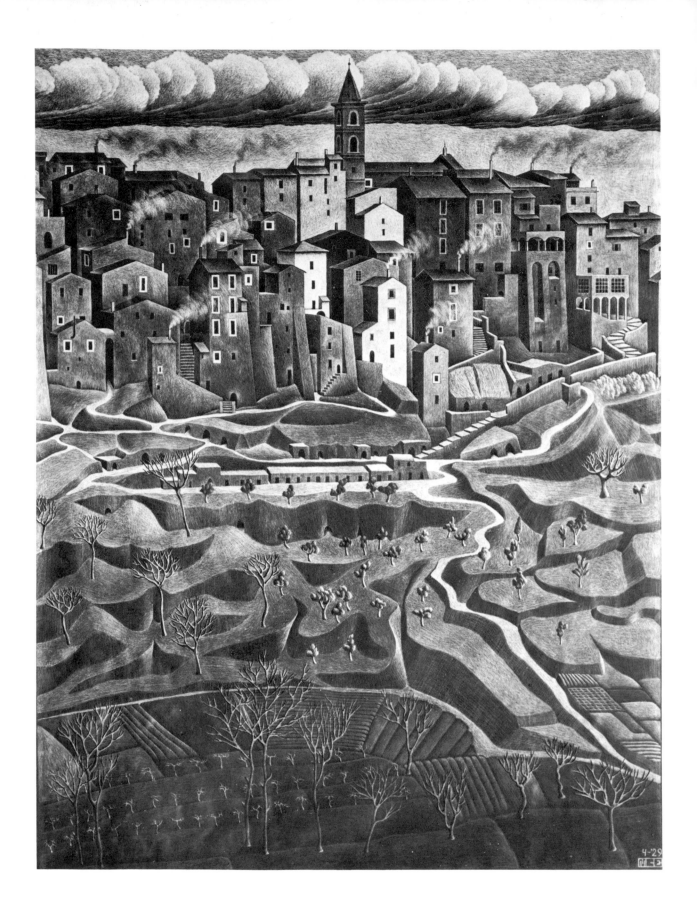

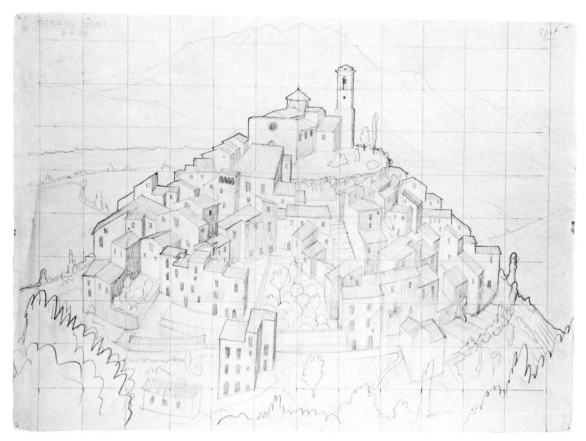

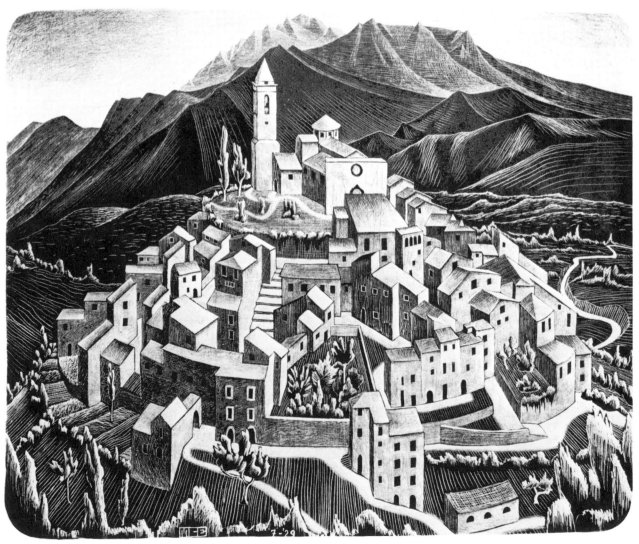

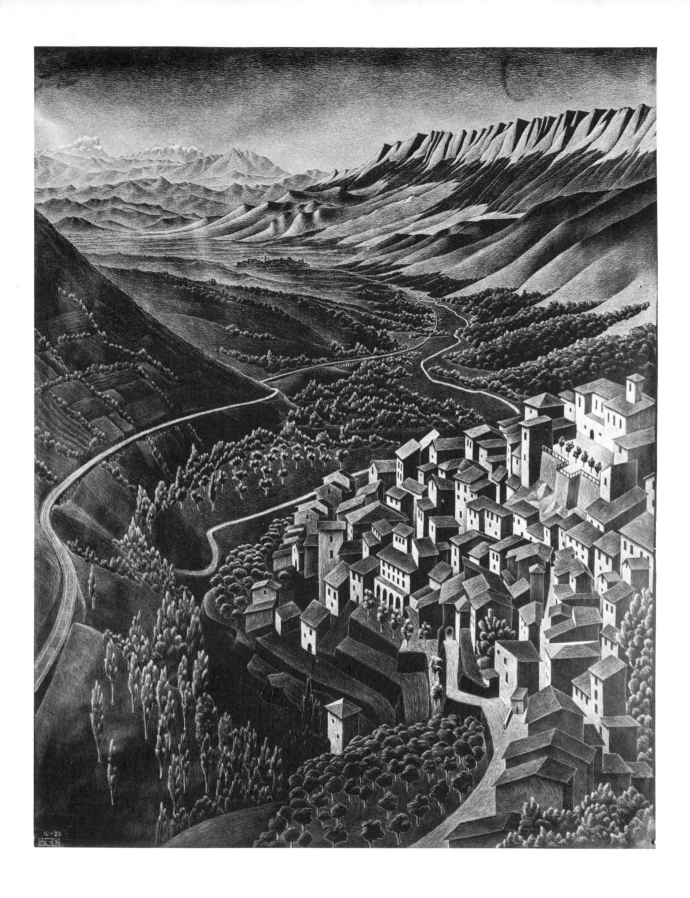

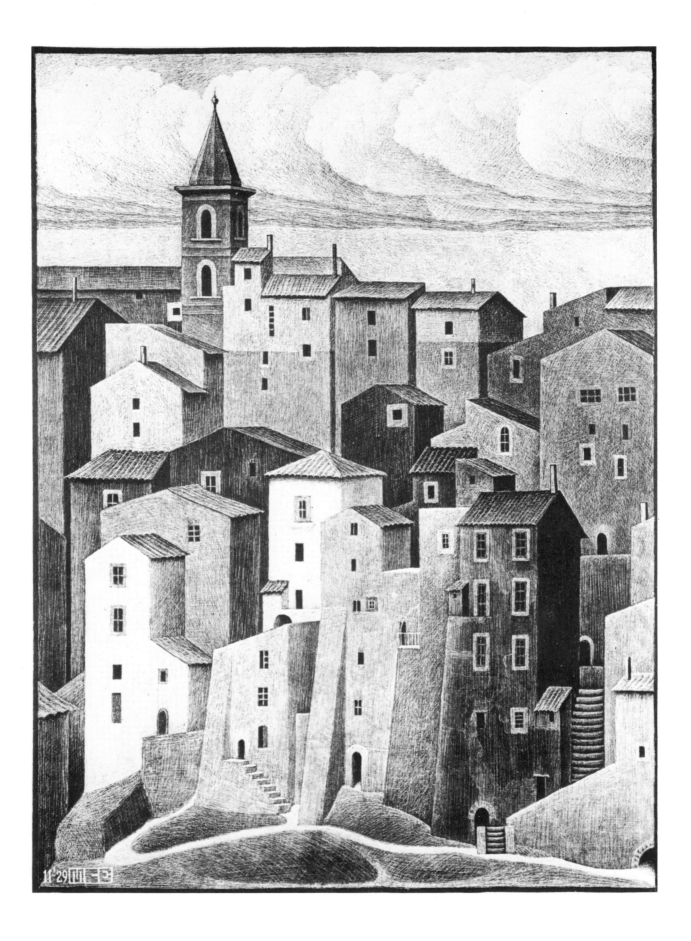

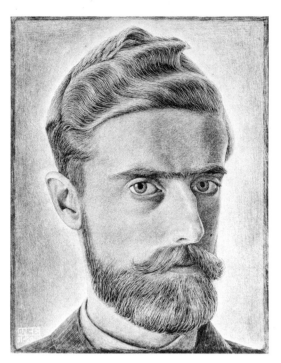

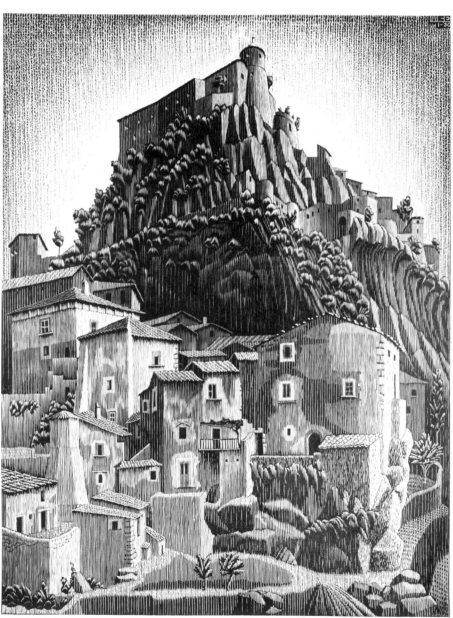

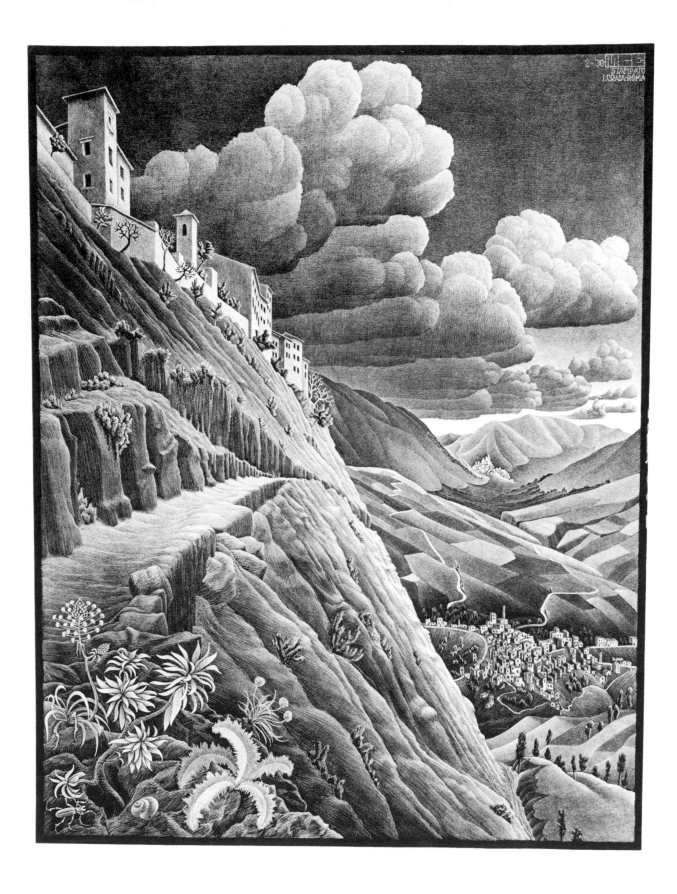

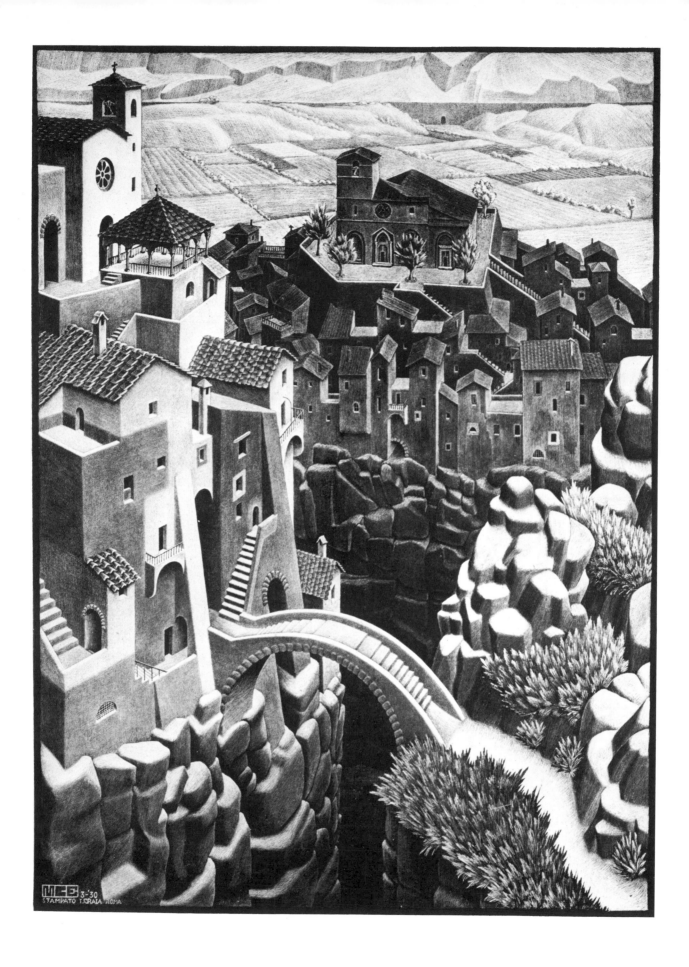

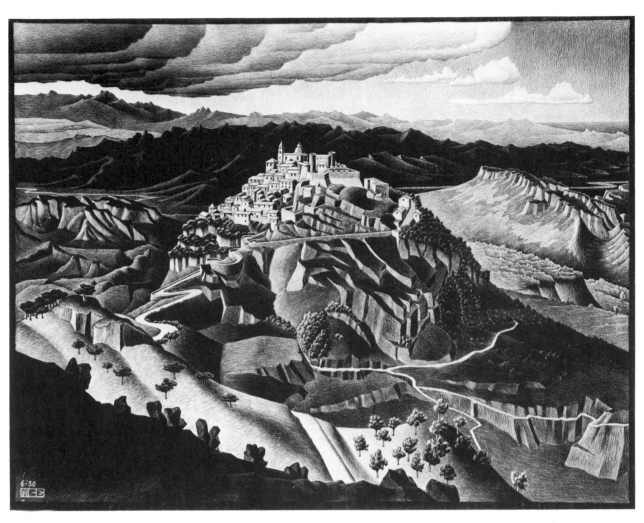

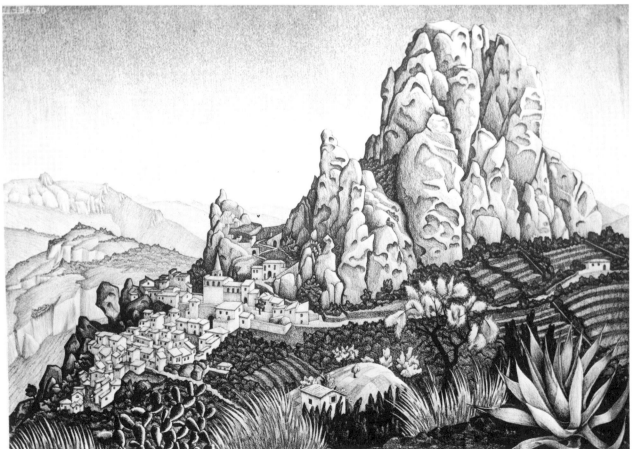

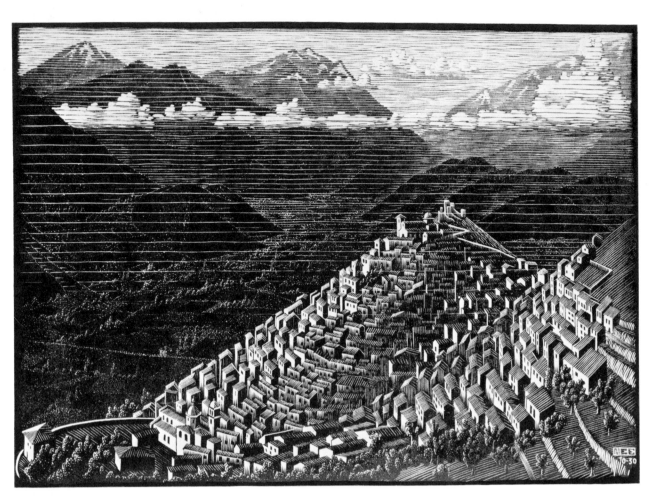

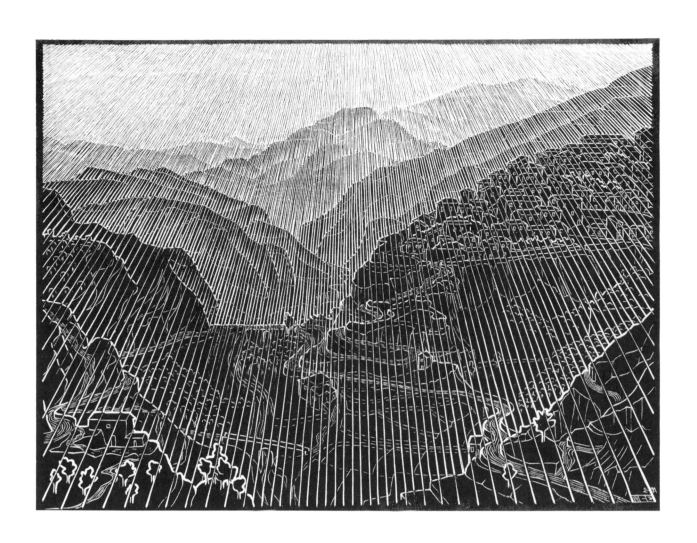

46

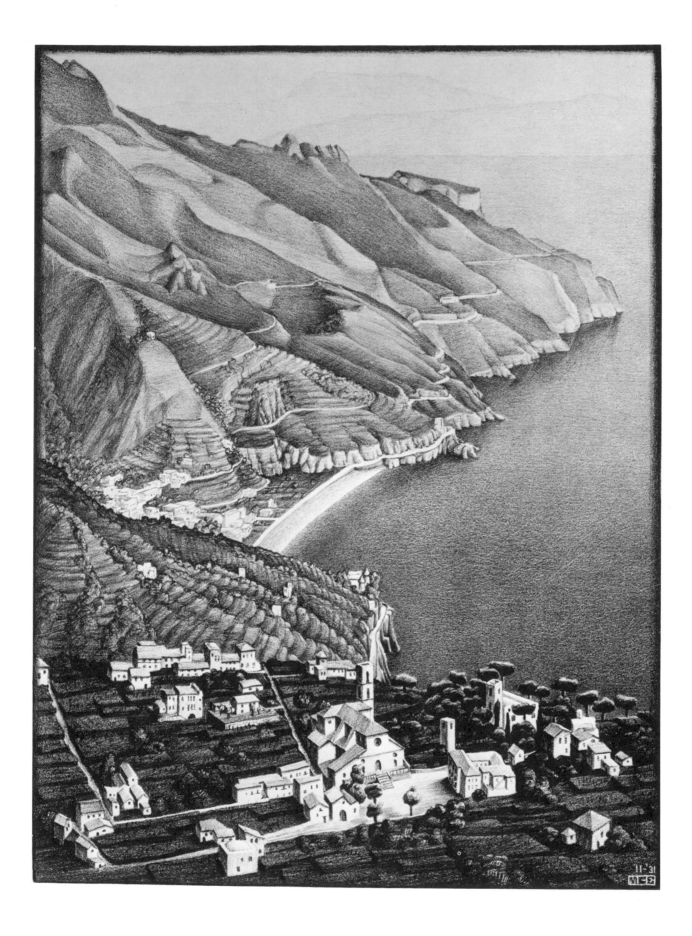

47

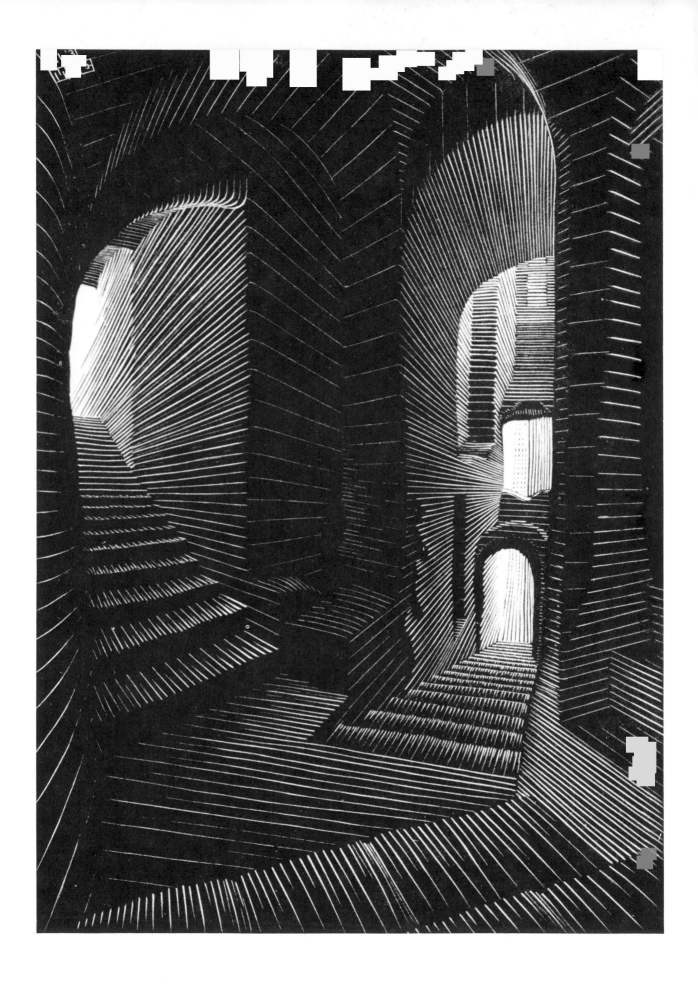

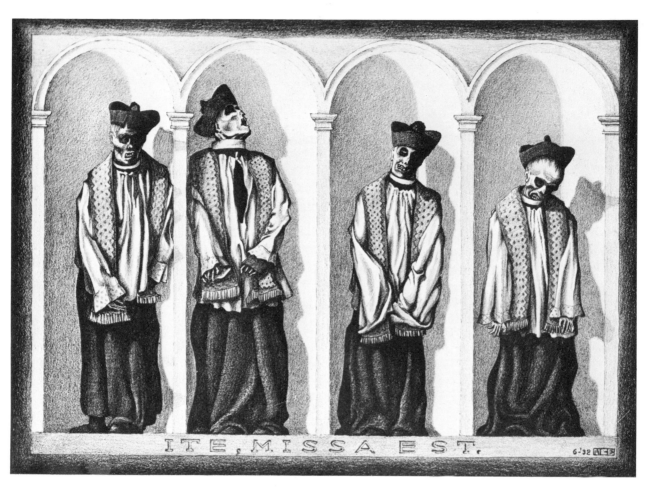

ITE, MISSA EST.

49

50

GAUDENTES·ALIENAM·MIRANTUR·TABEM

U ZIJ BEWUST HETGEEN WIJ DERVEN:
ONS VROEG VERSTERVEN EEN OOGENLUST.

MINIME OPPRESSAE
CONQUIESCUNT VOCES

GIJ HUNKERT NAAR WAT VREUGD
EN NAAR VERSTOMD GEZANG?
DE ACCOORDEN UWER JEUGD
WEERKLINKEN EEUWEN LANG!

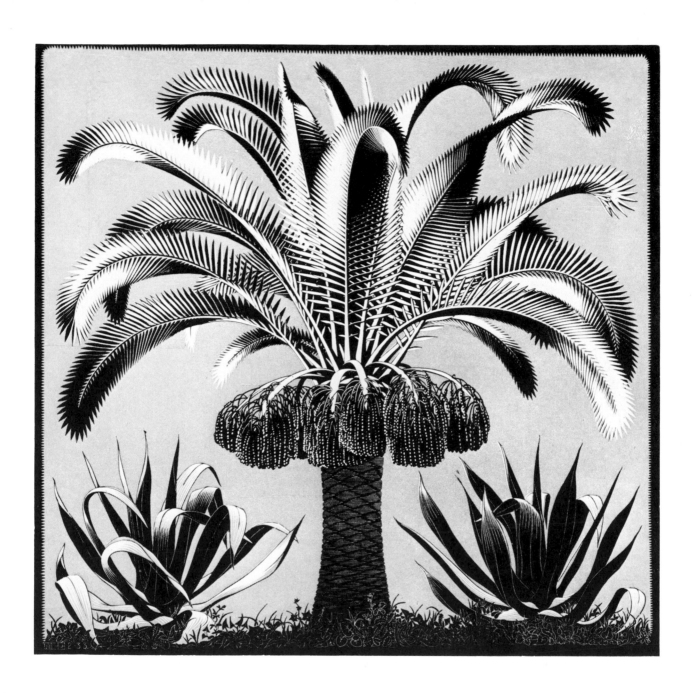

54

55

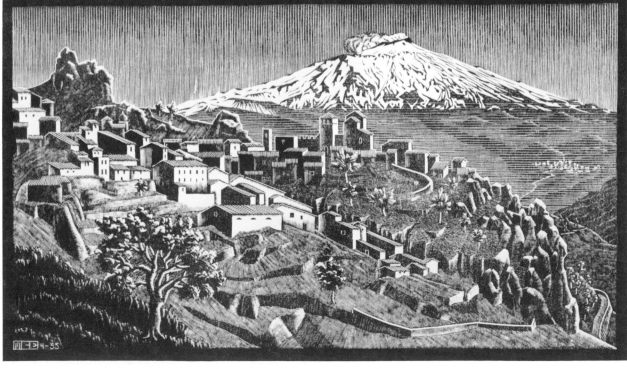

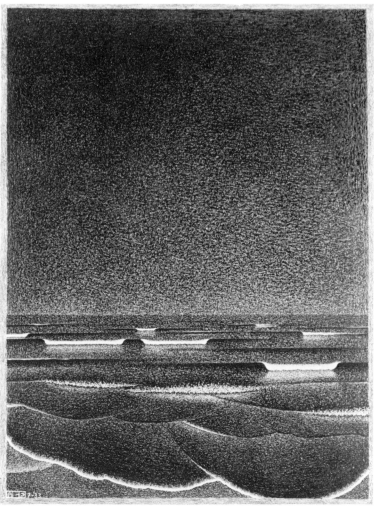

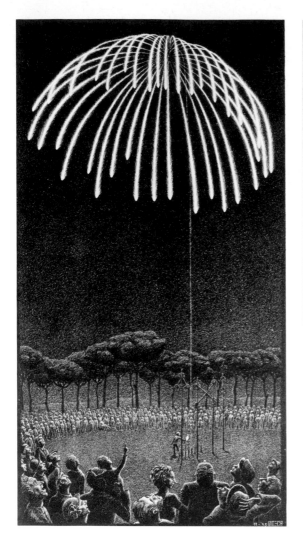

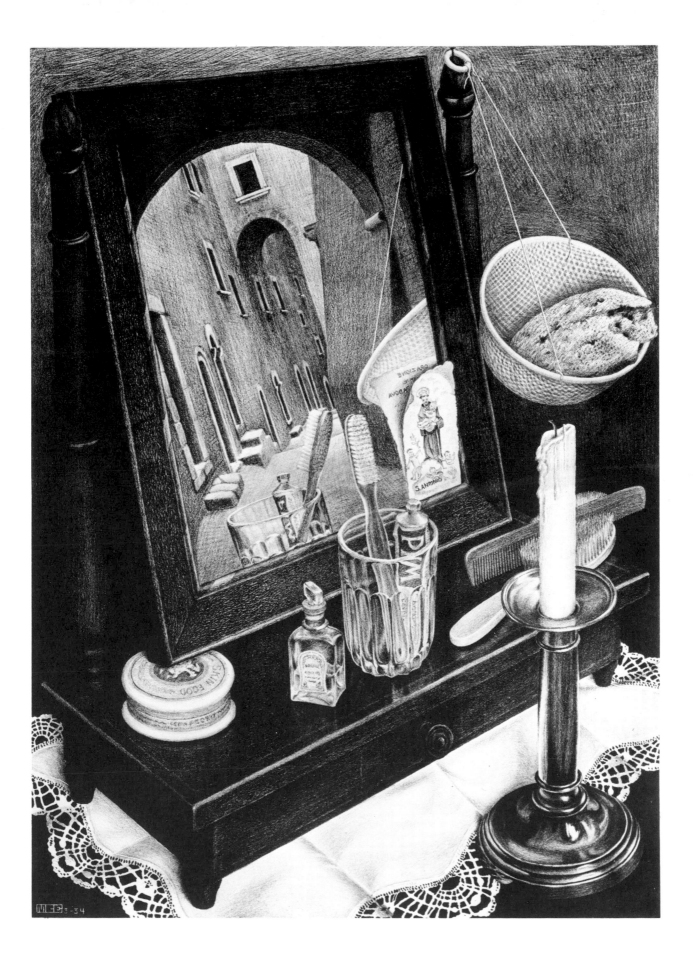

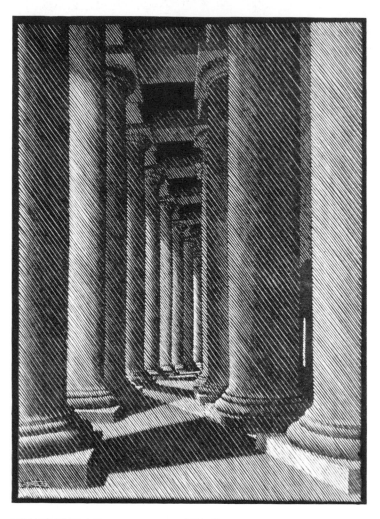

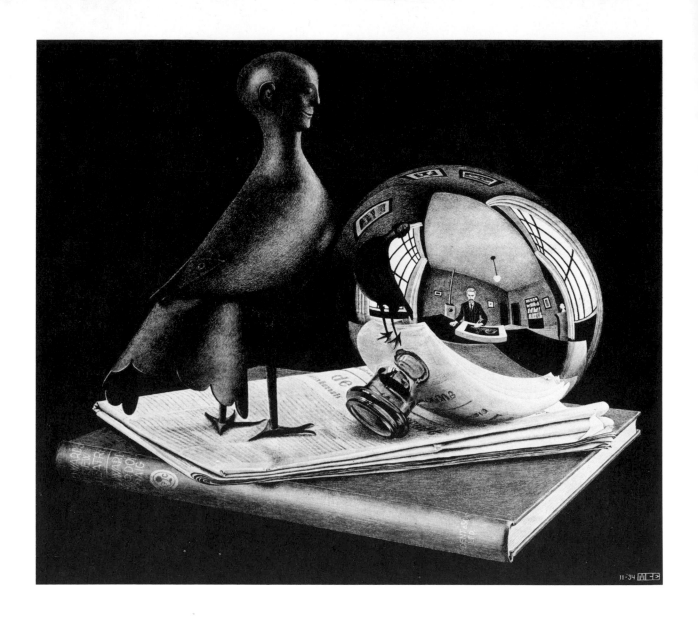

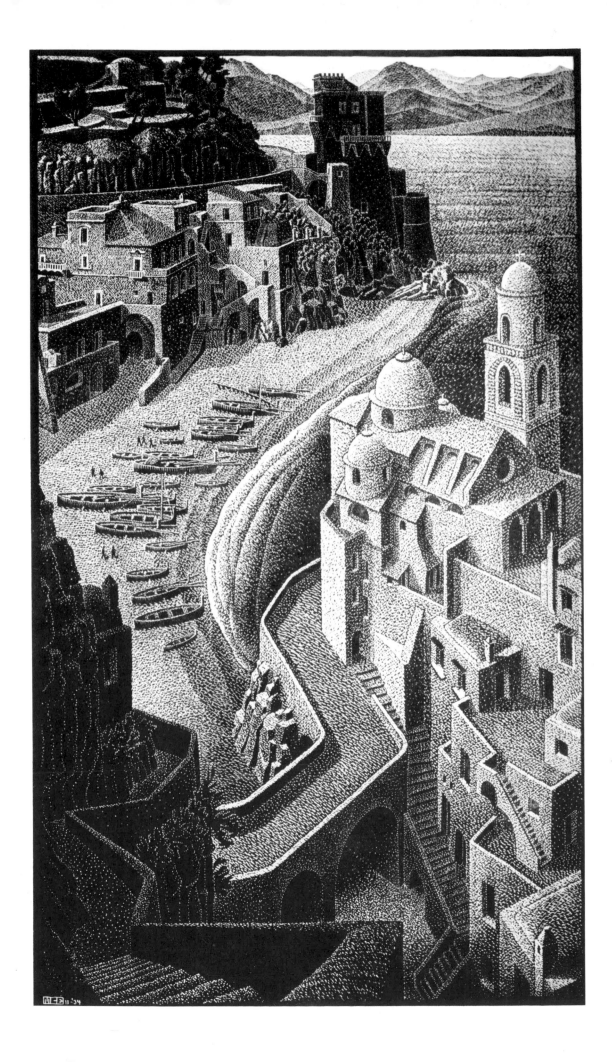

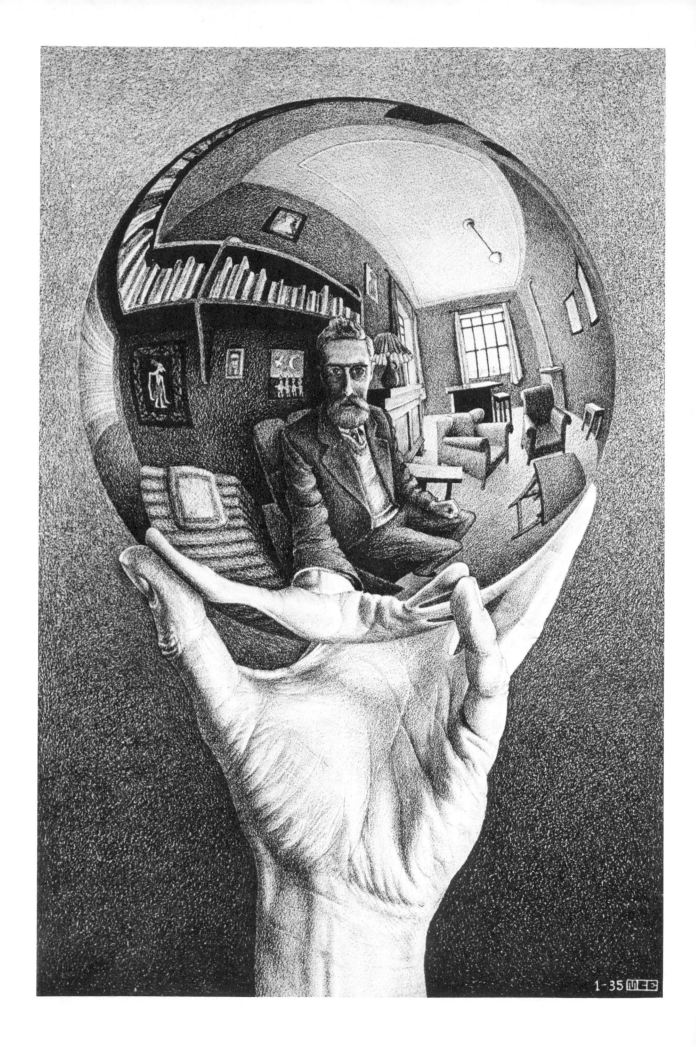

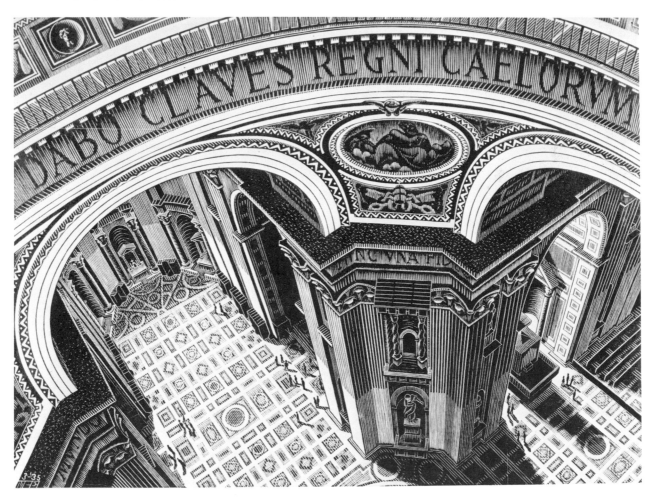

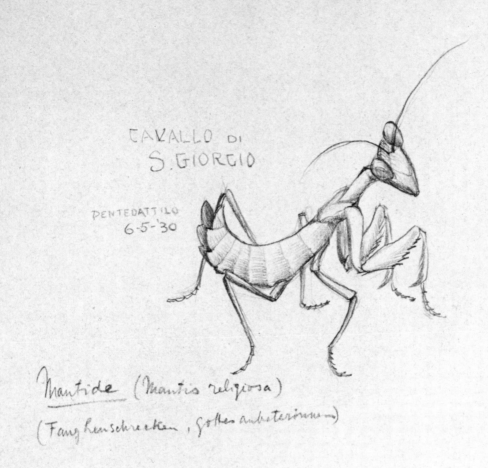

CAVALLO DI
S. GIORGIO

PENTEDATTILO
6-5-'30

Mantide (Mantis religiosa)
(Fangheuschrecken, Gottes anbeterinnen)

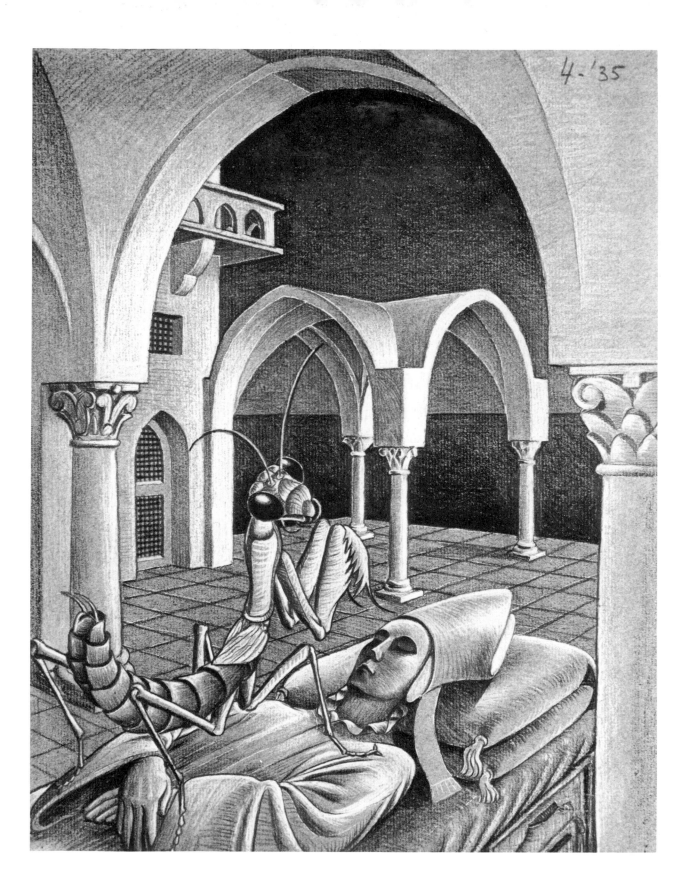

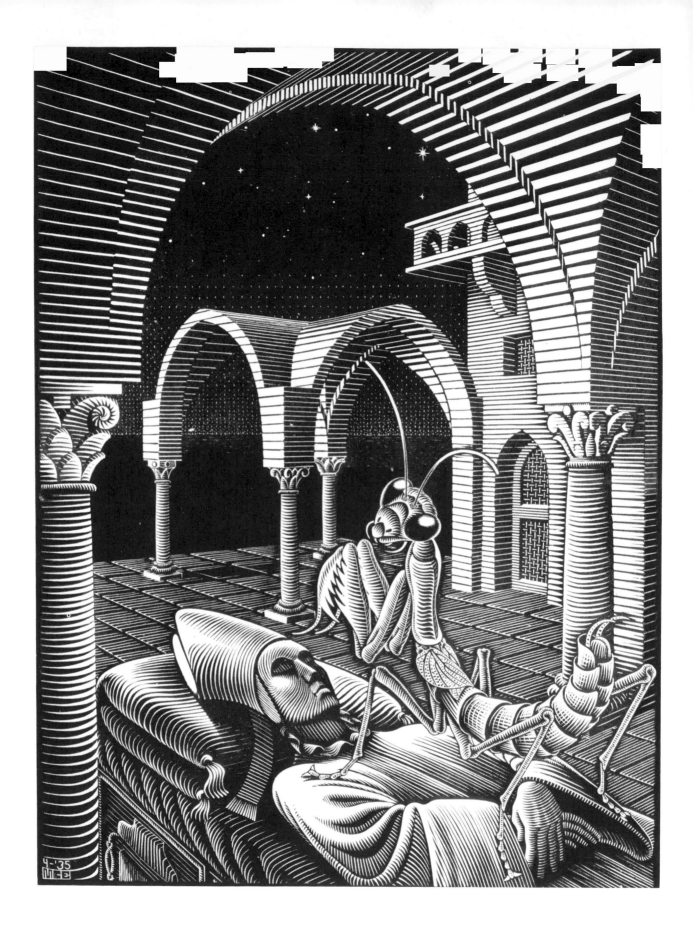

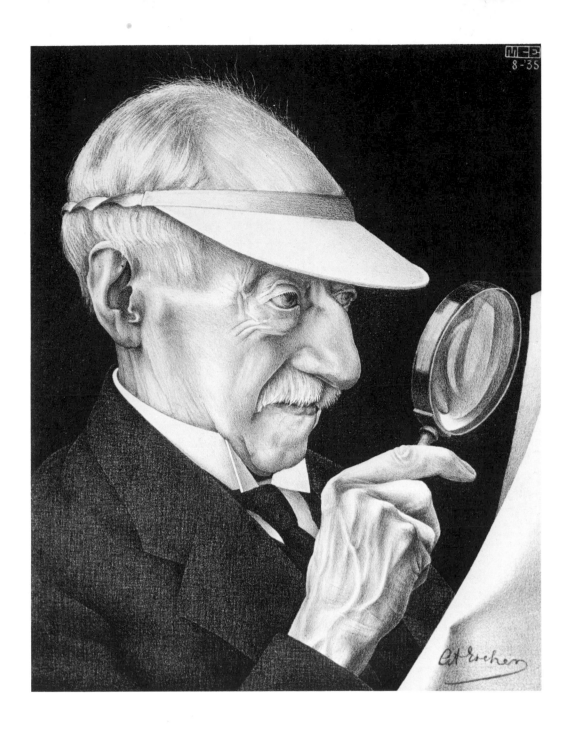

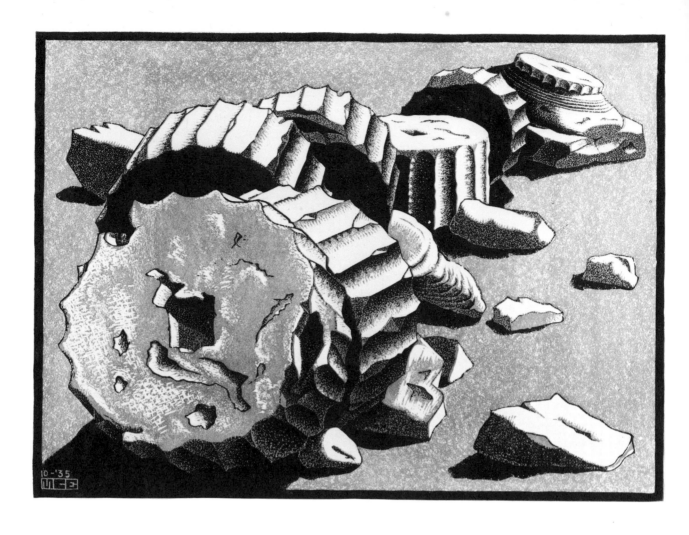

78

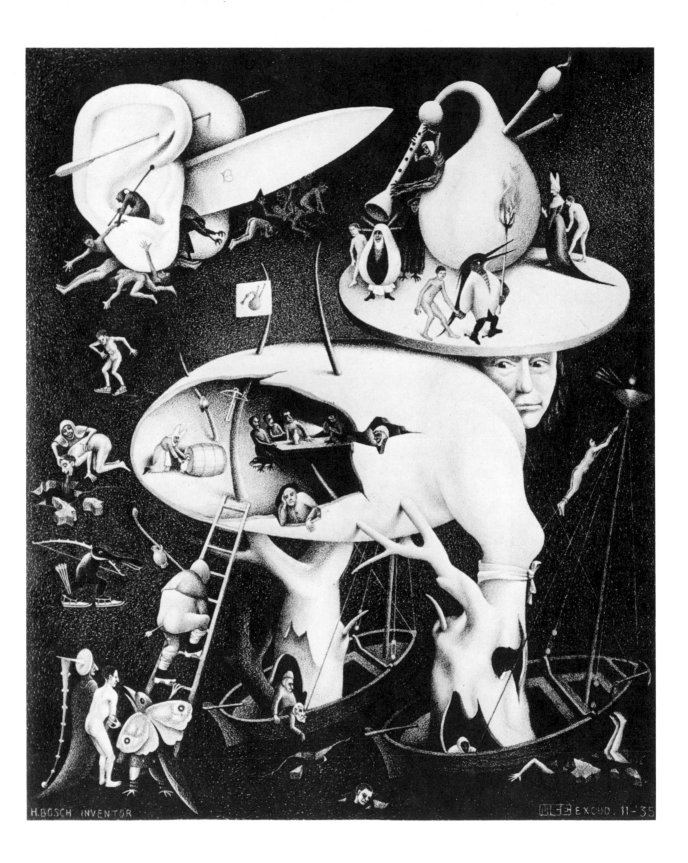

H.BOSCH INVENTOR

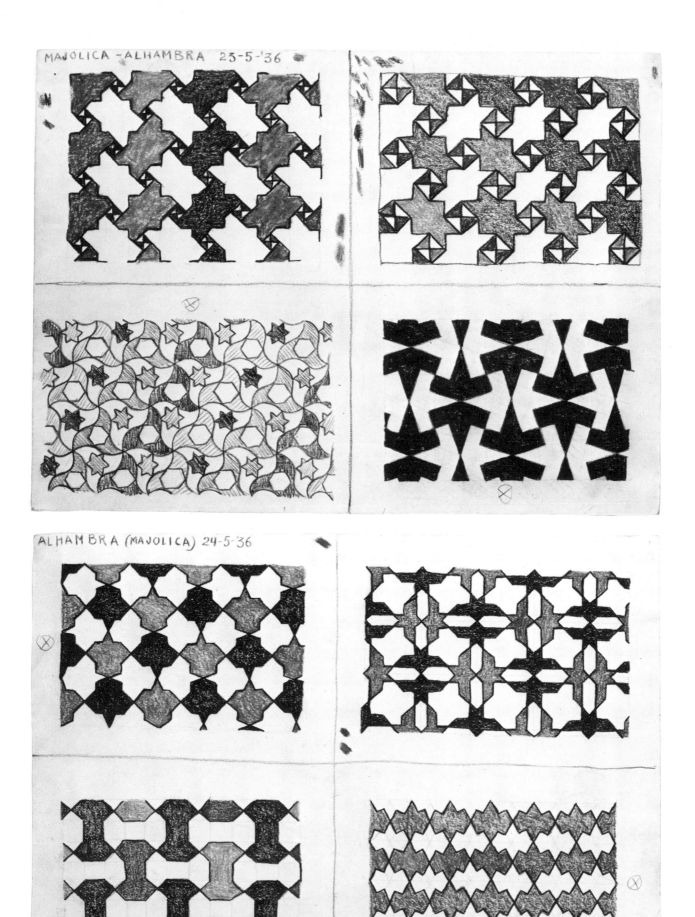

MAJOLICA - ALHAMBRA 23-5-'36

ALHAMBRA (MAJOLICA) 24-5-'36

MAJOLICA - ALHAMBRA 23-5-36

ALHAMBRA 26-5-'36 (STUC)

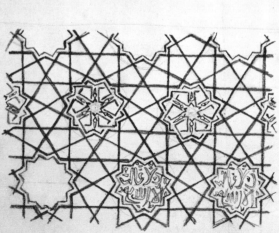

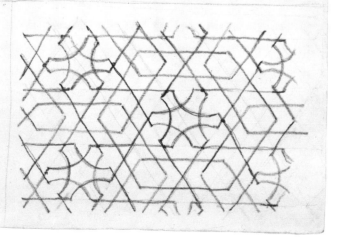

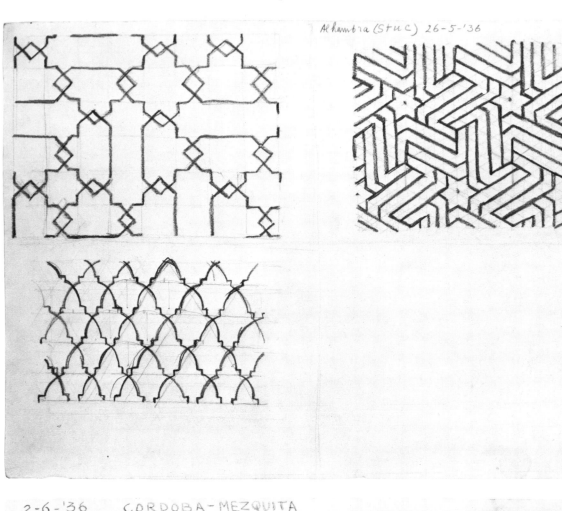

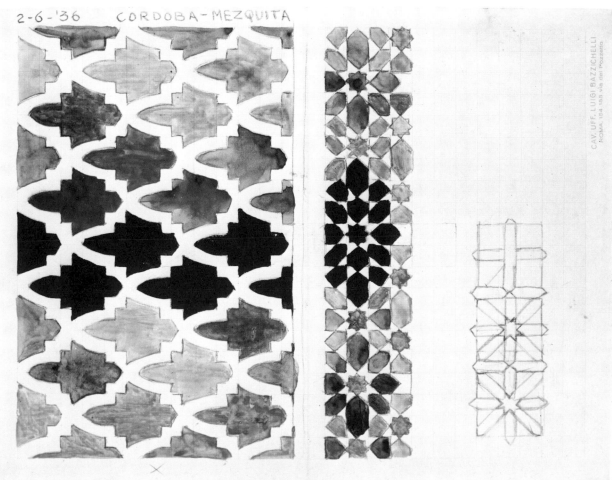

2-6-'36 CORDOBA - MEZQUITA

CAV. UFF. LUIGI BAZZICHELLI
ROMA, 104-105 via del Pozzetto

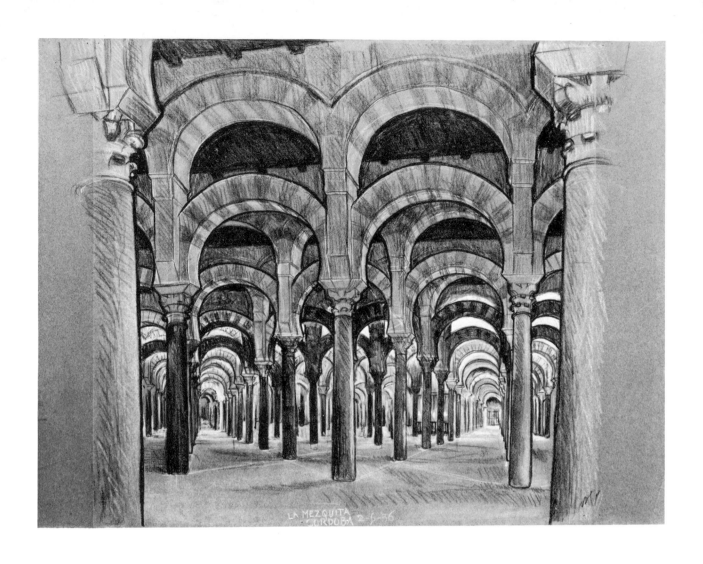

LA MEZQUITA
CORDOBA 2 6 36

89

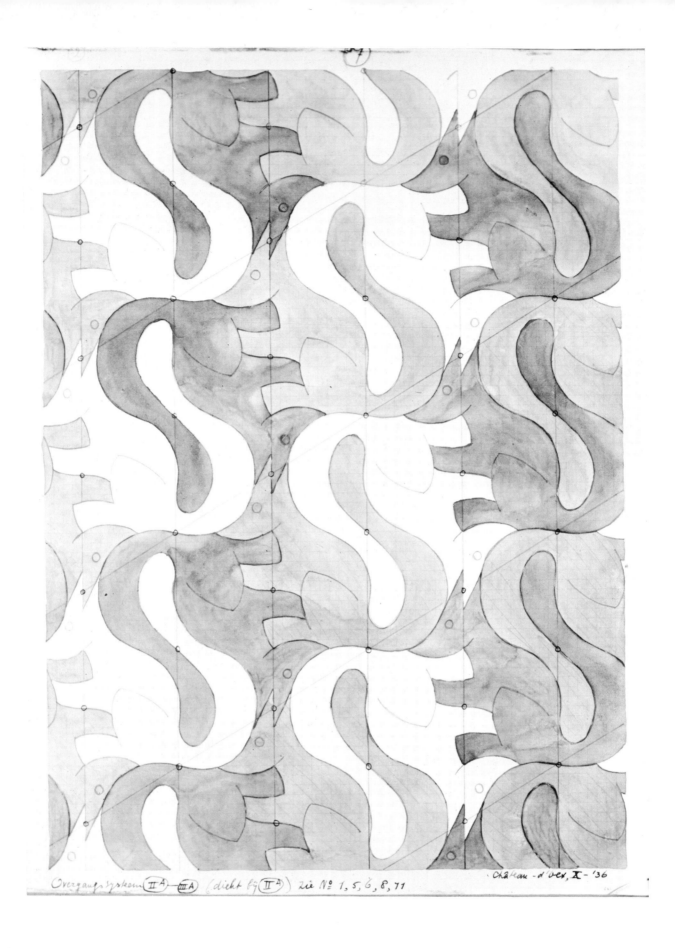

Overgangssysteem (II A)—(III A) (dicht bij (II A)) zie N° 1, 5, 6, 8, 11

Château-d'œx, X - '36

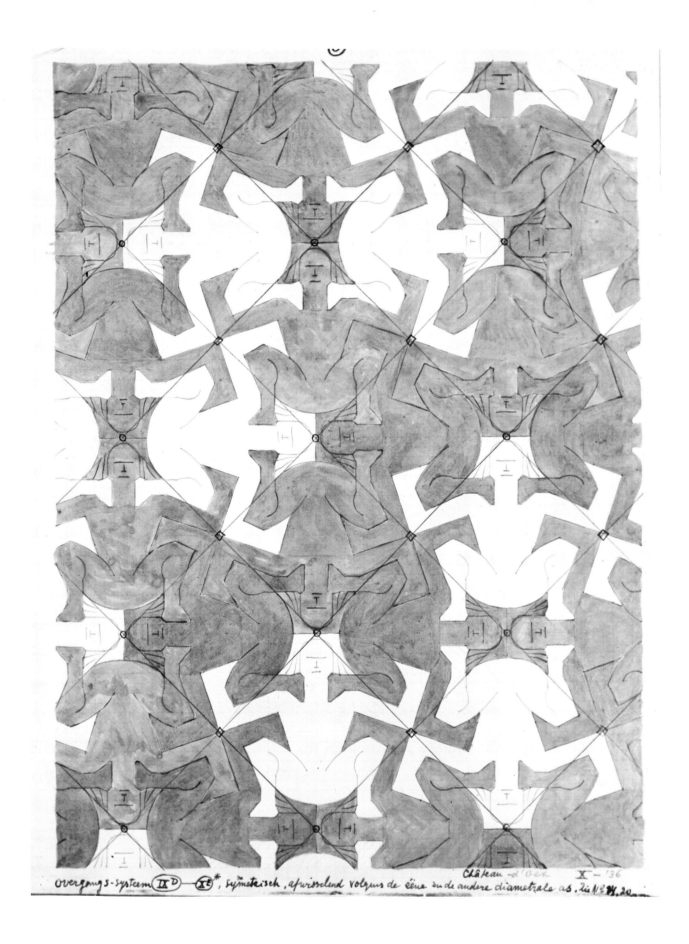

Overgangs-systeem ⅡD — ⅩE*, symmetrisch, afwisselend volgens de ёёne en de andere diametrale as. Zie N? ❦. 20

Château-d'Oex X – '36

SAVONA 10-6-'36

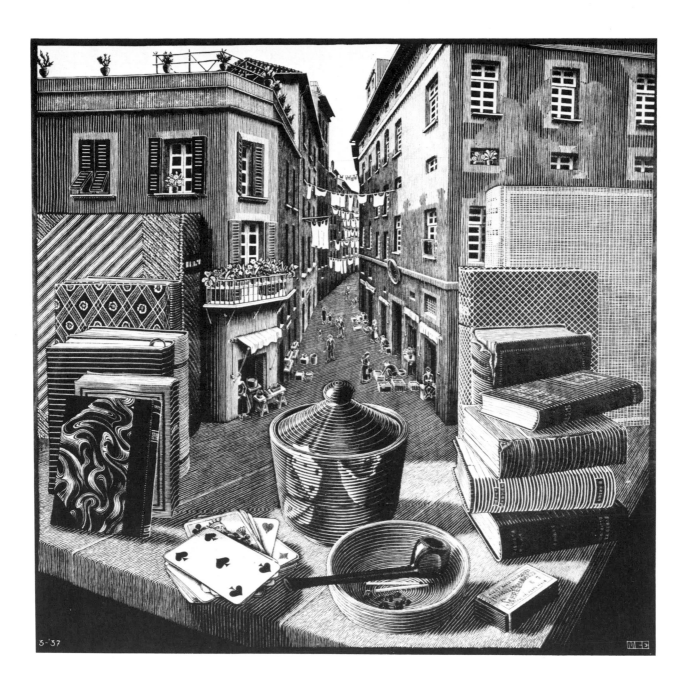

dreihoek Systeem I A3 type 1* Château-d'Oex X - '36

98

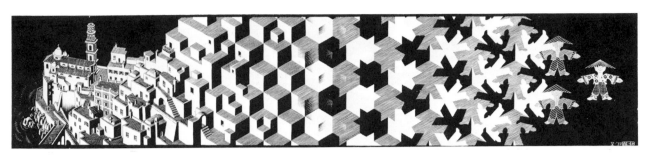

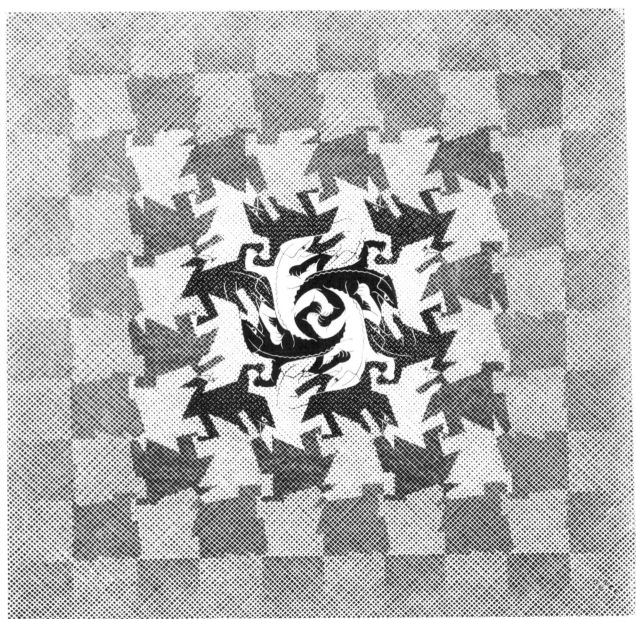

18

Mkkl, II-'38

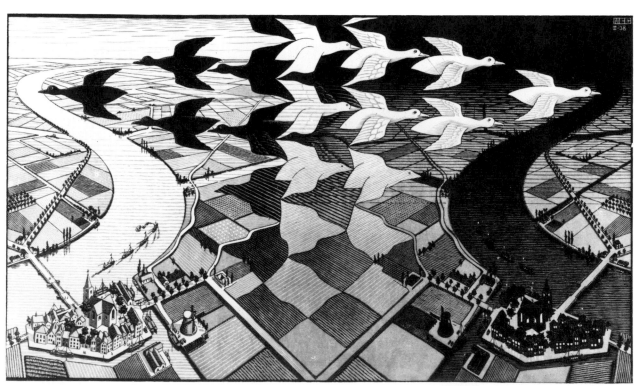

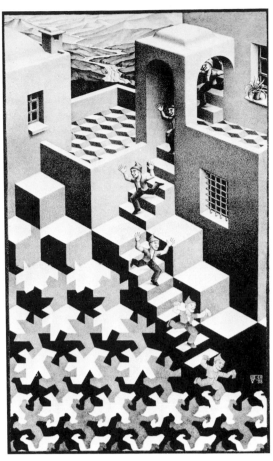

103

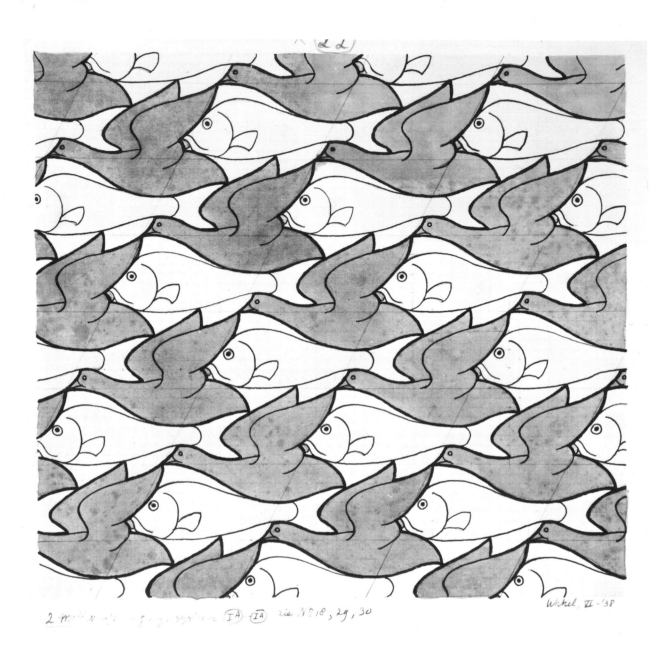

2 motieven's (IA) (IA) zie N° 18, 29, 30 Uccel, VI -'38

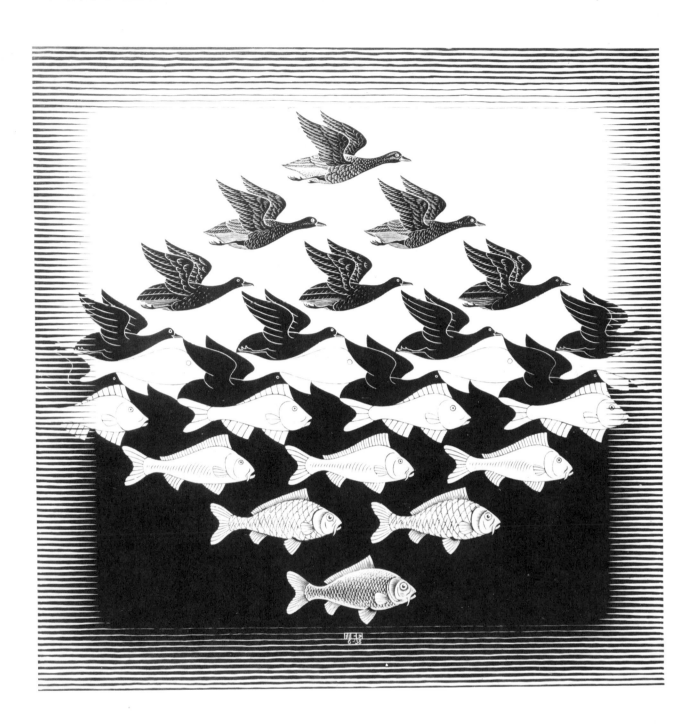

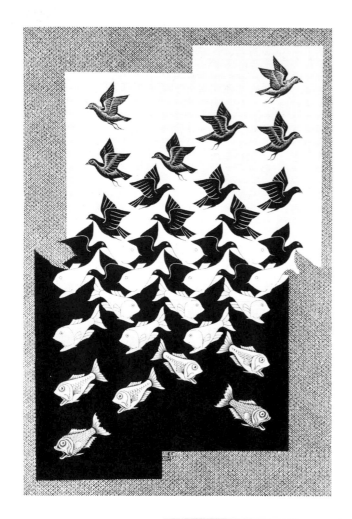

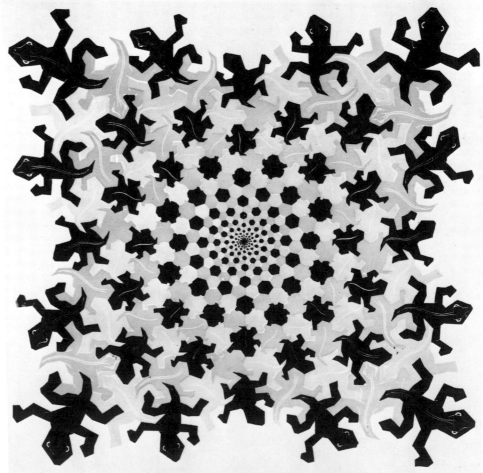

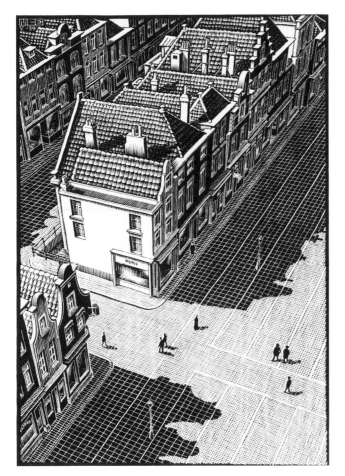

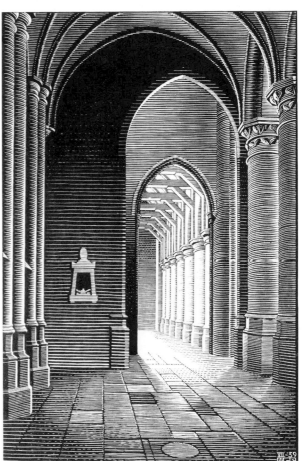

109

110

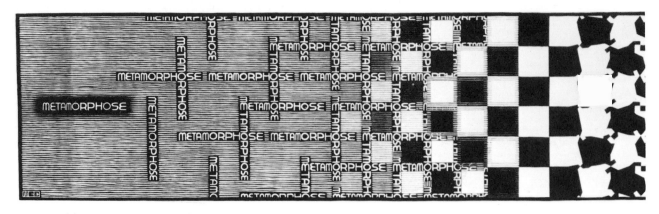

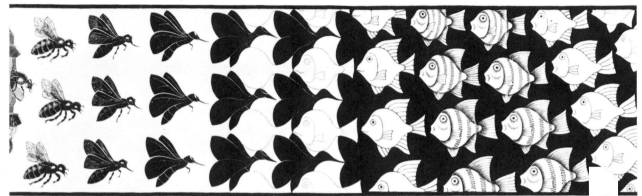

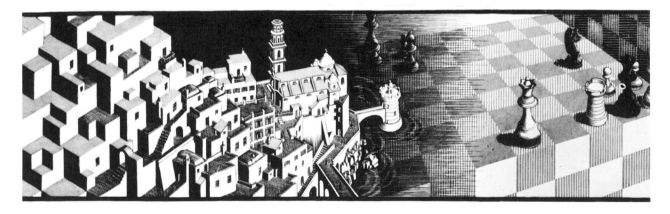

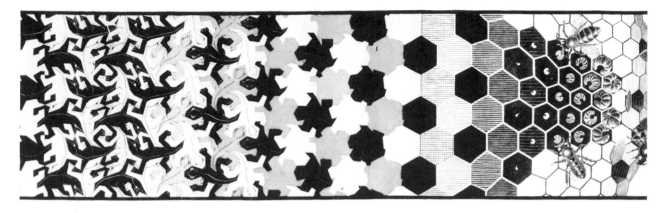

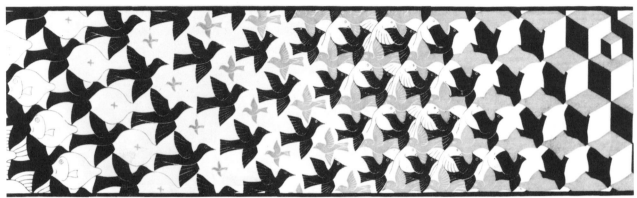

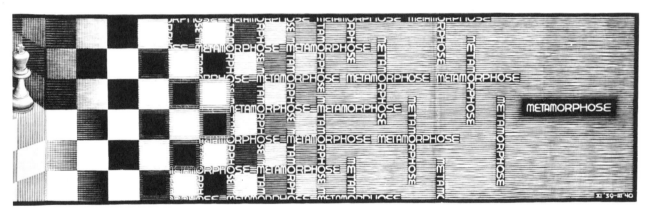

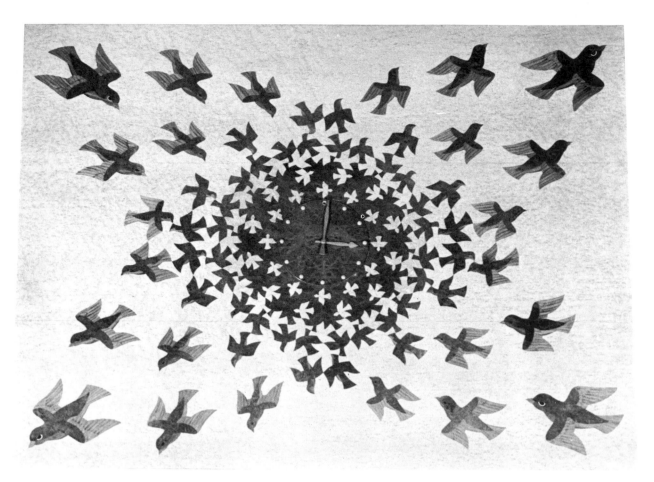

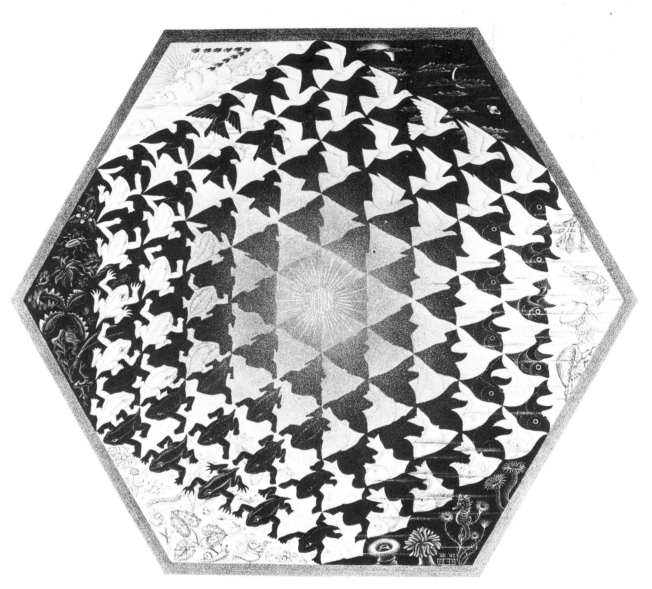

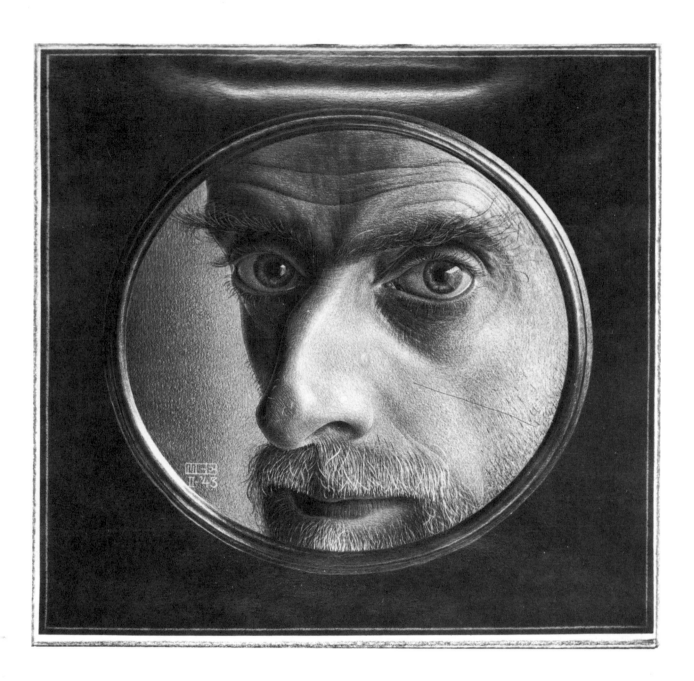

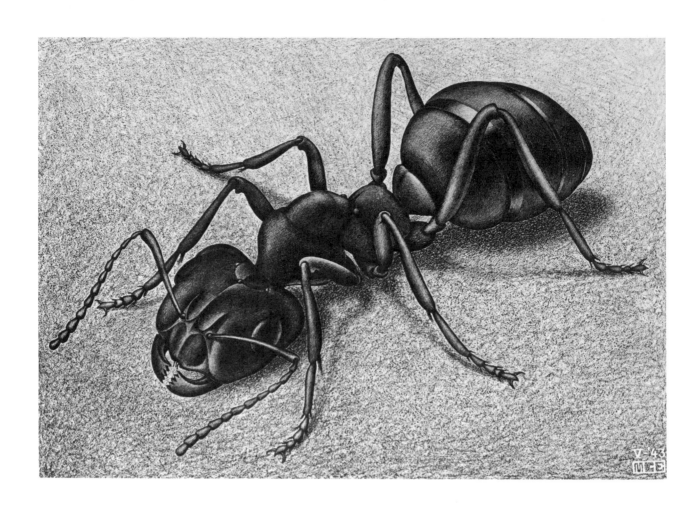

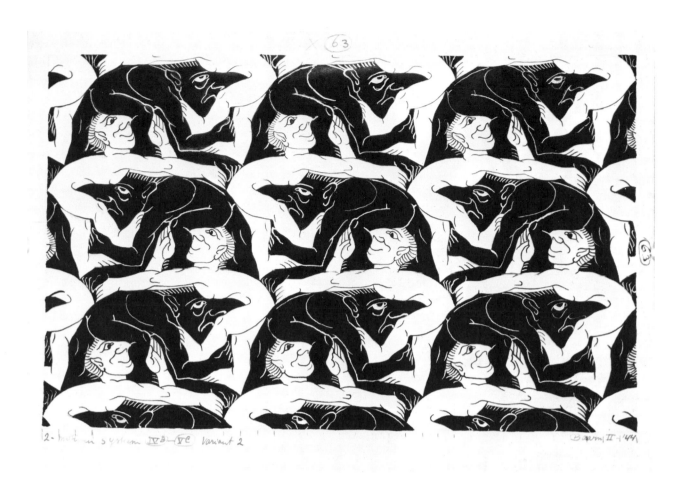

2-huit in systeem IV⁴/IV ⁵ Variant 2 Baarn II '44

122

123

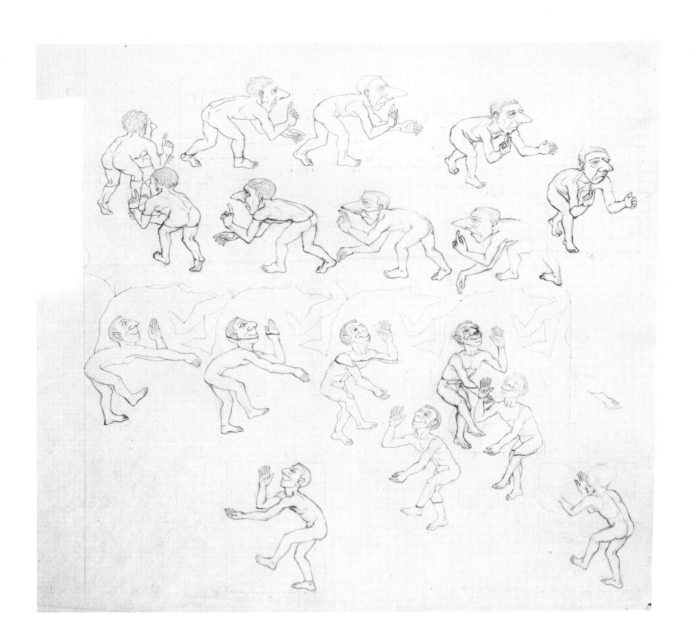

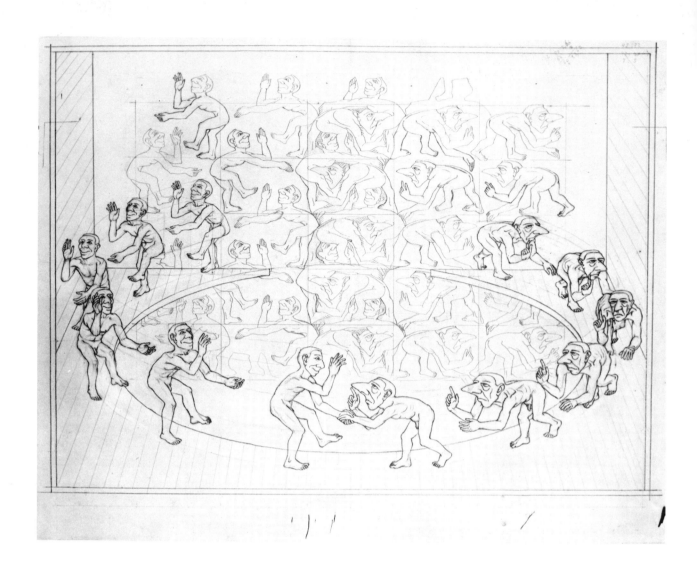

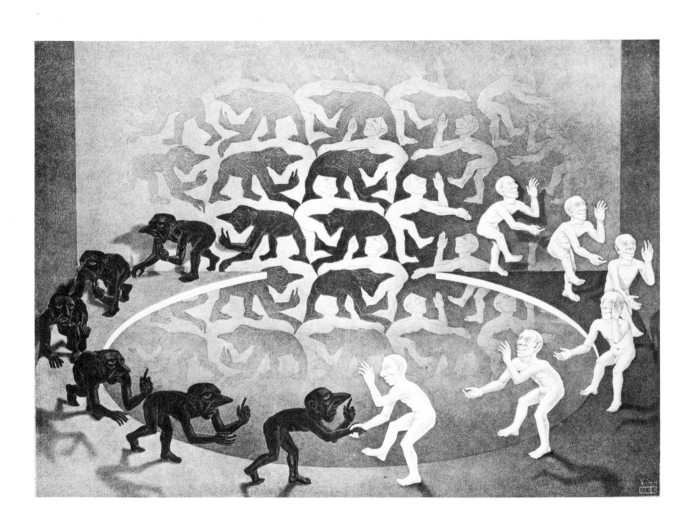

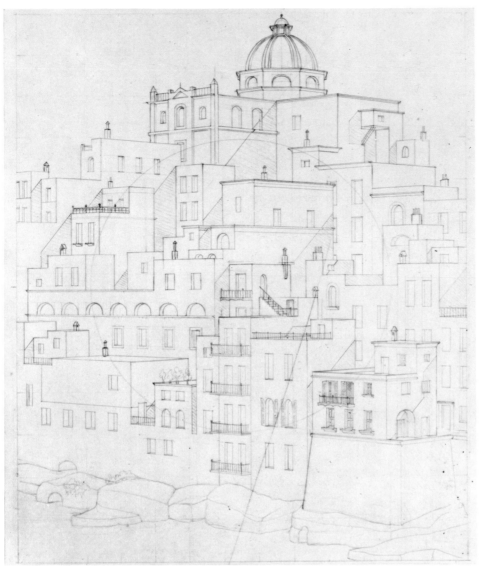

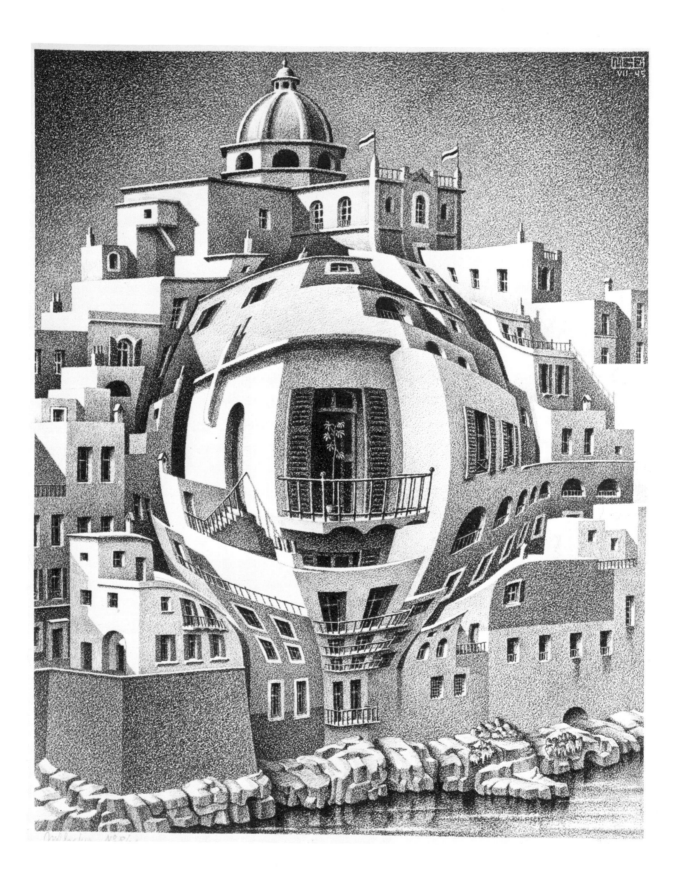

131

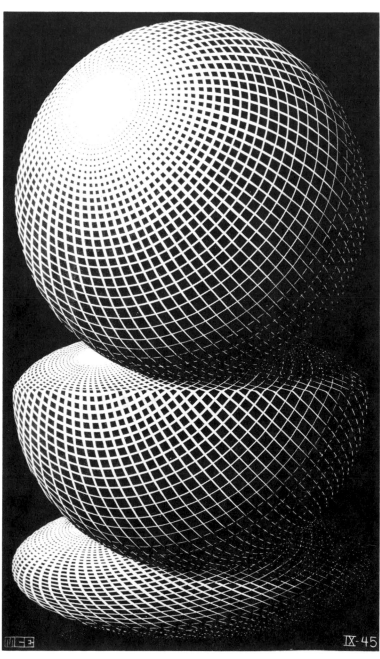

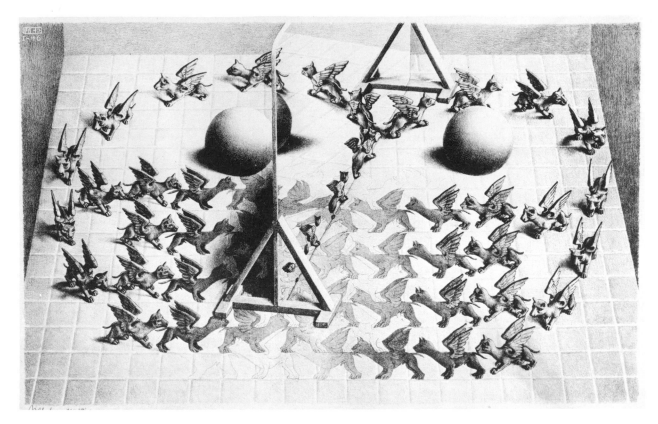

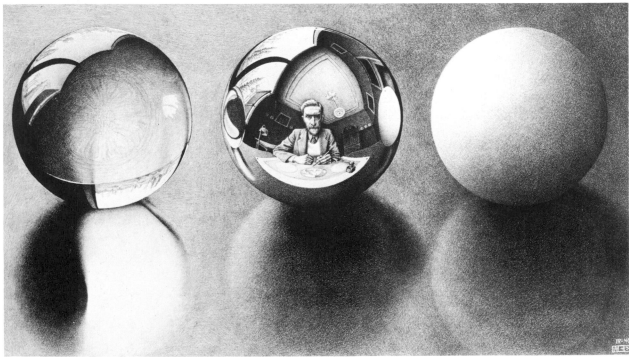

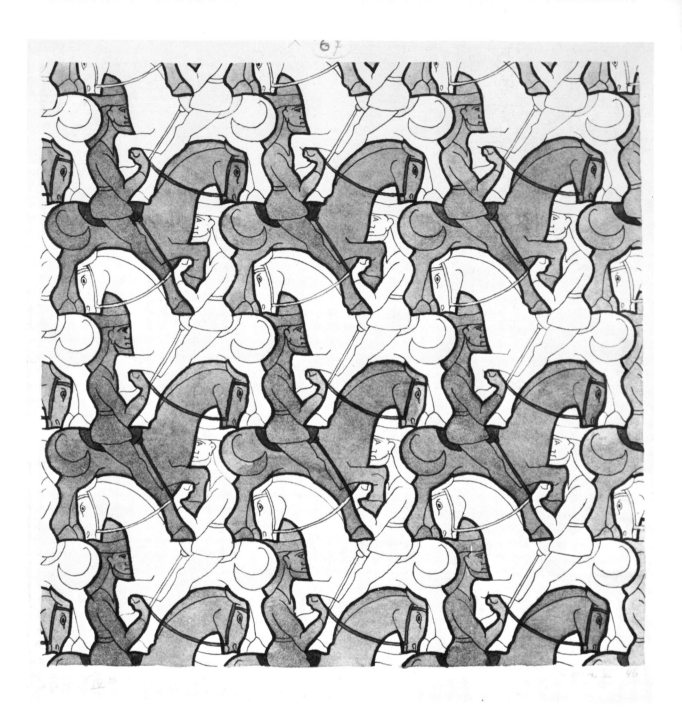

137

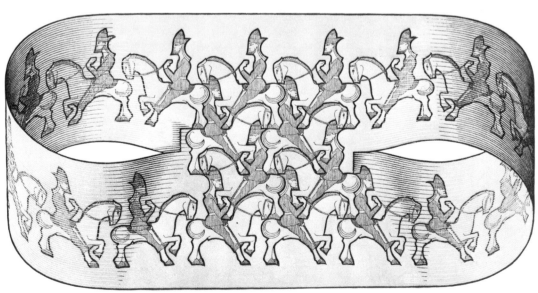

138

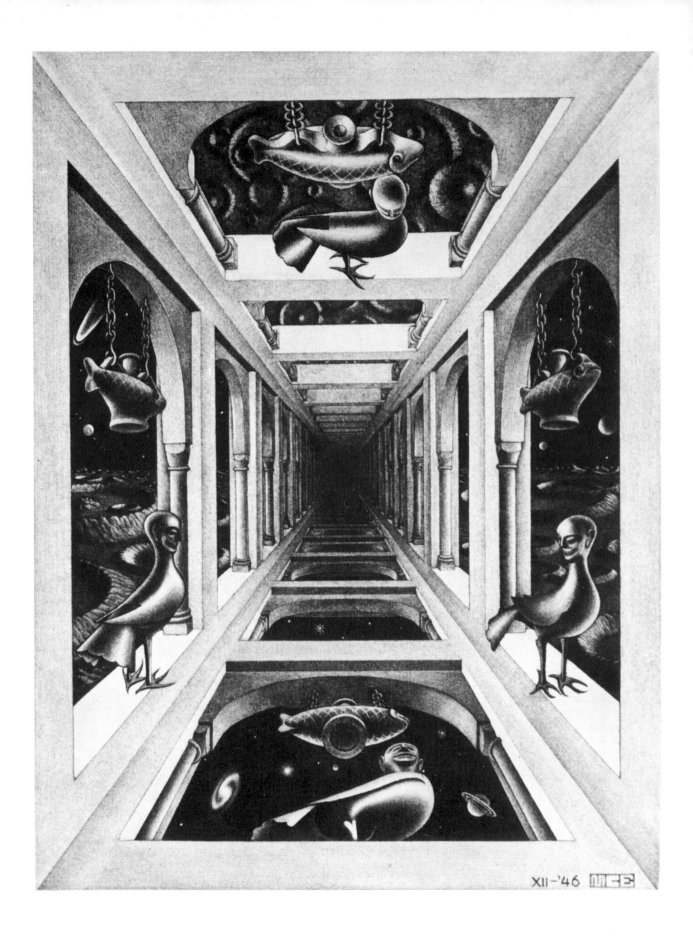

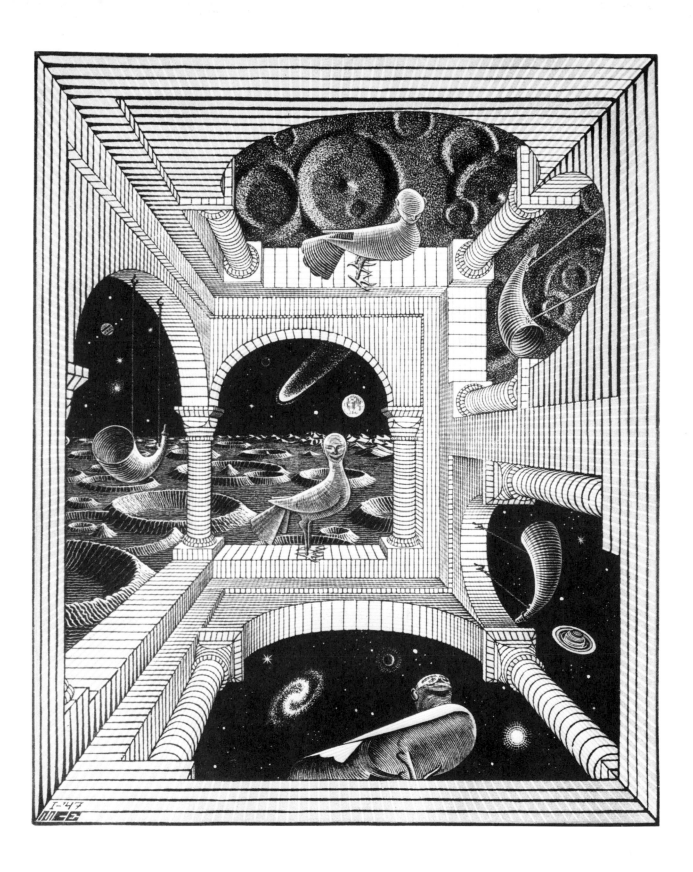

142

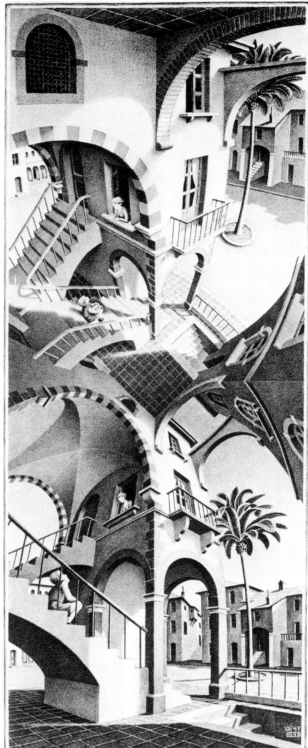

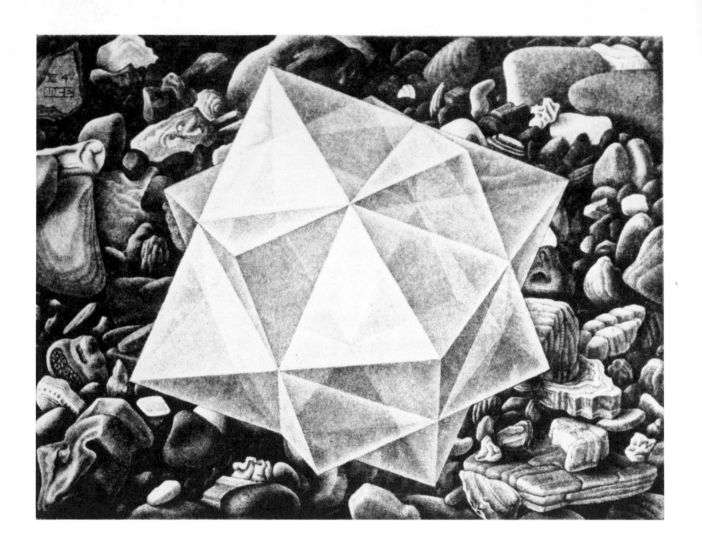

147

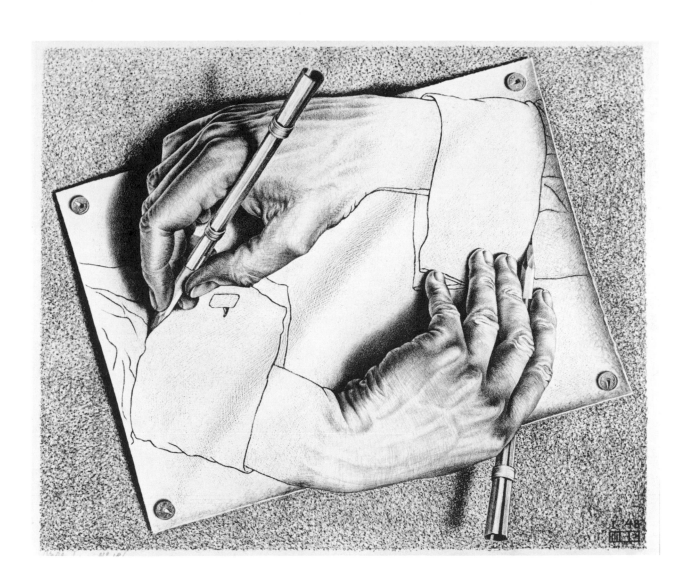

150

152

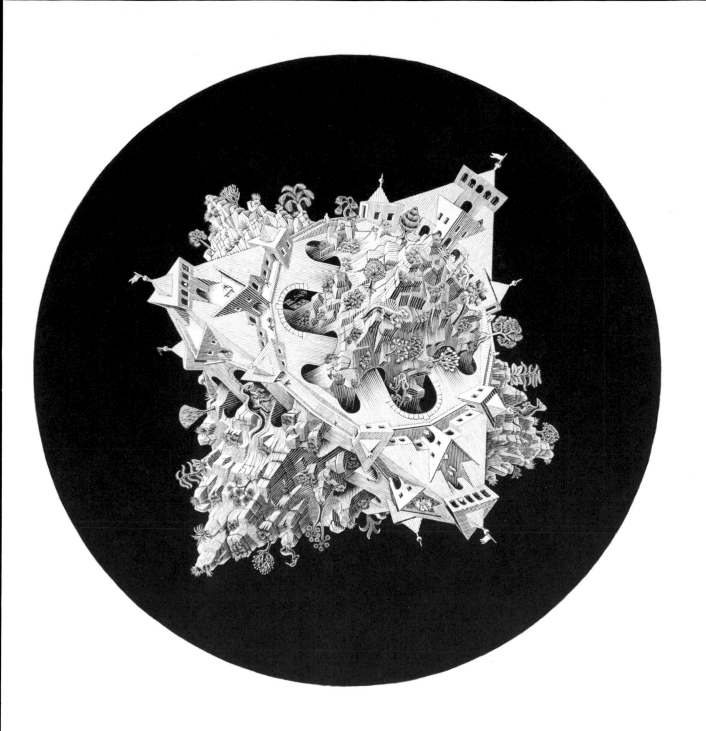

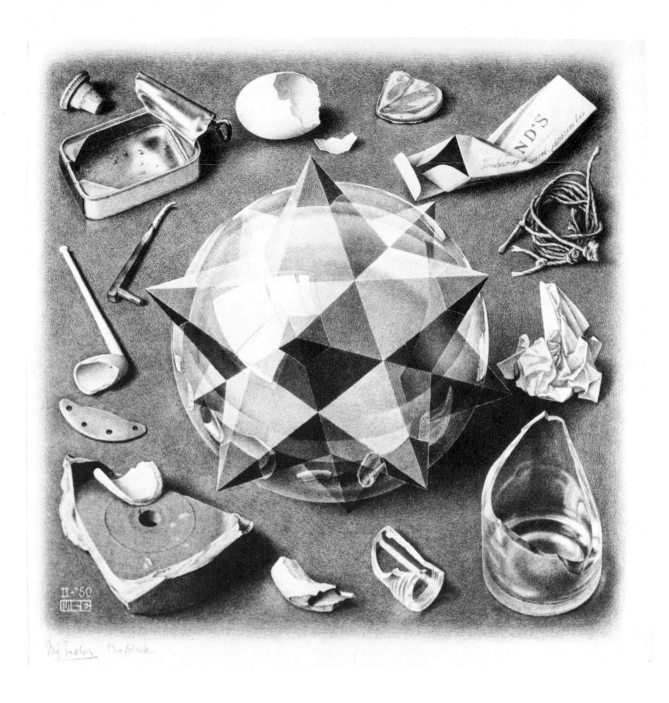

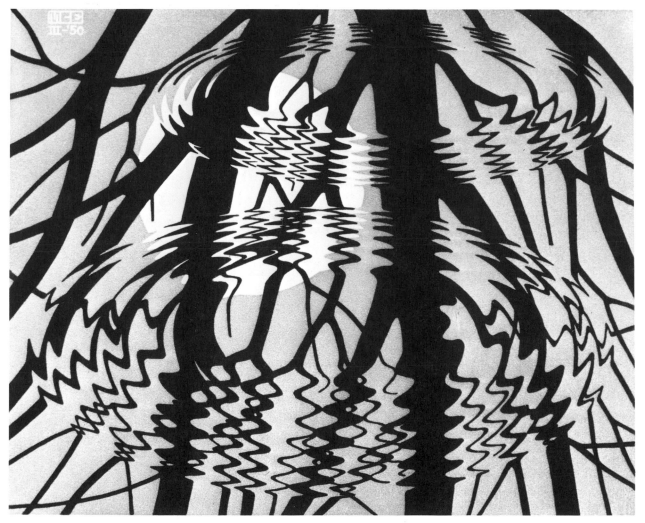

Oud

164

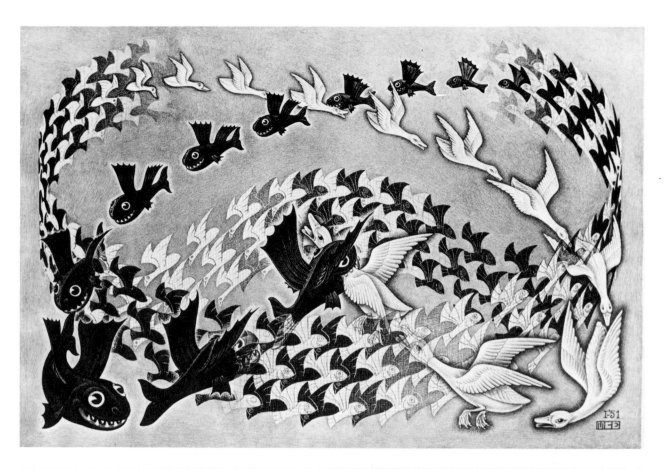

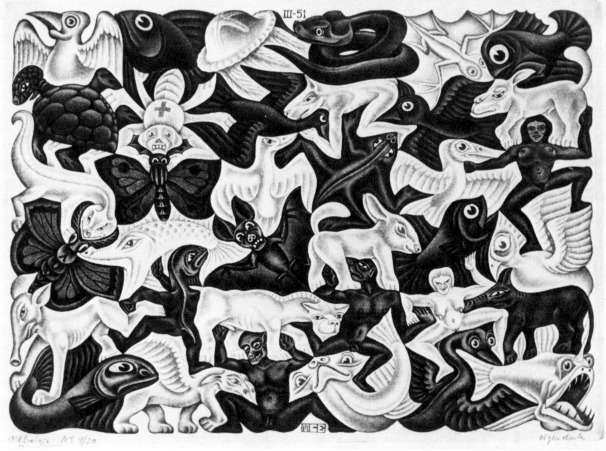

165

166

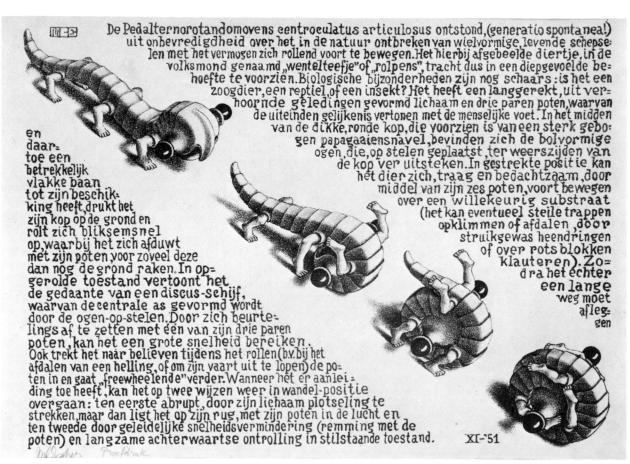

De Pedalternorotandomovens centroculatus articulosus ontstond, (generatio spontanea!) uit onbevredigdheid over het in de natuur ontbreken van wielvormige, levende schepse=len met het vermogen zich rollend voort te bewegen. Het hierbij afgebeelde diertje, in de volksmond genaamd „wentelteefje"of „rolpens", tracht dus in een diepgevoelde be= hoefte te voorzien. Biologische bijzonderheden zijn nog schaars: is het een zoogdier, een reptiel, of een insekt? Het heeft een langgerekt, uit ver= hoornde geledingen gevormd lichaam en drie paren poten, waarvan de uiteinden gelijkenis vertonen met de menselijke voet. In het midden van de dikke, ronde kop, die voorzien is van een sterk gebo= gen papagaaiensnavel, bevinden zich de bolvormige ogen, die, op stelen geplaatst, ter weerszijden van de kop ver uitsteken. In gestrekte positie kan het dier zich, traag en bedachtzaam, door middel van zijn zes poten, voort bewegen over een willekeurig substraat (het kan eventueel steile trappen opklimmen of afdalen, door struikgewas heendringen of over rotsblokken klauteren). Zo= dra het echter een lange weg moet afleg= gen

en daar= toe een betrekkelijk vlakke baan tot zijn beschik= king heeft, drukt het zijn kop op de grond en rolt zich bliksemsnel op, waarbij het zich afduwt met zijn poten voor zoveel deze dan nog de grond raken. In op= gerolde toestand vertoont het de gedaante van een discus-schijf, waarvan de centrale as gevormd wordt door de ogen-op-stelen. Door zich beurte= lings af te zetten met één van zijn drie paren poten, kan het een grote snelheid bereiken. Ook trekt het naar believen tijdens het rollen (b.v. bij het afdalen van een helling, of om zijn vaart uit te lopen) de po= ten in en gaat „freewheelende"verder. Wanneer het er aanlei= ding toe heeft, kan het op twee wijzen weer in wandel-positie overgaan: ten eerste abrupt, door zijn lichaam plotseling te strekken, maar dan ligt het op zijn rug, met zijn poten in de lucht en ten tweede door geleidelijke snelheidsvermindering (remming met de poten) en langzame achterwaartse ontrolling in stilstaande toestand.

XI-'51

167

168

170

171

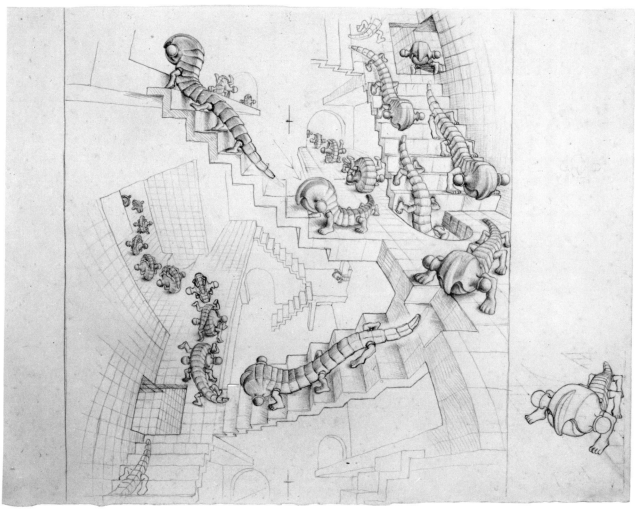

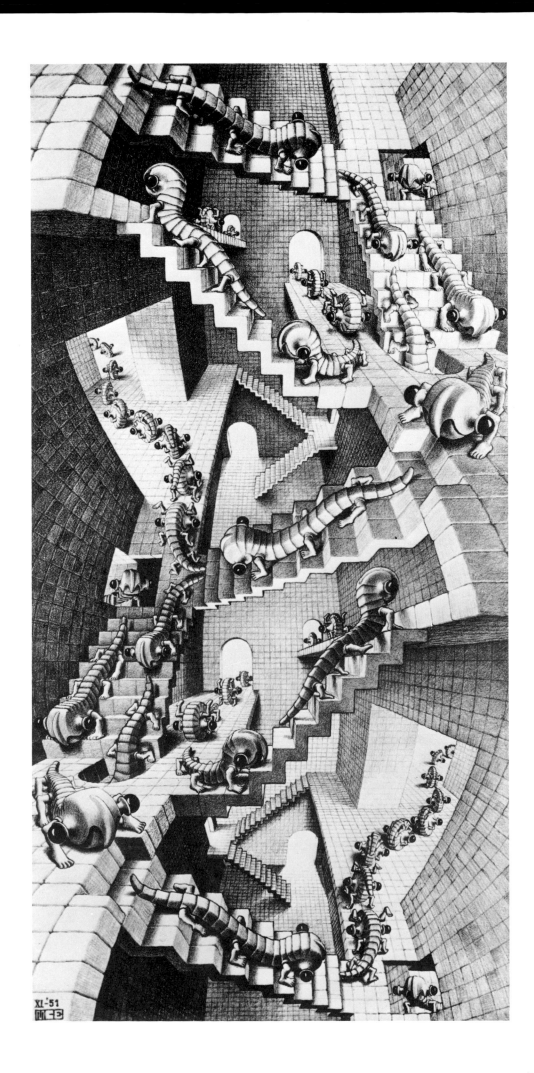

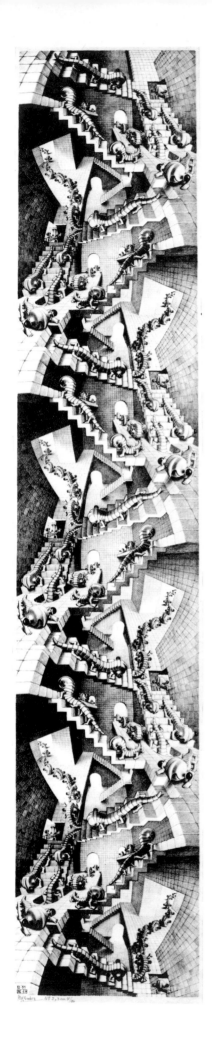

179

180

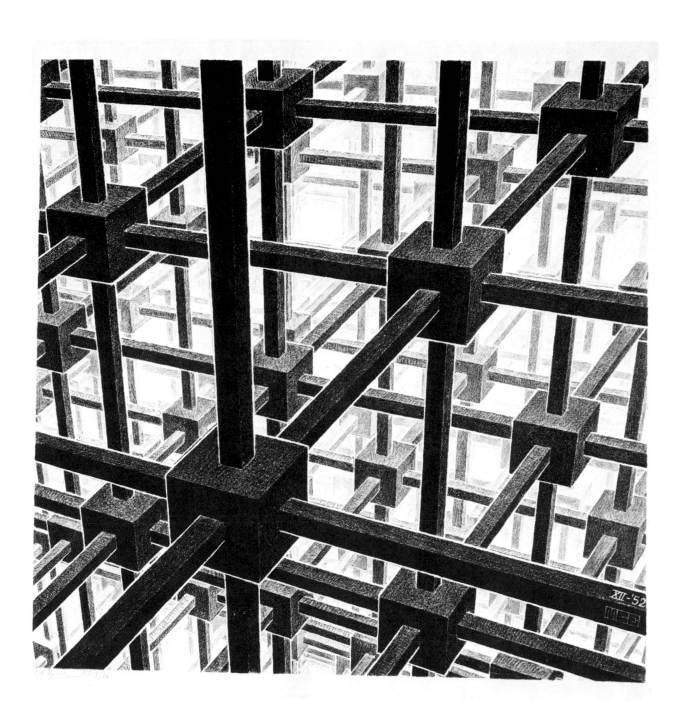

EUGÈNE & WILLY STRENS

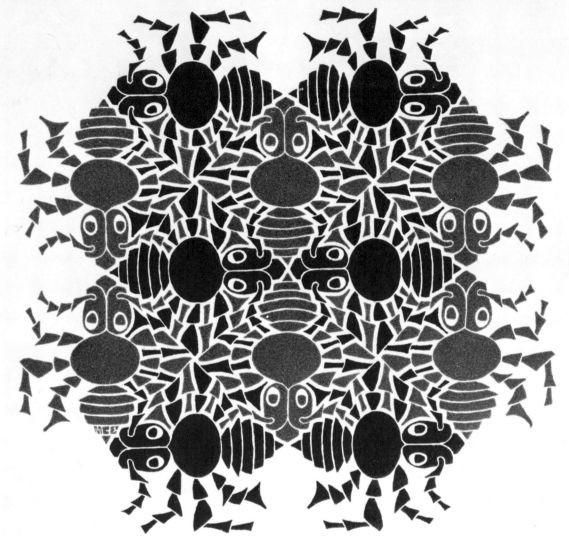

FELICITAS 1953

184

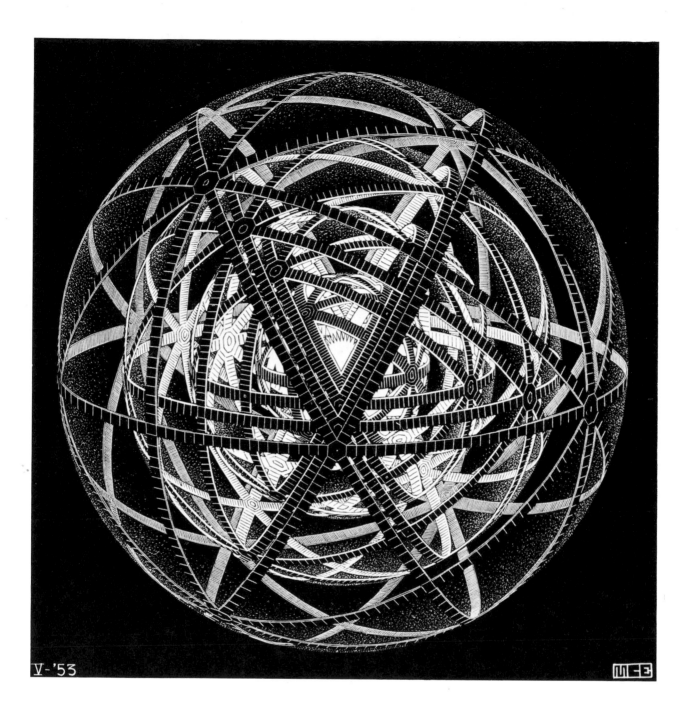

V-'53

185

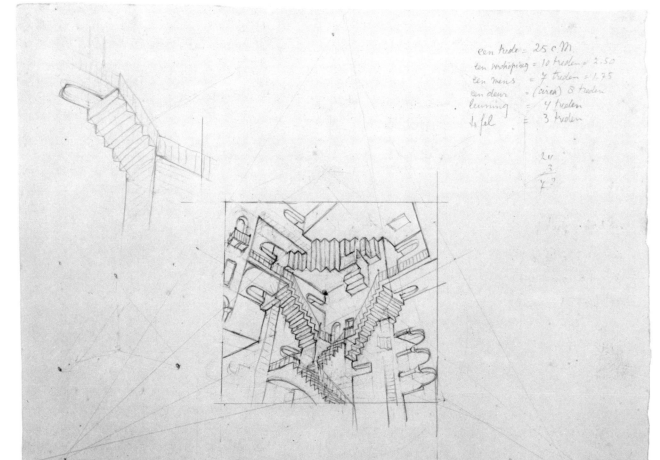

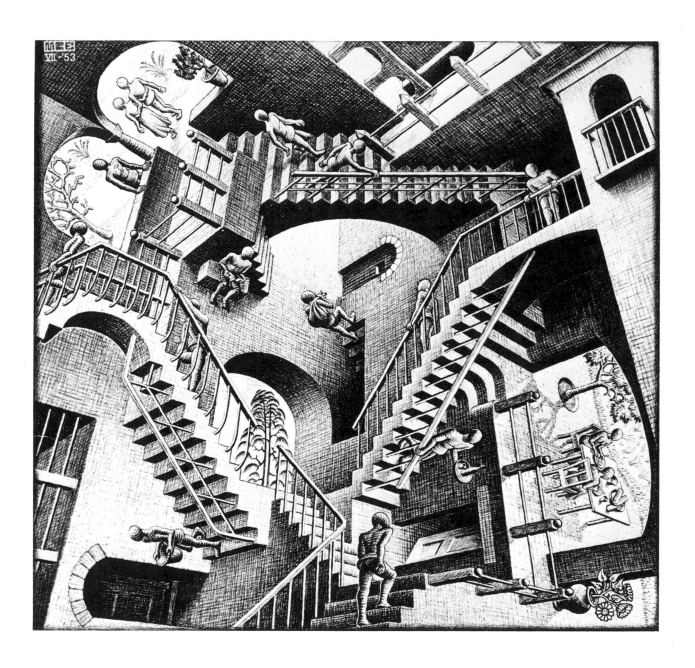

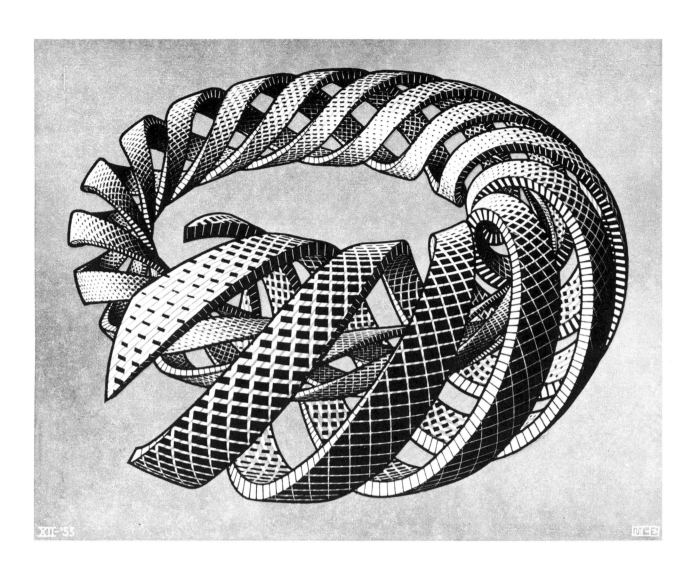

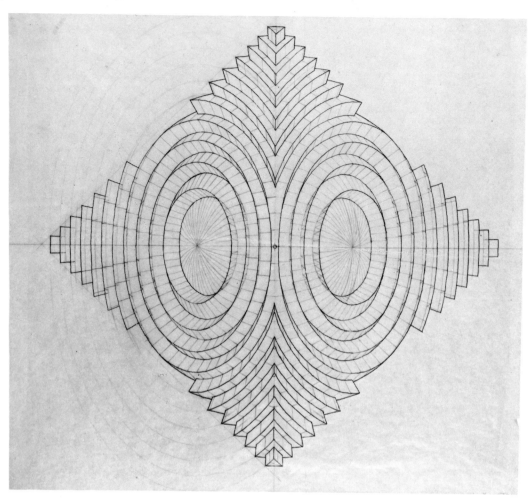

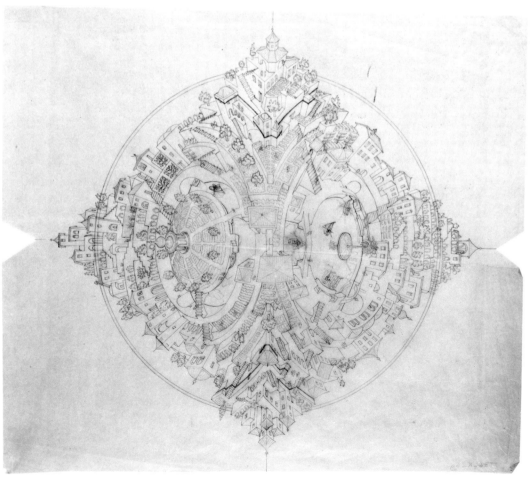

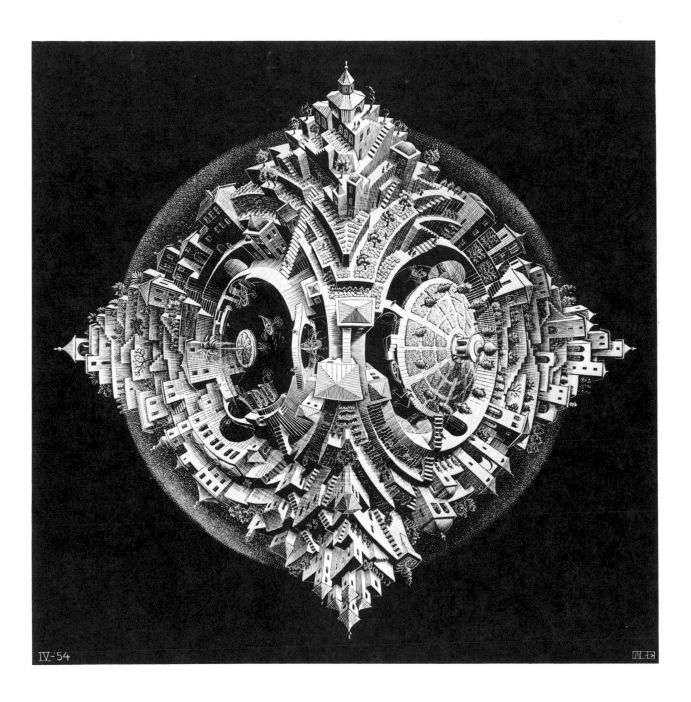

IV-'54

194

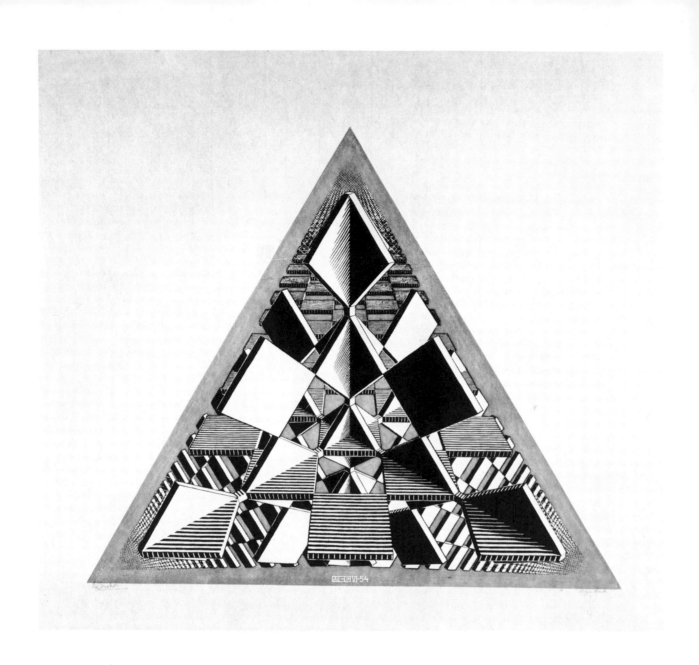

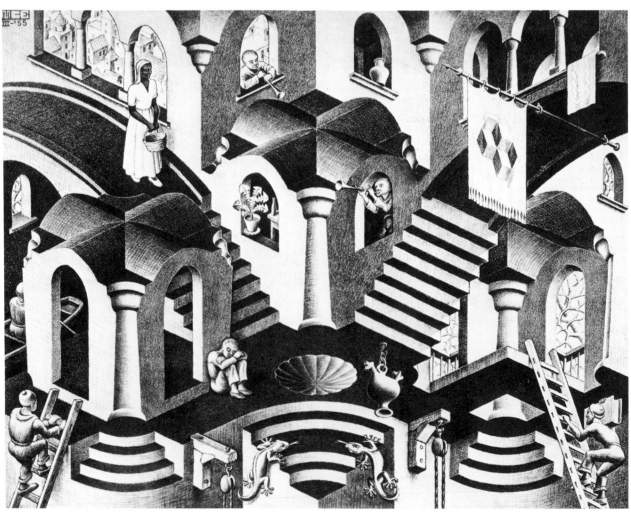

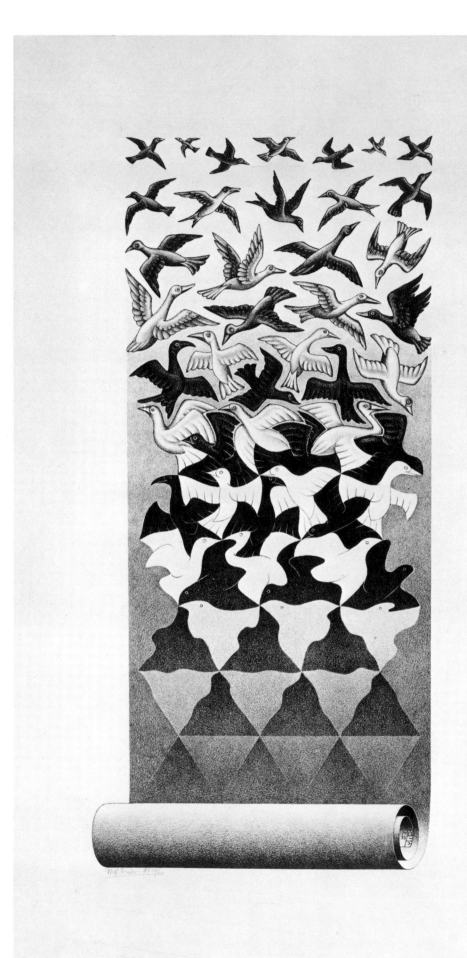

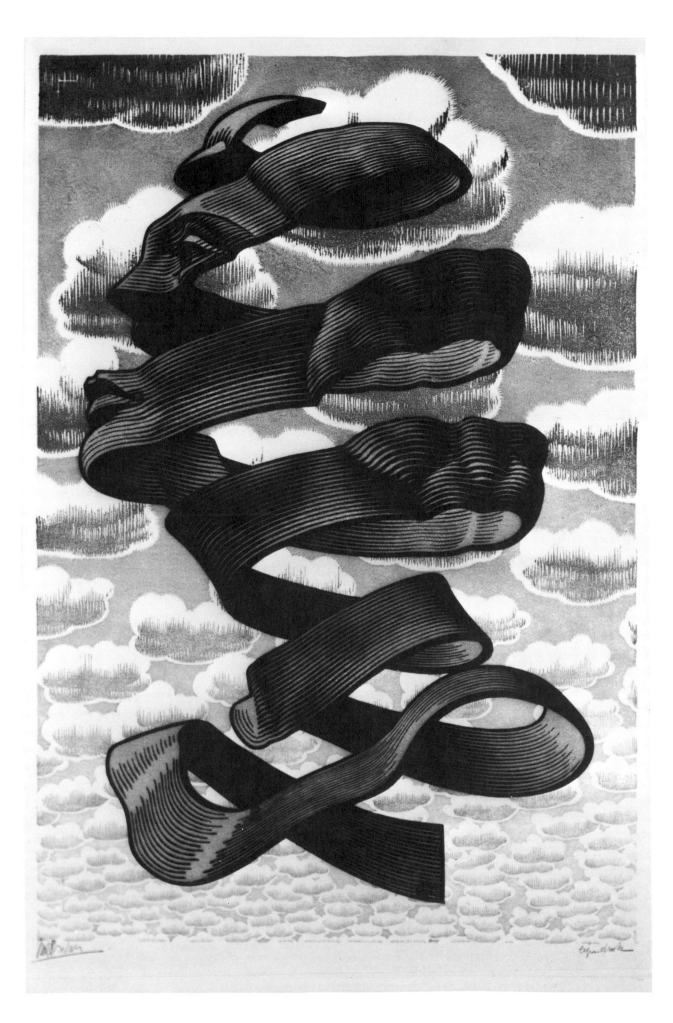

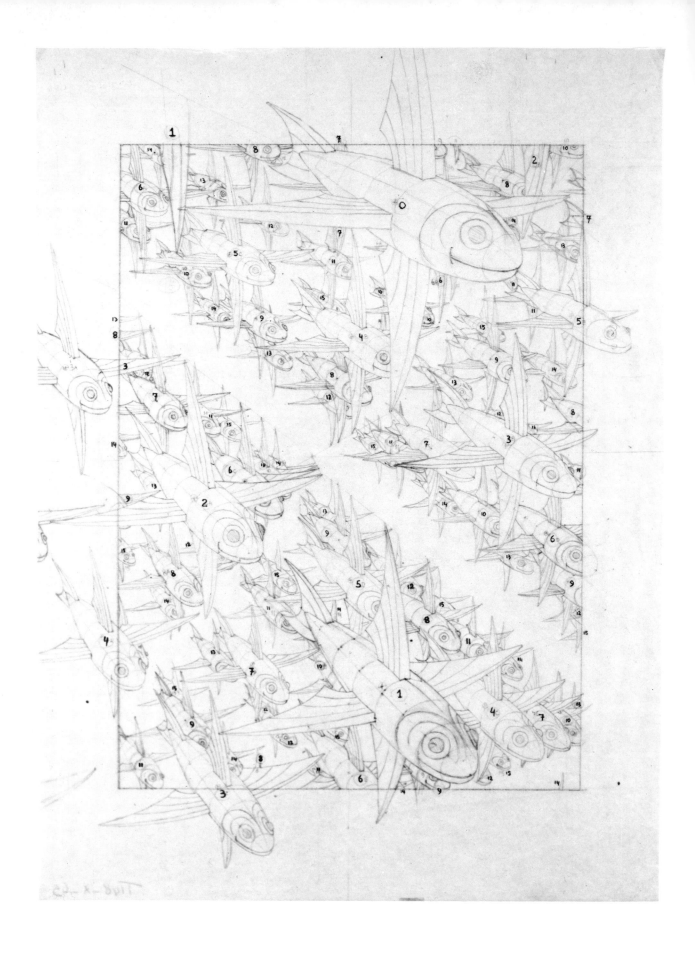

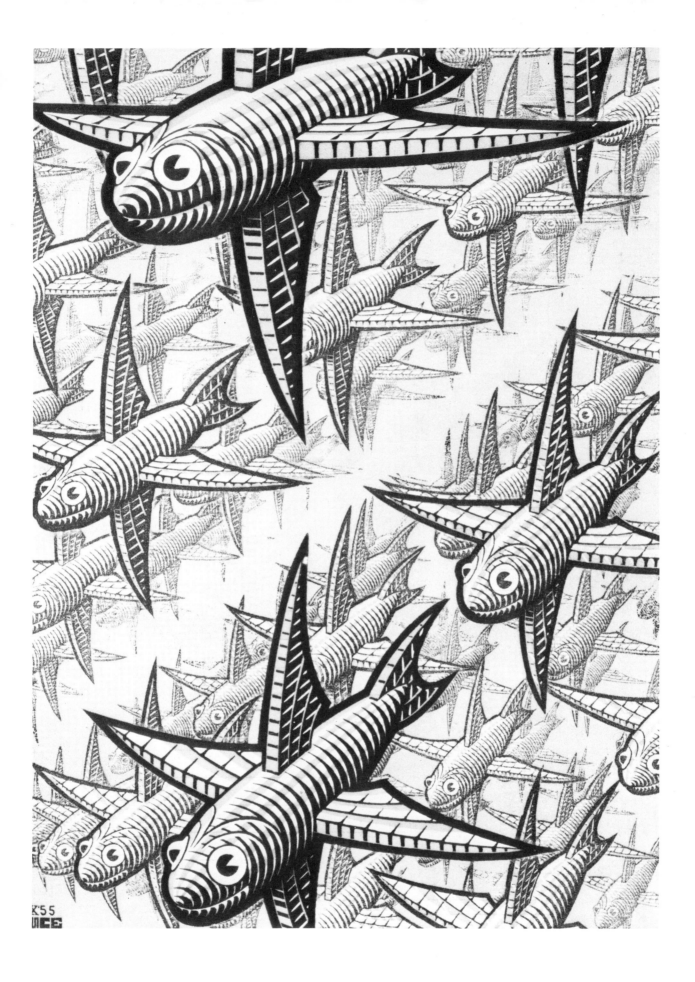

206

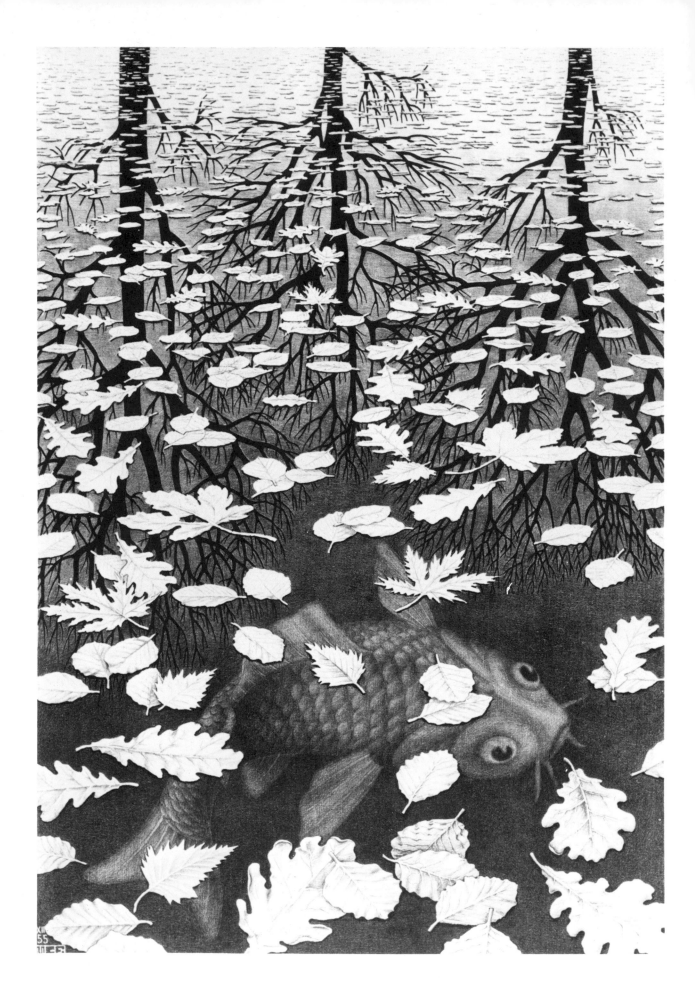

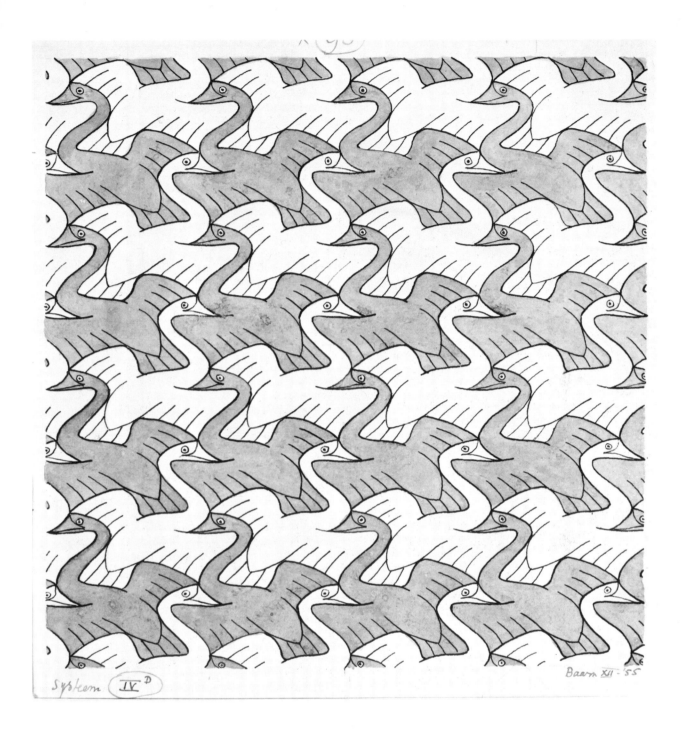

System (IV)D

Baarn XII - '55

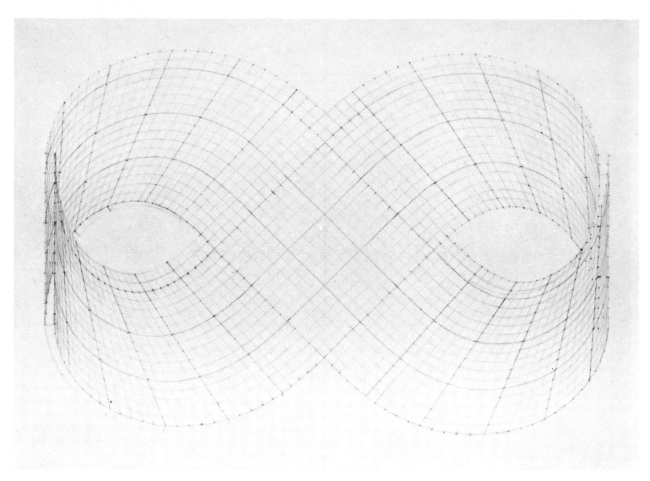

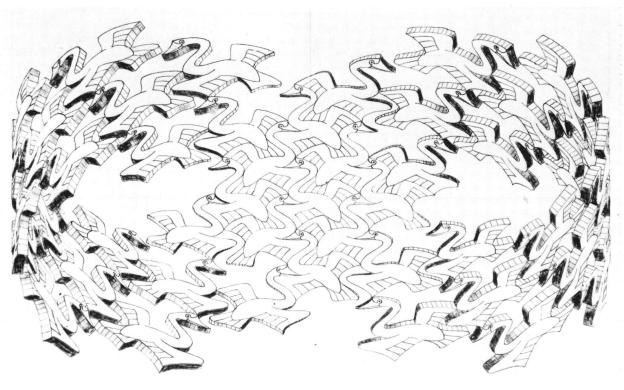

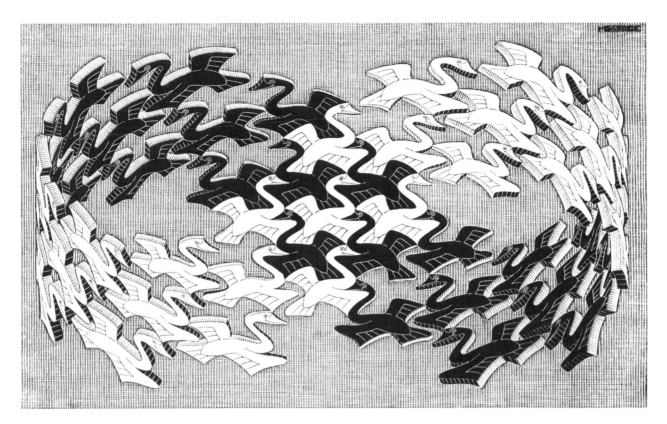

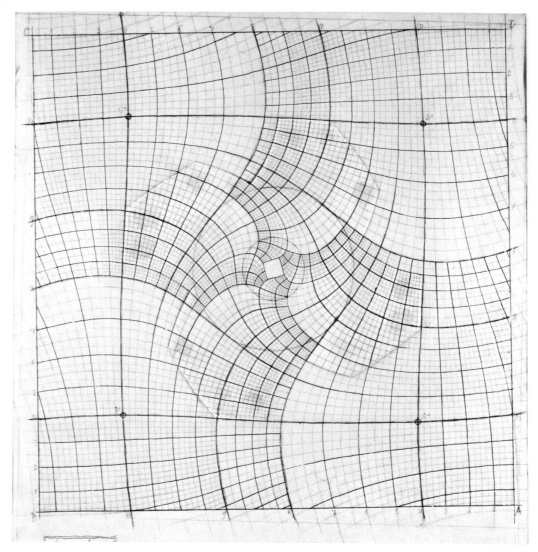

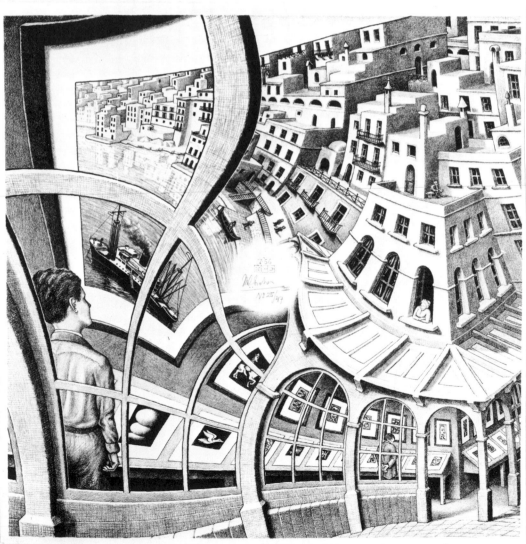

217

218

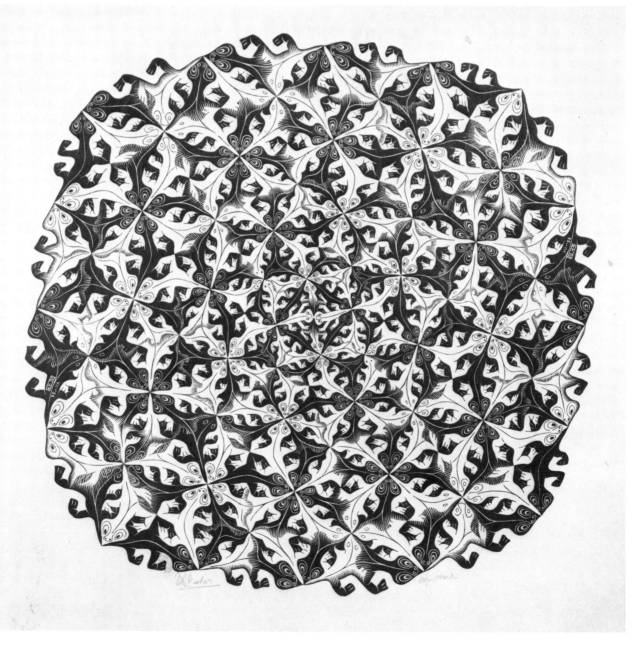

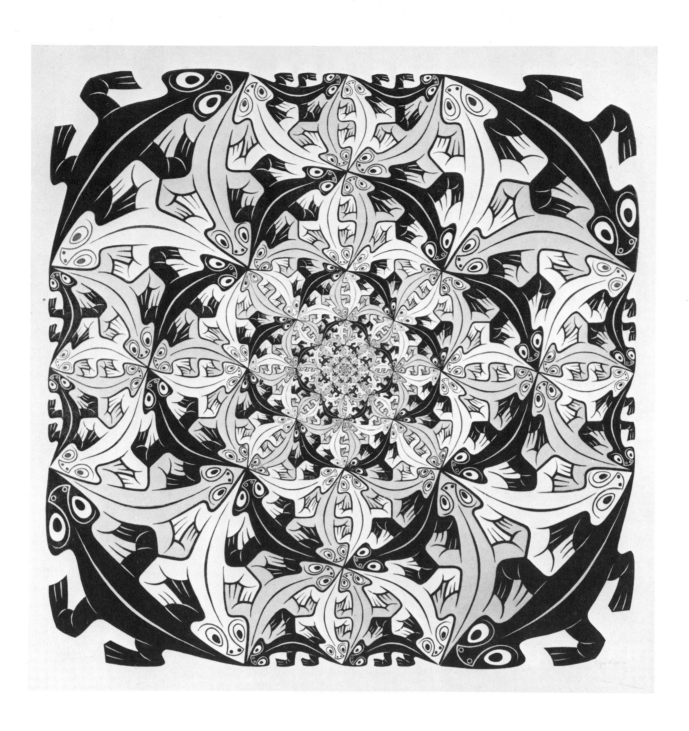

219

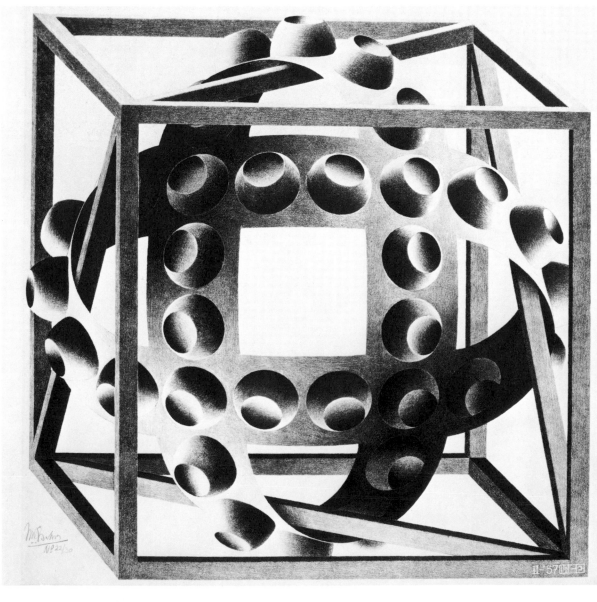

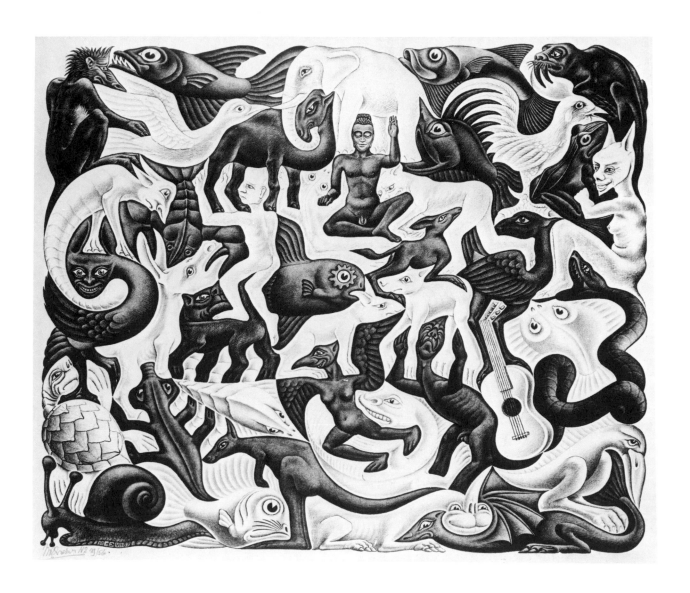

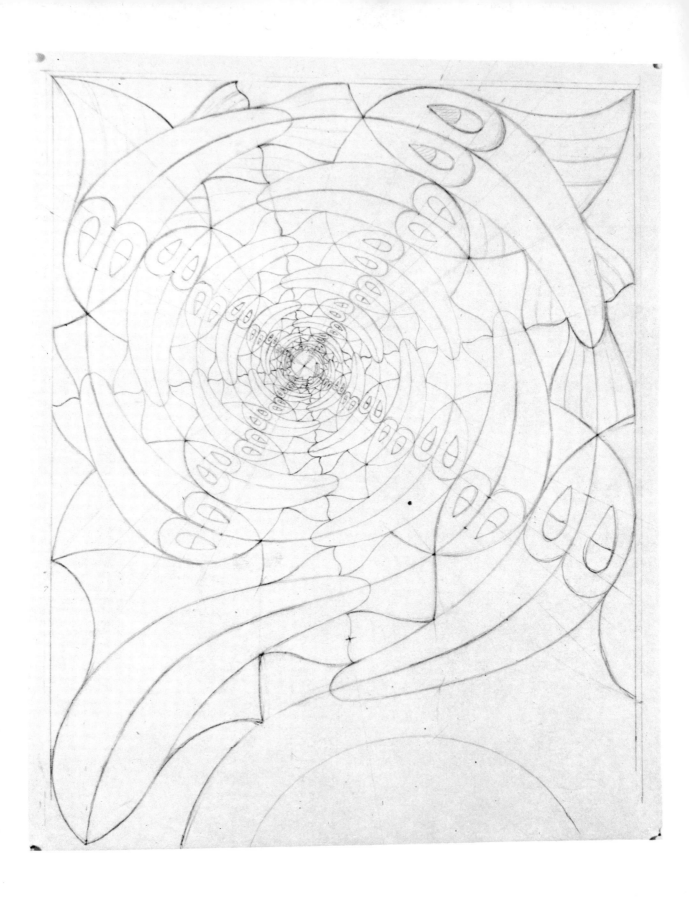

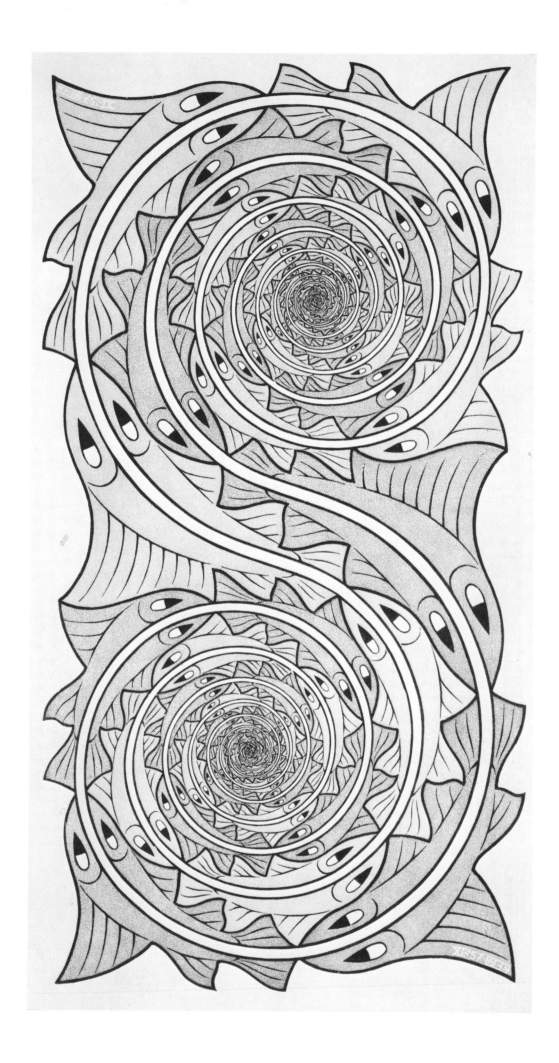

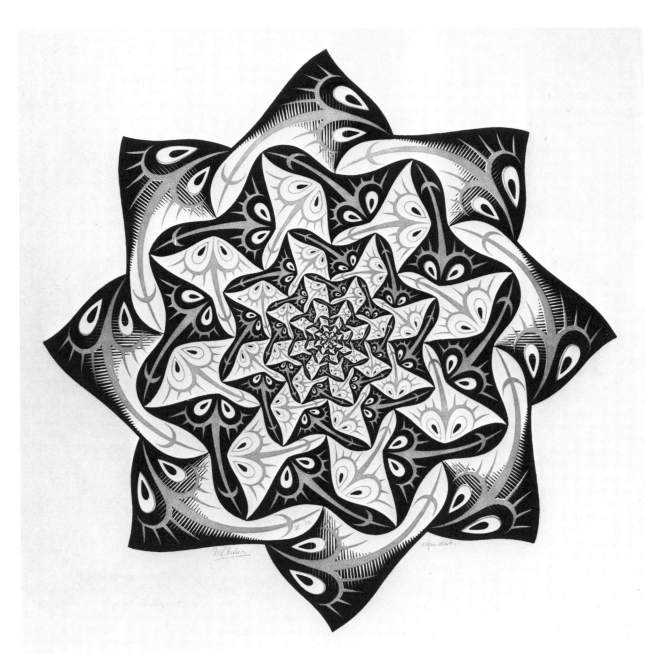

225

226

227

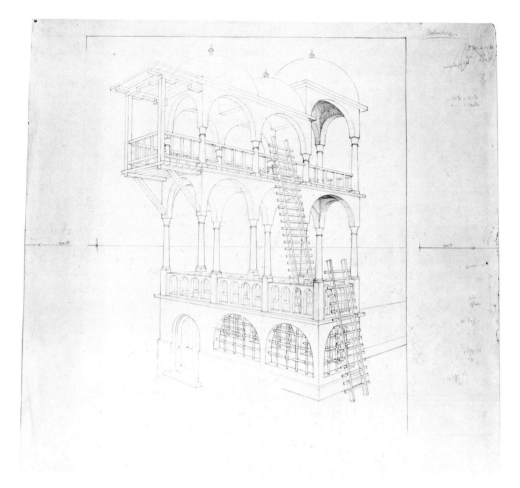

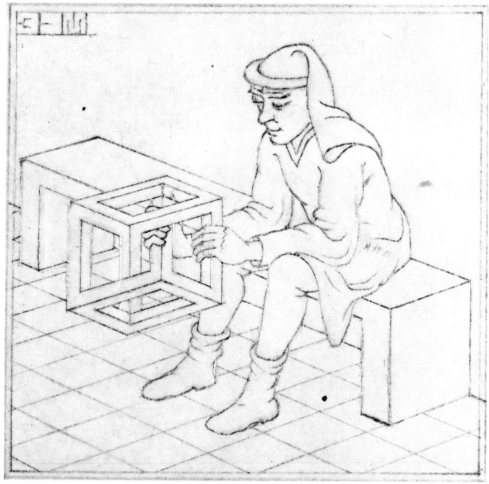

228

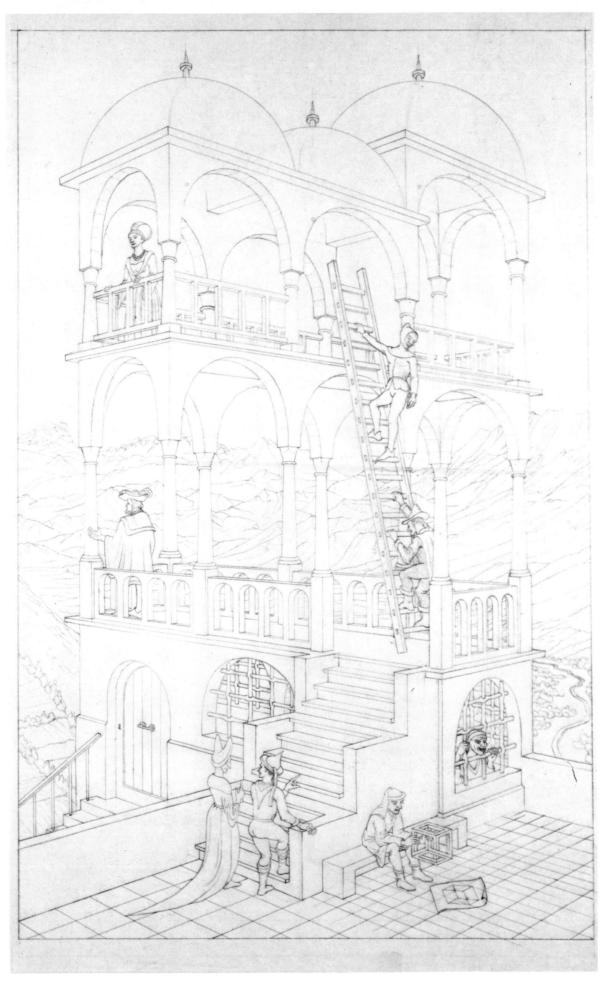

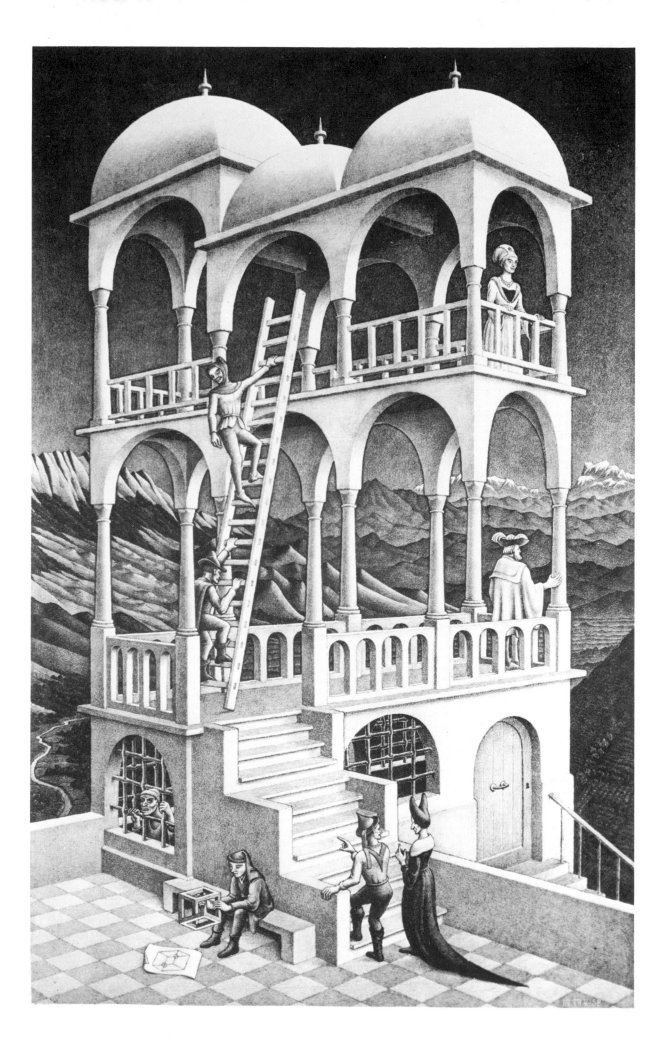

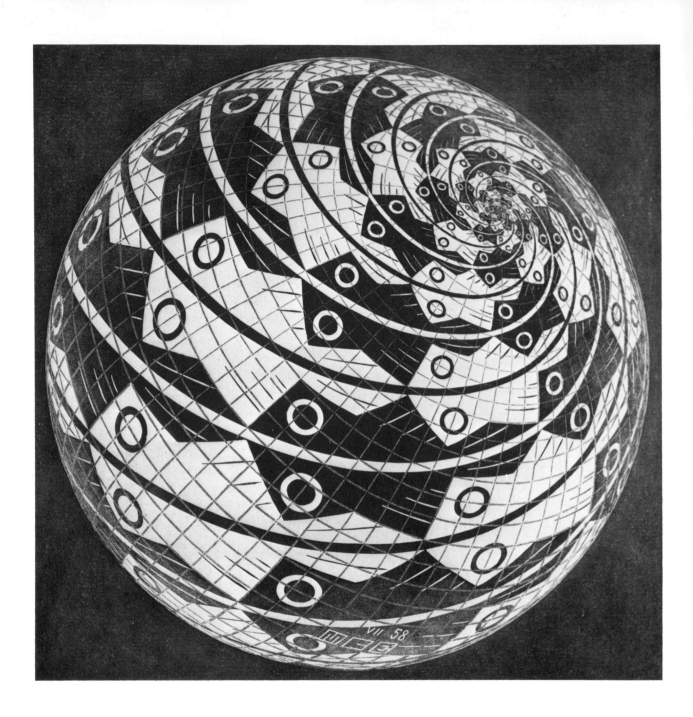

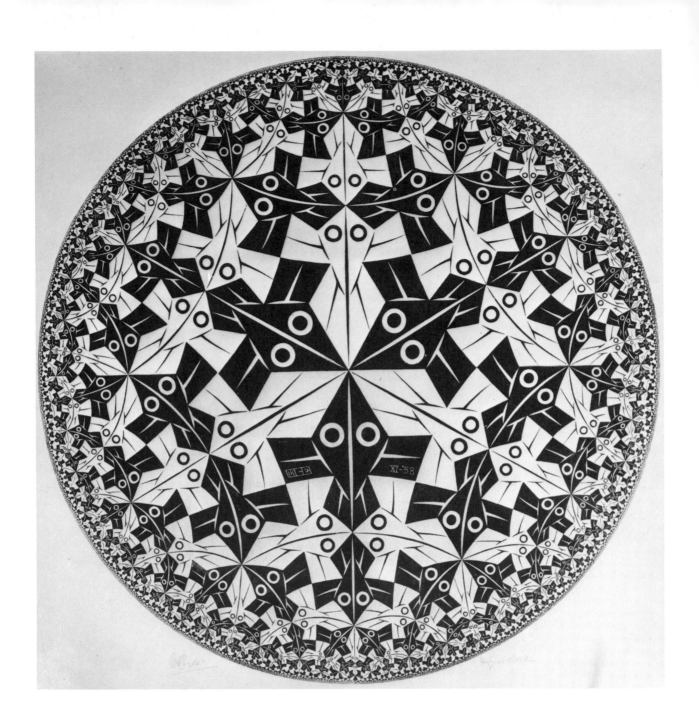

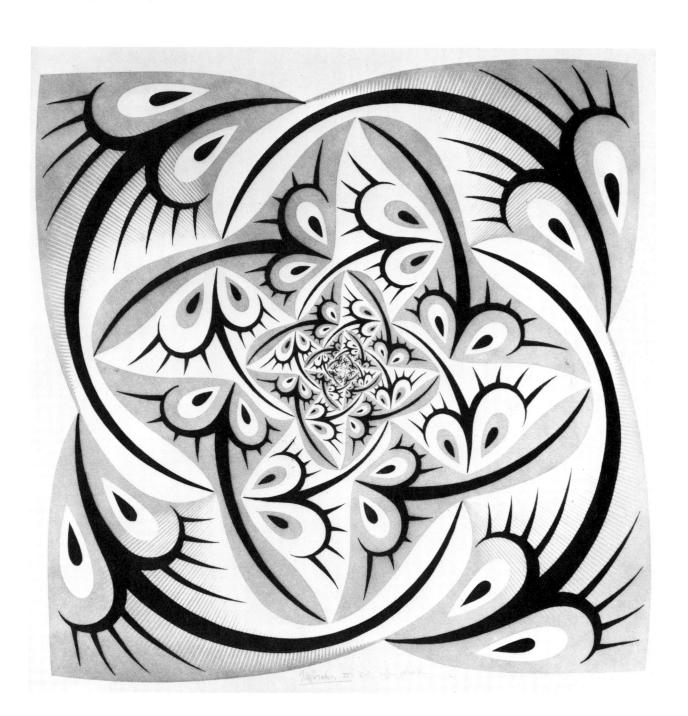

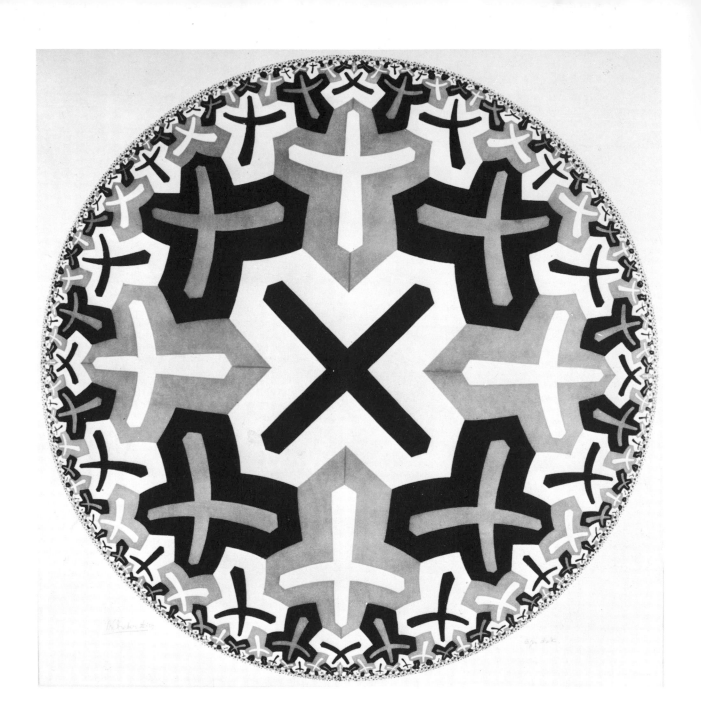

235

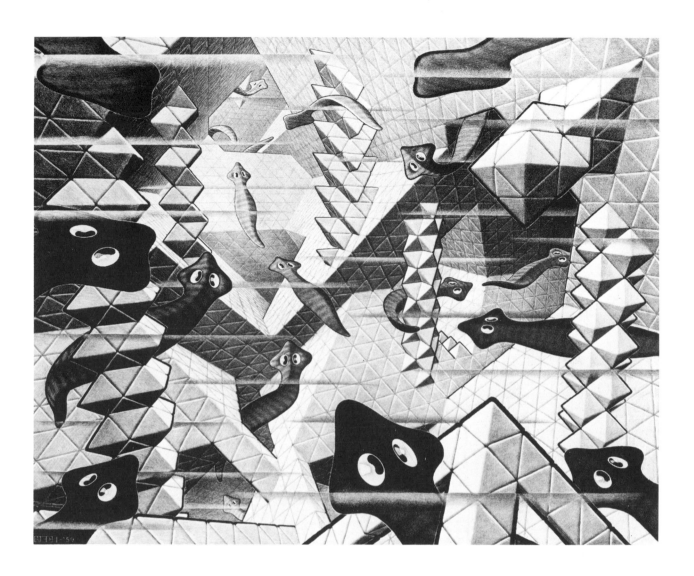

236

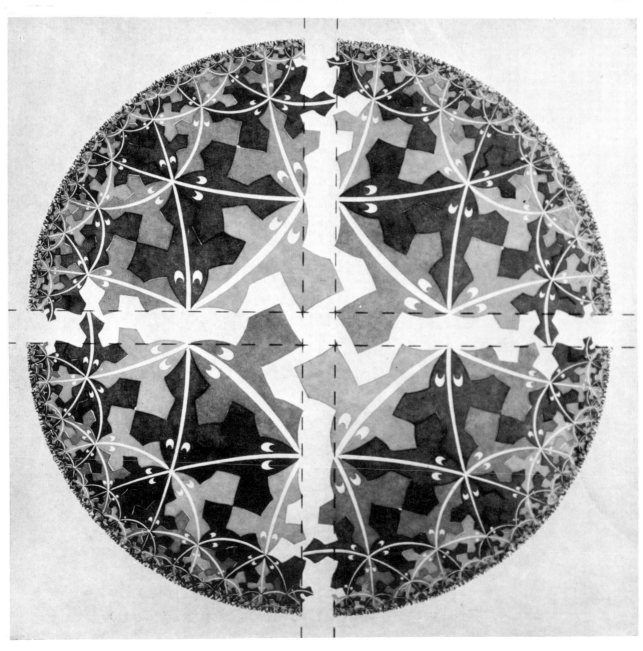

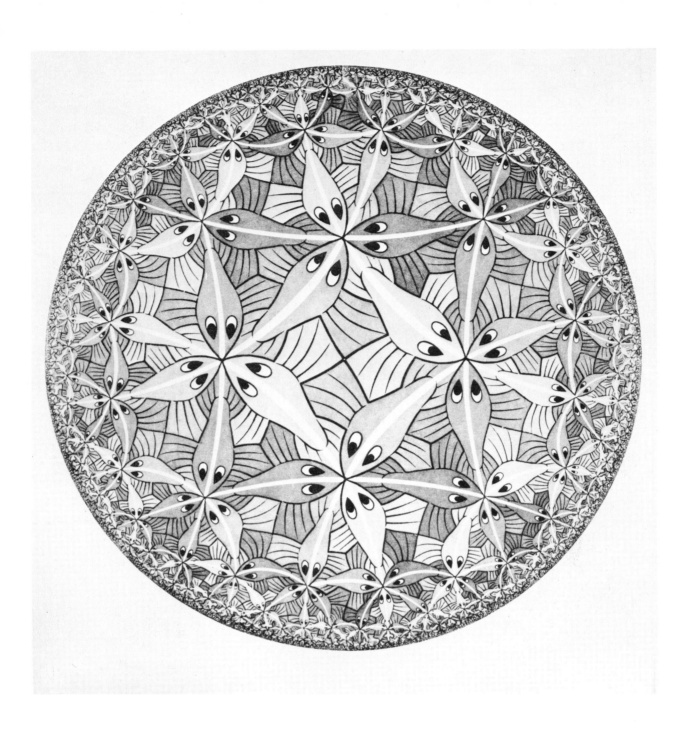

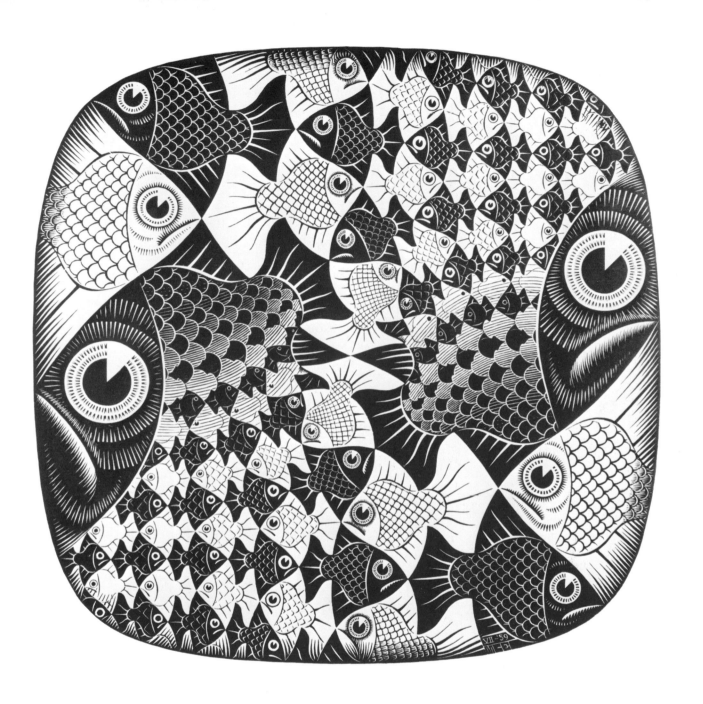

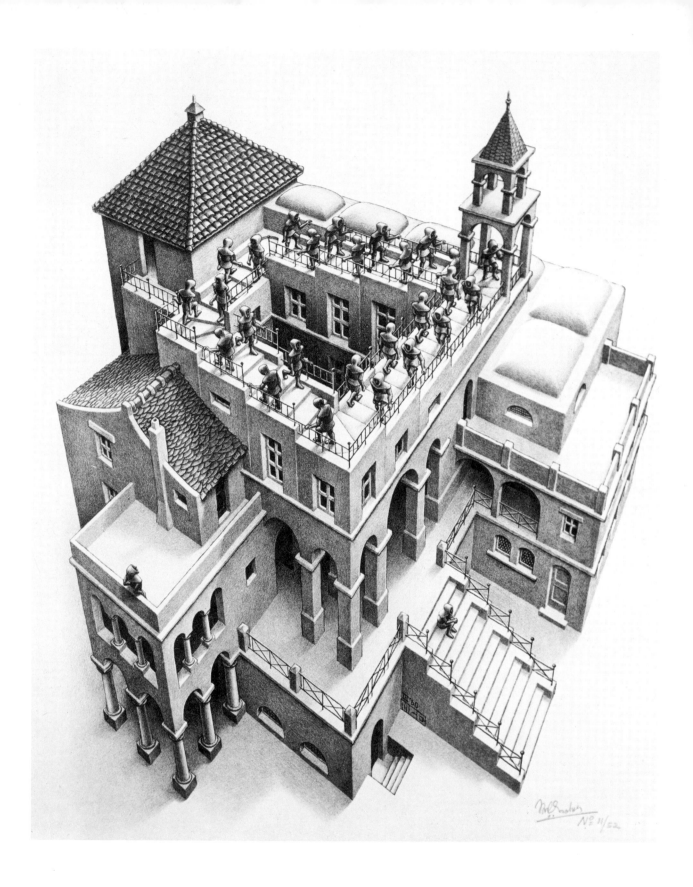

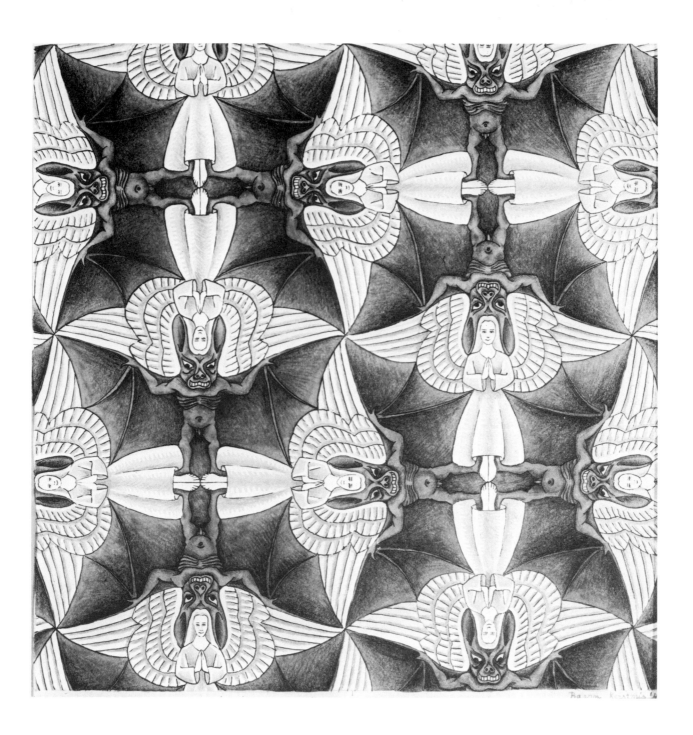

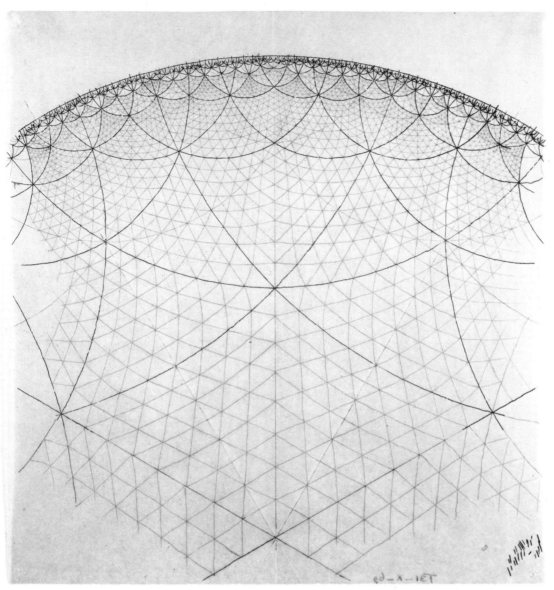

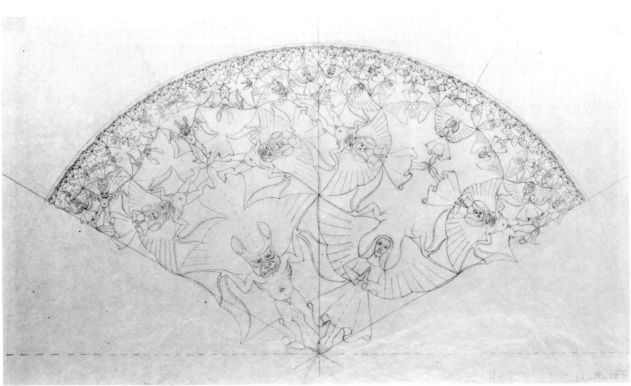

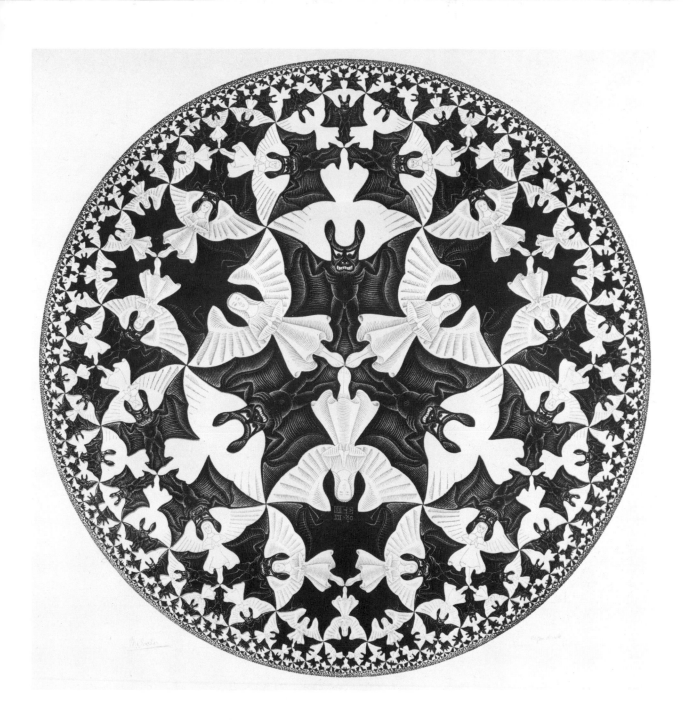

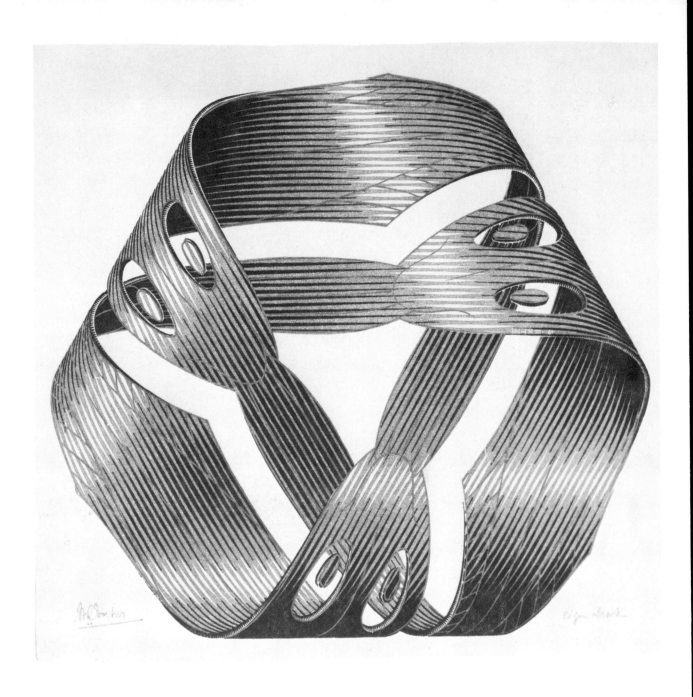

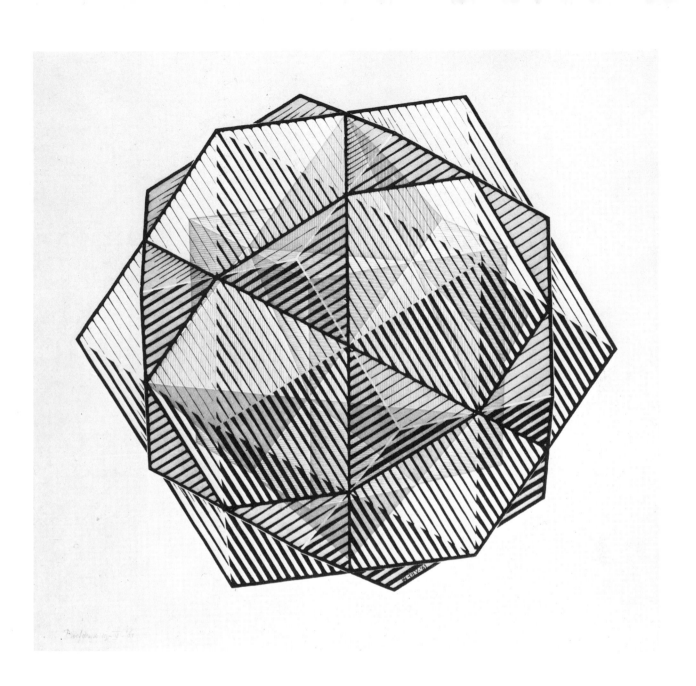

249

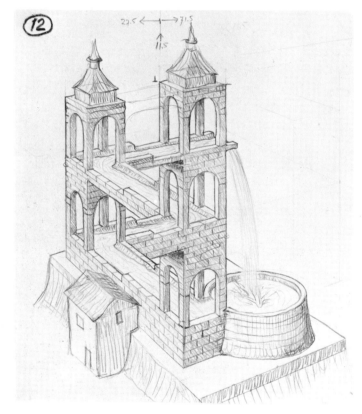

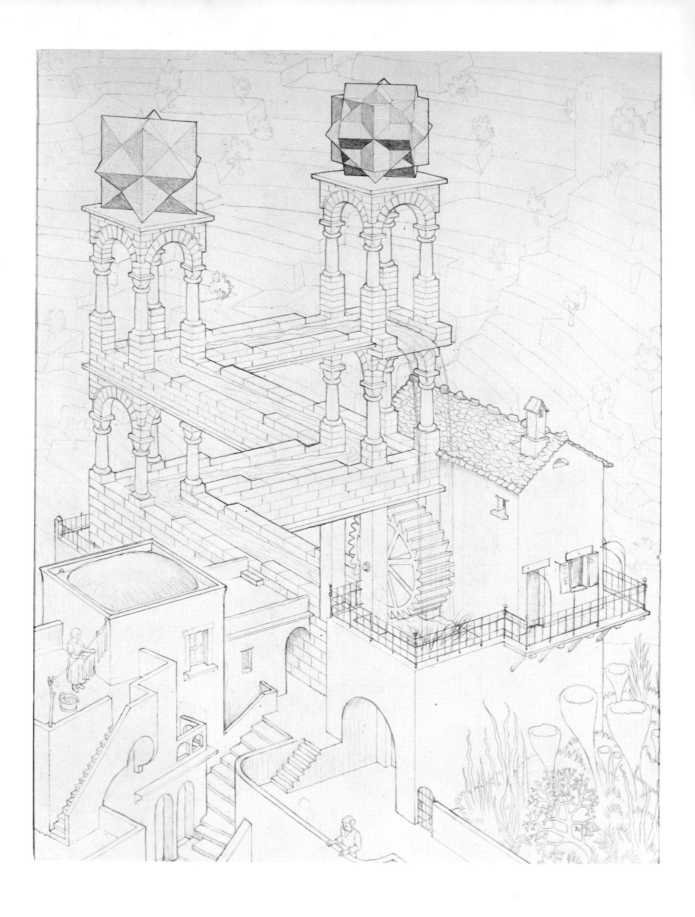

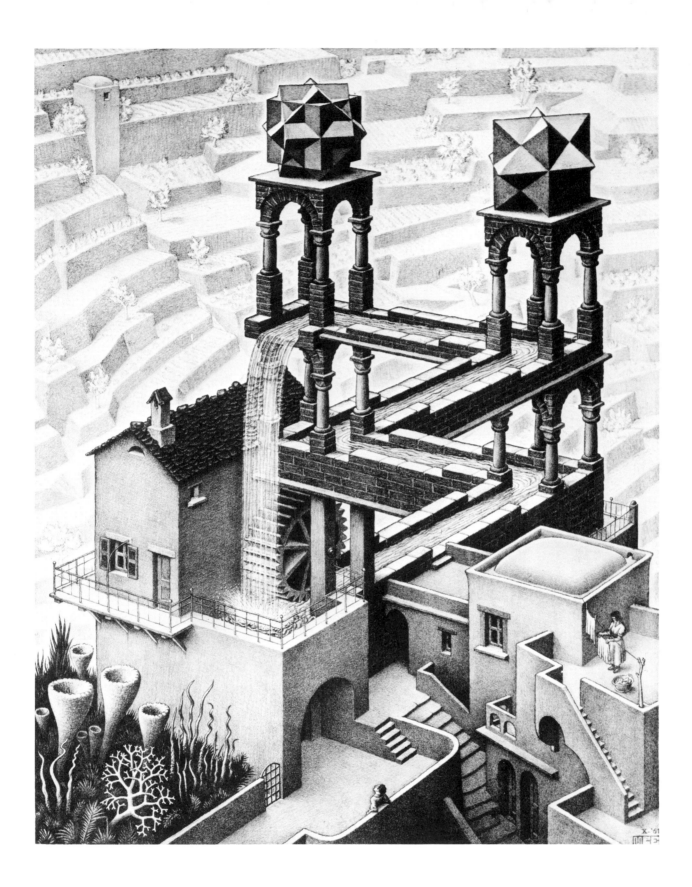

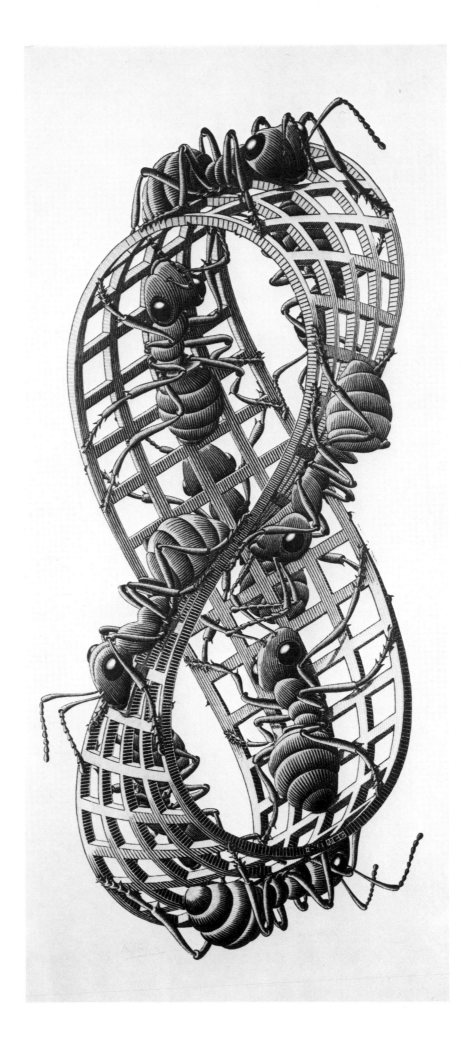

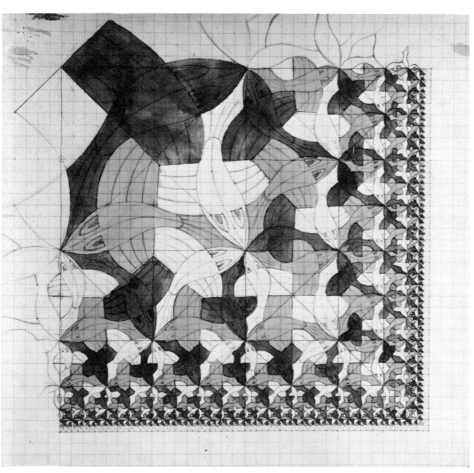

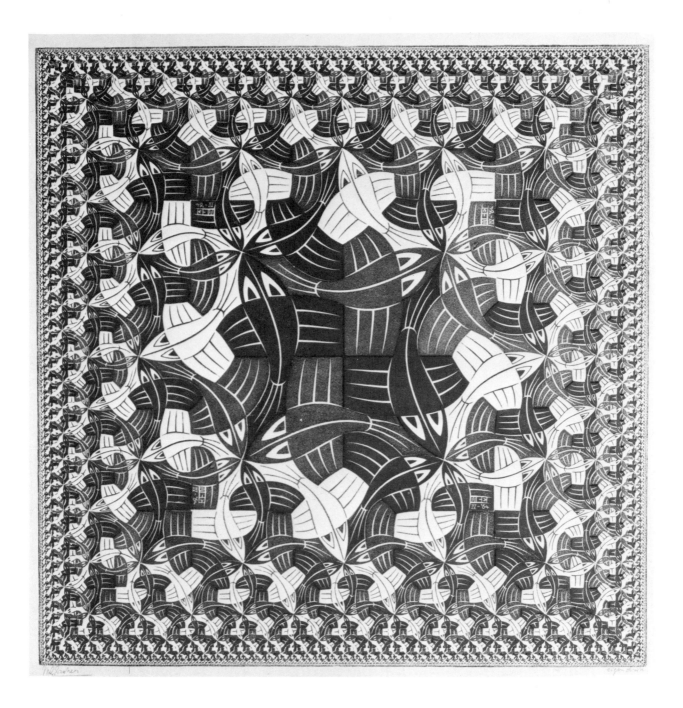

263

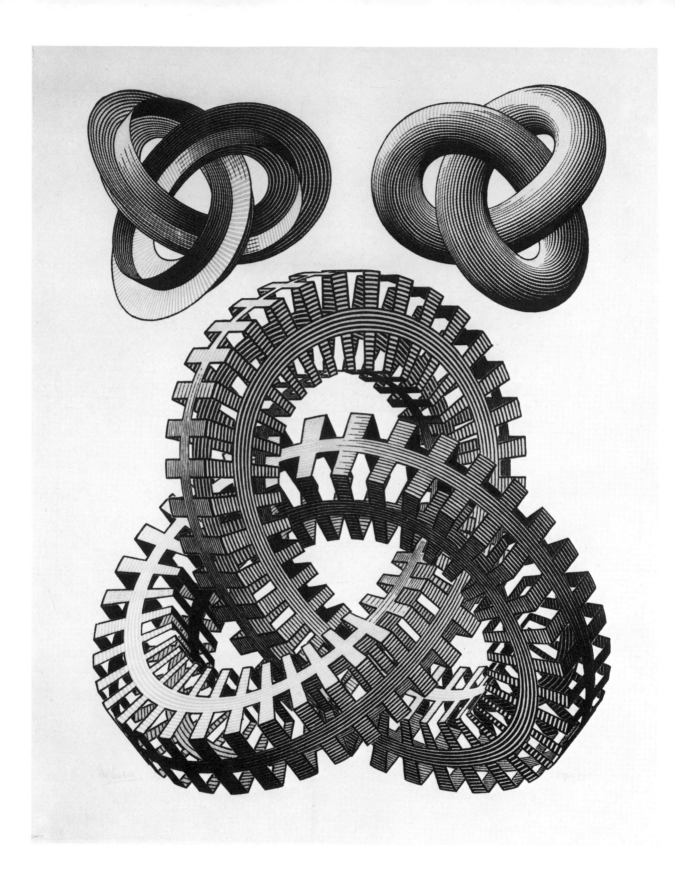

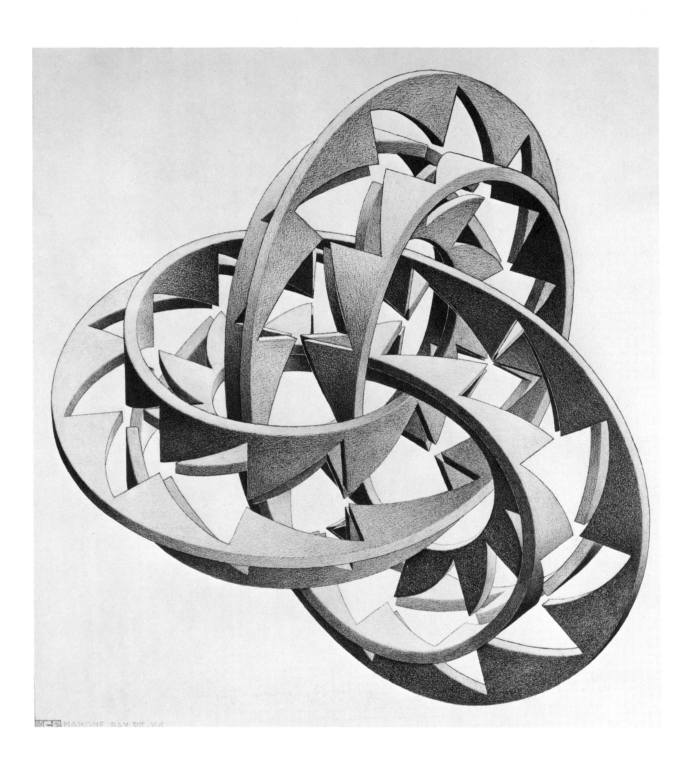

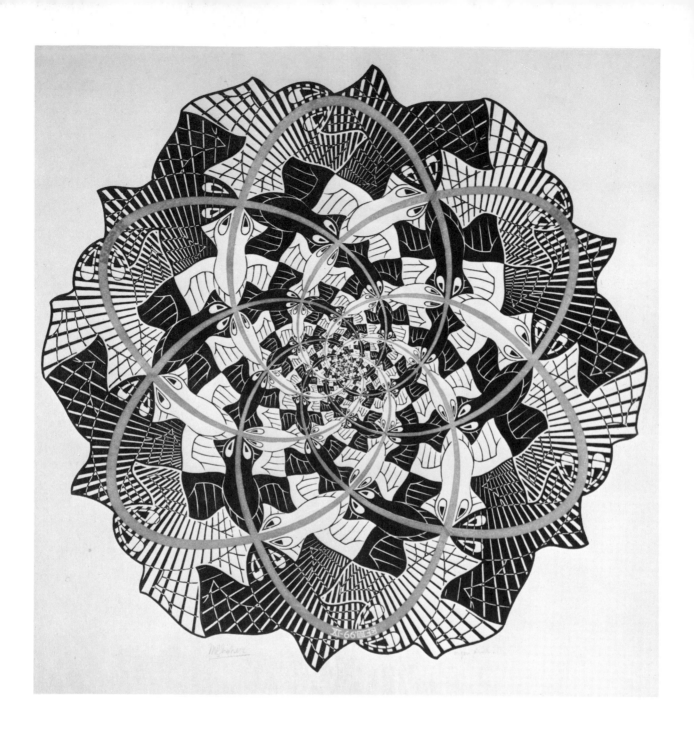

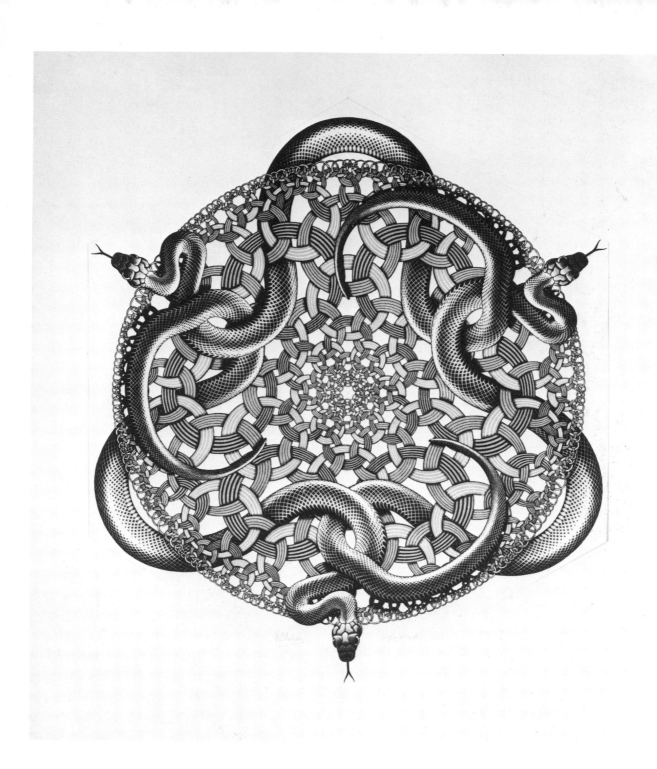